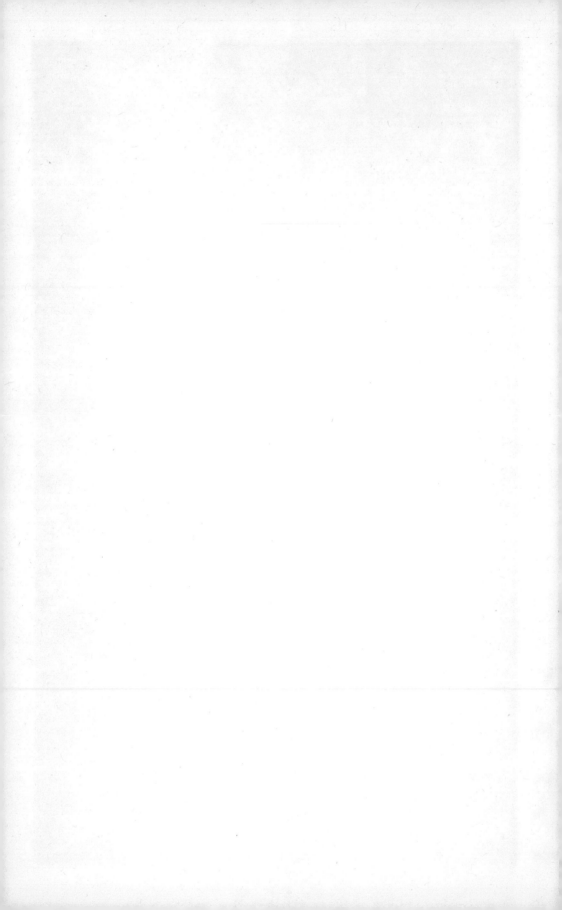

Looking at architecture with Ruskin

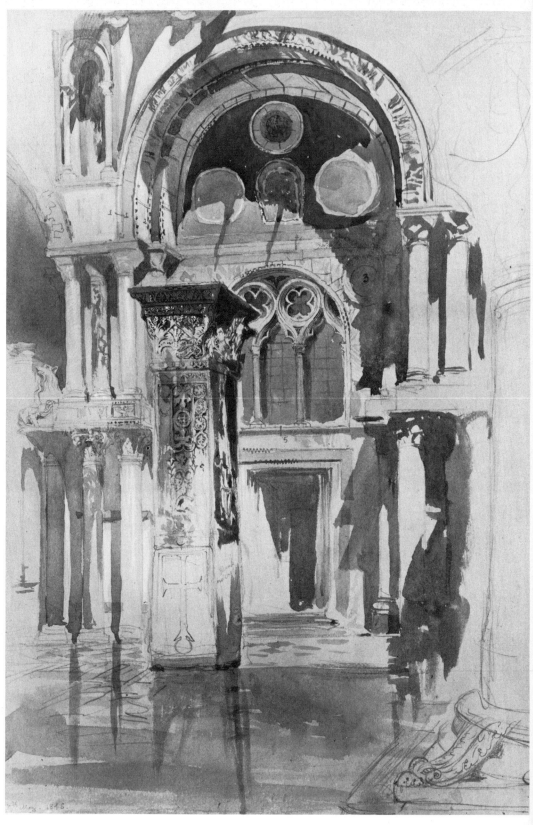

Frontispiece Ruskin *South side of St Mark's after rain* 1846

JOHN UNRAU

Looking at architecture with Ruskin

With 101 illustrations, 4 in colour

UNIVERSITY OF TORONTO PRESS:
TORONTO BUFFALO

© 1978 Thames and Hudson Ltd, London
First Published 1978
in Canada and the United States of America by
University of Toronto Press
Toronto Buffalo

Text filmset and monochrome section printed in Great Britain
by BAS Printers Limited, Over Wallop, Hampshire
Colour section printed in Great Britain by MCH International Ltd, London

ISBN 0-8020-2284-7

CONTENTS

Throughout this work, reference will be made to the Library Edition of *The Works of John Ruskin*, edited by E. T. Cook and Alexander Wedderburn in 39 volumes, and published between 1903 and 1912. This edition will be referred to by volume and page number, thus (23.163).

PREFACE

THIS BOOK surveys Ruskin's contribution as an observer and analyst of architectural composition. It deliberately ignores the ethical, religious and historical theories woven round architecture in his writings. Those theories are intriguing, but have already received attention from many able scholars; whereas a simple, concentrated survey of how Ruskin looked at buildings and interpreted what he saw has long been overdue. In a number of important areas, his discussion of architectural composition is carried on at a level of sophistication equalled by only the best modern work. Much of his original insight has not even been absorbed, let alone superseded, by criticism in our day.

Tolstoy and Proust judged Ruskin to be one of the greatest of all writers – and both were thinking of the content, not the mere stylistic strength, of his works. But he suffered from a tendency to dogmatic exaggeration and petulance which makes even his best writings repugnant to some readers. The architectural books are particularly notable for these flaws, and in his old age Ruskin came to loathe *The Seven Lamps of Architecture*, and dislike much of *The Stones of Venice*, because of them. The 1879 edition of the *Stones*, and 1880 edition of the *Lamps*, are savaged by footnotes pouring scorn upon many of the ethical and historical dogmas which had made them famous (of 'The Lamp of Truth': 'The closing paragraph is very pretty – but, unfortunately – nonsense'). This older, and in some ways wiser, Ruskin might well have approved of my selectivity.

Even with discussion centred entirely upon Ruskin's visual response, however, the book cannot be more than an extended introduction to its subject. This is because of the sheer quantity of Ruskin's published and unpublished references to architecture. Discussions of the art are scattered liberally and more or less at random through those thirty-two volumes of the Library Edition that are not specifically set aside for architectural publications. *The Seven Lamps* and *The Stones of Venice* contain less than half his published writing on the subject. When the

relevant materials in the published and unpublished diaries, notebooks, letters, and discarded drafts of lectures and chapters for various books are also taken into account, one is reduced, on contemplating it all, to a state of numb astonishment. Ruskin himself remarked to his publisher George Allen in 1877 (with a dozen years of writing, and almost as many new volumes, still before him): 'I've no more to say, I believe, now on any subject, if I knew all I *had* said and could index it.' My task has, indeed, been as much one of searching out and arranging what he said as of comment and interpretation. Since Ruskin is one of the masters of English prose, the argument of the book has been presented as much as possible in his own words. Similar reliance has been placed upon his drawings. Ruskin is a draughtsman of unique gifts, and his drawings are often the best illustrations that could be obtained of their subjects.

I wish to thank Thomas and Rachel Sharp for their constant help and encouragement; Rachel Trickett for valuable advice during early stages of the work; James Dearden for making my visits to the Ruskin Galleries at Bembridge School so pleasant. My gratitude is due also to: H. Cahoon, R. Ellenwood, D. Ewing, D. Foley, M. Friedrich, K. Garlick, B. Kanarens, S. King, A. G. and E. McCalla, R. D. McMaster, N. Pevsner, D. Phippard, D. S. Richardson, R. Sanfaçon, I. Sowton, H. Taliaferro, P. Turner, C. J. G. Wright and my editors.

For financial assistance which made my research possible I am grateful to the Rhodes Trustees; Pembroke College, Oxford; the Canada Council; and Atkinson College of York University, Toronto. The book is published with the aid of funds from Atkinson College.

I am grateful to all owners of Ruskin manuscripts for permitting me to quote previously unpublished passages. Acknowledgement is due also to the Ruskin Literary Trustees, as owners of the copyright in these materials, and their publishers, George Allen and Unwin Ltd, for kindly consenting to their publication. I wish to thank all owners of Ruskin drawings for allowing me to reproduce the works illustrated in this book.

I owe a special debt of gratitude to Susan Foley, Harold Brodie and my mother for the interest they have taken in my work. Lastly, and chiefly: my thanks to my wife and children for their patience and good-humoured support.

8

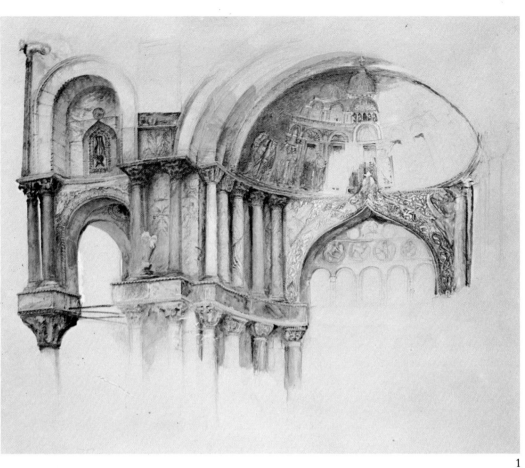

1

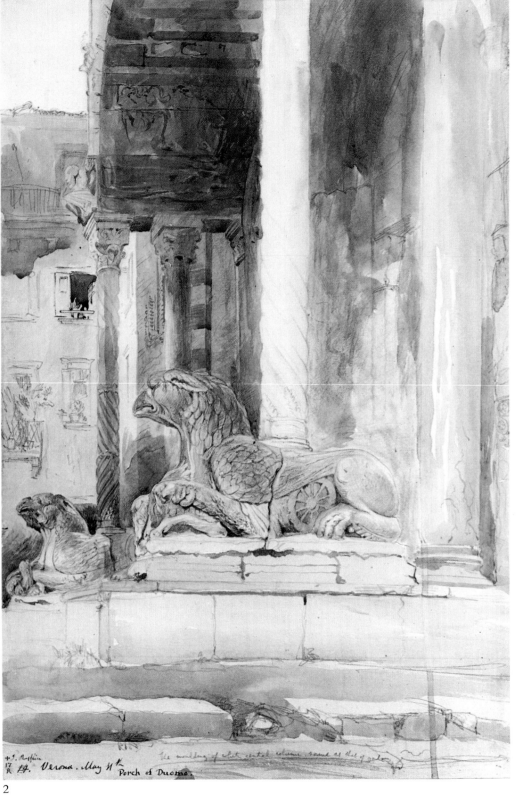

+ J. Ruskin

17 / R . ♯ . Verona . May 11th

Porch of Duomo .

The moulding of whit central column round of that of below.

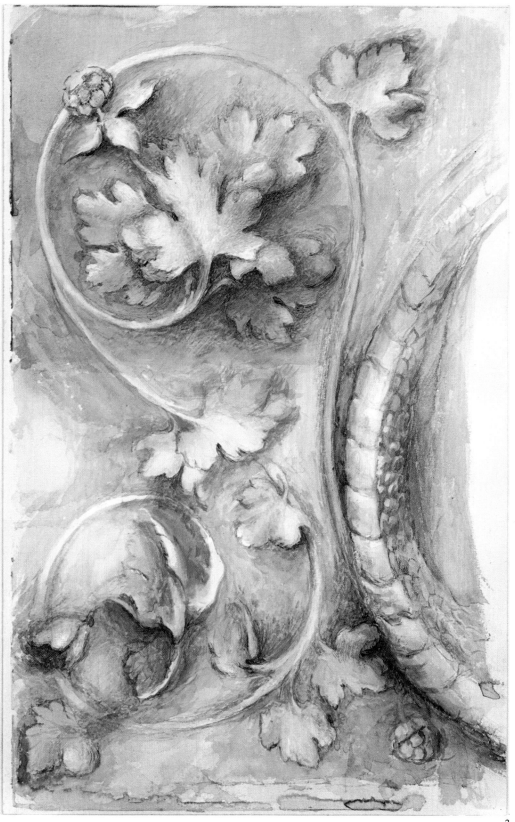

3

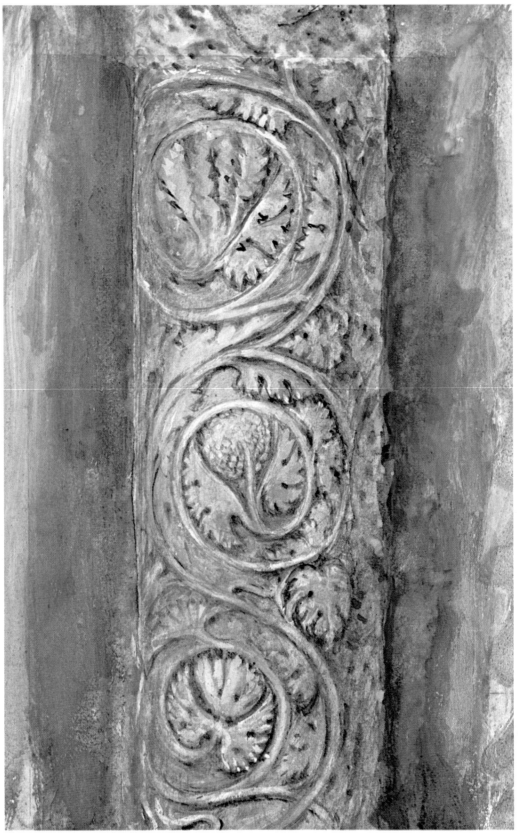

4

INTRODUCTION

No WRITER on architecture has devoted more attention to the detail of buildings than John Ruskin (1819–1900). Some critics in his day – mostly architects – claimed that the degree of emphasis he placed upon ornament was sure proof that he was not aware of the true nature of architecture at all. Responding with that taunting arrogance he was often to regret in later life, Ruskin made a number of provocative statements in the *Lectures on Architecture and Painting* (published 1854) and the preface to the second edition of *The Seven Lamps of Architecture* (1855) which have made it all too easy for subsequent writers to dismiss his architectural thought without making the strenuous effort necessary to obtain a full and balanced reading of his work on the subject. Two passages in particular have been cited with monotonous regularity from the 1850s onward:

Ornamentation is the principal part of architecture.(12.83)

The fact is, there are only two fine arts possible to the human race, sculpture and painting. What we call architecture is only the association of these in noble masses, or the placing them in fit places.(8.11)

It is perhaps no wonder that potential readers of Ruskin should conclude that there is no point in pursuing, through all those fat red volumes, the views of a man who could say such apparently nonsensical things. But to dismiss Ruskin's architectural criticism on the basis of these and certain other famous quotations is as unfair as it would be to dismiss Tolstoy's writings because of his eccentric essay on Shakespeare.

Not to read Ruskin is perfectly excusable. Not to be often baffled, even enraged, when one does read him is a sign of inattentiveness. But to generalize about his architectural thought on the basis of a reading of *The Seven Lamps* and 'The Nature of Gothic' is, inevitably, to mislead. A recent example typifies the kind of unjust accusation that can so easily be made by the critic who has not read Ruskin with sufficient care. Paul Frankl has charged that

just as Ruskin rejects the new insight regarding the ribbed vault . . . so his whole conception of the subject [Gothic architecture] is two-dimensional. He does not see the significance of ribbed vaulting because he is not properly aware of the three-dimensional interior; his interest always remains fixed on the two-dimensional surfaces.[1]

This statement is highly misleading. Ruskin read, took notes from, and repeatedly recommended to his readers, the most important book of the 1830s demonstrating the 'new insight' on Gothic vaulting referred to by Frankl – Robert Willis's *Remarks on the Architecture of the Middle Ages, Especially of Italy* (1835).[2] There are many references in his writings to the visual pleasures to be derived from a fine Gothic vault, and his notebooks and diaries contain numerous diagrams and commentaries on the vaulting of French medieval buildings.[3] A page from one of his rough notebooks is reproduced in ill. 5.

But there is even more persuasive evidence of the falsity of Frankl's charge. Consider, for example, the passage in which Ruskin introduces the reader of *The Bible of Amiens* to the interior of the cathedral:

I know no other which shows so much of its nobleness from the south interior transept; the opposite rose being of exquisite fineness in tracery, and lovely in lustre; and the shafts of the transept aisles forming wonderful groups with those of the choir and nave; also, the apse shows its height better, as it opens to you when you advance from the transept into the mid-nave, than when it is seen at once from the west end of the nave; where it is just possible for an irreverent person rather to think the nave narrow, than the apse high.(33.129)

A passage such as this, and there are many others, is surely sufficient to discredit the charge that Ruskin's interest in architecture is entirely two-dimensional. His remarks about the effect of the position of the viewer at Amiens on the apparent

5 Ruskin *Architectural notes at Mortain* 1848 or 1849

height of the apse are in themselves convincing proof of three-dimensional awareness. Rudolf Arnheim has pointed out that

When we look from the entrance door of a church toward the altar, the projective pattern we receive is symmetrical. This symmetry will reduce depth perception. . . . If we look at the interior of the church from an oblique position, three-dimensionality increases.[4]

Ruskin's drawings offer further evidence. His treatment of the interior of San Frediano in Lucca (ill. 6), of the buttresses of St Wulfran in Abbeville (ill. 86), of the central doorway of Rouen Cathedral (ill. 54), and of a capital at the Doge's Palace in Venice (ill. 7) – to give just four examples of architectural subjects drawn at varying range – reveals a remarkable sensitivity to three-dimensional impressions. Shadows can be

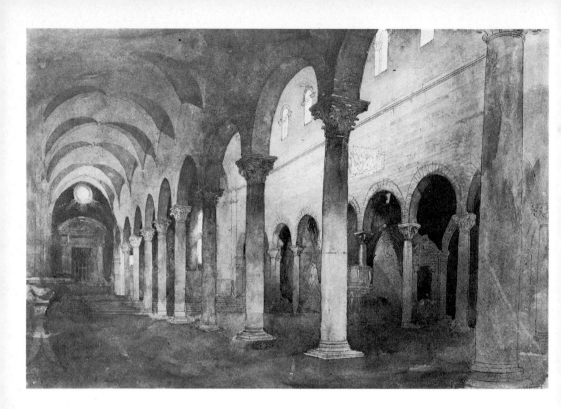

perceived accurately only if they are seen as having depth, as well as breadth and height, and the effectiveness of Ruskin's drawings in rendering the modulation of shadow on solid forms provides the surest proof of his three-dimensional awareness. Paul Walton has remarked on the 'truth of atmosphere and three-dimensional form'[5] achieved by Ruskin in his mature architectural drawings. The reader should glance at the selection of drawings reproduced in this book for further confirmation of this judgment.

It is true that Ruskin appears to be most interested, on the whole, in such matters as sculptured decorations, mouldings, the grouping of arches in an arcade, the clustering of shafts in a Gothic pier, or the sciography of a façade such as that of St Mark's in Venice. But a carved capital is surely no less three-dimensional than the nave of a cathedral, and requires for its beautiful design and full appreciation an equally subtle three-dimensional discernment. In his drawings and analyses of architectural sculpture, as in his study of interiors, Ruskin is fully aware of all three dimensions.

Another charge brought against Ruskin is that, in the words of Joan Evans, he 'never seems to have looked at a building

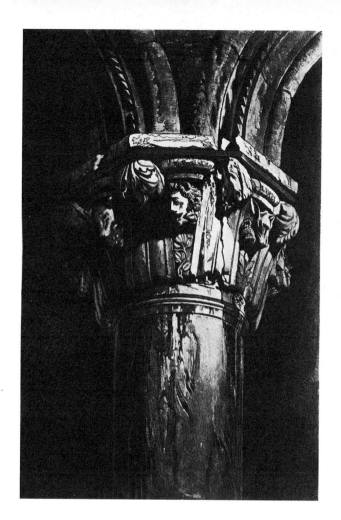

6 (*left*) Ruskin *Interior of San Frediano, Lucca* 1845

7 (*right*) Ruskin *Capital of the Doge's Palace, Venice* 1851

structurally'[6] and 'had hardly any conception of architecture as construction'.[7] This claim cannot be sustained any more than can Frankl's: chapters 3 to 19 of the first volume of *The Stones of Venice* stand as its firm rebuttal. A man who had never looked at a building structurally could not have written so well about the structural features – especially the wall, the shaft, and the masonry of arches – which he felt it important for the lay reader to understand. Joan Evans remarks that though Ruskin had great powers of scrutinizing intensely a single object such as a carved capital, 'the capital was not seen to perform an architectural function'.[8] But Ruskin devotes an entire chapter to the structure and function of the capital, and it is the question of the stability of variously shaped capitals under differing loads which interests him most (9.141–46). In any case, it seems grossly unfair to suggest that his lack of engineering expertise

17

might in any way lessen the value of his aesthetic insights. A modern scholar has written:

The contrivance by means of which Wren achieved his inner and outer domes and crowning lantern in St Paul's is no doubt of considerable ingenuity. But in contemplating the cathedral as it stands we are not affected, one way or the other, by our knowledge of it. It is beside the point.[9]

This is a most sensible approach and is, in large part, shared by Ruskin.

His attitude toward construction is well summed up in the statement that there cannot be 'any architecture which is not based on building, nor any good architecture which is not based on good building'. The distinction between building and architecture is, however, a clear one, in that architecture 'concerns itself only with those characters of an edifice which are above and beyond its common use'(8.29). An appendix to the first volume of *The Stones of Venice* puts it more bluntly:

Mr Garbett asks a question, 'Why are not convenience and stability enough to constitute a fine building?' – which I should have answered shortly by asking another, 'Why we have been made men, and not bees nor termites . . .'(9.451).[10]

Addressing the Architectural Association in 1857, he states:

if an architect does his working-drawing well, we praise him for his manipulation – if he keeps closely within his contract, we praise him for his honest arithmetic – if he looks well to the laying of his beams, so that nobody shall drop through the floor, we praise him for his observation. But he must, somehow, tell us a fairy tale out of his head beside all this, else we cannot praise him for his imagination, nor speak of him . . . as being in any wise out of the common way, a rather remarkable architect.(16.347)

One of the most famous architects of the present century has written in a closely similar vein:

You employ stone, wood and concrete, and with these materials you build houses and palaces. That is construction. Ingenuity is at work.

But suddenly you touch my heart, you do me good, I am happy and I say: 'This is beautiful.' That is Architecture. Art enters in.

My house is practical. I thank you, as I might thank Railway engineers, or the Telephone service. You have not touched my heart.[11]

18

Ruskin and Le Corbusier agree that architecture begins where construction and utility end. They agree also that expression of the feelings and thoughts of the individual artist is what makes architecture an art. Le Corbusier finds the essence of that art in the 'thought which reveals itself . . . solely by means of shapes which stand in a certain relationship to one another',[12] and by 'shapes' he tends to mean large-scale structural masses. Ruskin is aesthetically sensitive to the disposition of large masses, but he tends to seek the 'fairy tale' of the building in the features usually thought of as being ornamental. This is because, in his view, all art 'which is worth its room in this world' is

art which proceeds from an individual mind, working through instruments which assist, but do not supersede, the muscular action of the human hand, upon the materials which most tenderly receive, and most securely retain, the impressions of such human labour.(9.456)

It is in the details of architectural sculpture, mouldings, ornamental arcades, inlaid and painted ornament, and the ways in which such details relate to the building as a whole, that he most often – though by no means always – finds evidence of this individual human touch in architecture. In the *Lectures on Architecture and Painting* he asserts that while ornamental features are usually expressive of feeling, structural features tend to be dictated by considerations of necessity or convenience(12.45n.). The ornamental details of a building usually make up that part of it 'in which its mind is contained', and Ruskin concludes:

I do with a building as I do with a man, watch the eye and the lips: when they are bright and eloquent, the form of the body is of little consequence.(12.89)

This is Ruskin's most extreme statement on the subject, and it would be most unwise to make it the basis for any general-izations concerning his actual visual response to buildings.[13] Nonetheless, it is undoubtedly true that he scrutinized the minutiae of the buildings he admired more closely than any other English writer has done.

Of his gift for the kind of intense and detailed observation which served as foundation for his architectural writings, he wrote to his father in 1852 that

8 Ruskin *Architectural notes, Venice* 1850–52

9 Ruskin *Architectural notes, Venice* 1850–52

> there is the strong instinct in me which I cannot analyse to draw and describe the things I love – not for reputation, nor for the good of others, nor for my own advantage, but a sort of instinct like that for eating or drinking. I should like to draw all St Mark's, and all this Verona stone by stone, to eat it all up into my mind, touch by touch.(10.xxvi)

This is almost literally what Ruskin did. Countless drawings, sketches, and sheets of closely written notes and measurements made by him of Italian and French buildings are now scattered around museums and galleries in Great Britain and abroad. A good deal of medieval Venice, were it to sink beneath the sea, could be reconstructed in detail with the aid of the notebooks now preserved at Bembridge School and elsewhere (ills 8, 9 and 10). The astonishing fidelity to detail of many of his architectural drawings (ills 11 and 87, for example) is traceable to Ruskin's visual acuity, his powers of concentration, and above all to the voracious appetite for visual fact which had sent

20

10 Ruskin *Study of the façade of the Palazzo da Mosto, Venice* 1852

him scrambling up ladders and scaffoldings to examine a host of minor intricacies before he undertook the large-scale drawing. The chain pattern surrounding the bird frieze at St Mark's which is visible at right centre in ill. 11 and in the top left-hand corner of ill. 58, for example, is examined with great concern for accuracy in one of the notebooks from the early 1850s at Bembridge. In one entry the profile of projection of each element in the pattern is noted. Twenty-five pages later, we find another obsessive memorandum listing the exact sequence of squares and circles which fill the chain.[14]

The importance of careful looking to all Ruskin's architectural commentary cannot be overstressed. His own skills as a draughtsman, and the care with which he looked at most buildings before writing about them, prompted him to be rather severe with authors (including even G. E. Street)[15] who, it seemed to him, rushed through France and Italy from building to building, scribbling ground plans, elevations, and

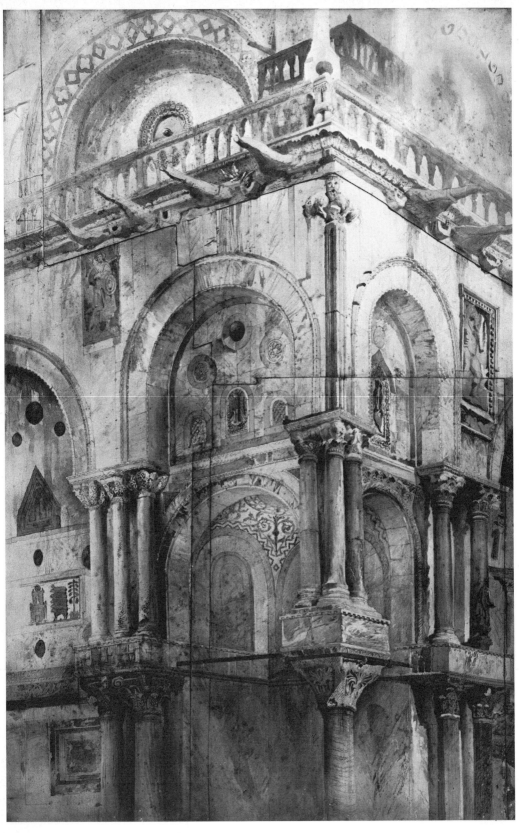

11 Ruskin *Angle of the façade, St Mark's, Venice*

12 Ruskin *Casa Contarini Fasan,*
Venice 1841

dates in their notebooks, but taking not the slightest care to note
with precision the details, especially of colouring, which are
often so vital in determining the individual character of a great
building:

> Foolish and ambitious persons think they can form their judgment by
> seeing much art of all kinds. They see all the pictures in Italy; – all the
> architecture in the world – and merely make themselves as incapable
> of judgment as a worn-out Dictionary. . . .
> To have drawn with attention a porch of Amiens, an arch at
> Verona, and a vault at Venice, will teach . . . more of architecture
> than to have made plans and sections of every big heap of brick or
> stone between St Paul's and the Pyramids. Farther, it is absolutely
> necessary that fine architecture should be drawn separately both in
> colour and in light and shade; – with occasional efforts to combine the
> two, but always with utmost possible delicacy; – the best work
> depending always on the subtlest lines.(13.501)

Many of Ruskin's readers – especially architects – have been
infuriated by this attitude, which demands of them a kind of
aesthetic training quite different from any they might have
aspired to themselves in setting out on their architectural tours

of the Continent. Yet it is interesting to note that he was for the most part deeply dissatisfied with even the best of his own architectural drawings. Referring to his rendering of the Casa Contarini Fasan (ill. 12) in the late 1870s, he remarks:

A sketch of my own in 1841, shows the main detail of a little piece in this group of houses in some completeness; but it would take a month to draw even this small group rightly, and it is totally beyond any man's power, unless on terms of work like Albert Dürer's, to express adequately the mere 'contents' of architectural beauty in any general view on the Grand Canal.(13.500)

In a note on one of the drawings he donated to his drawing-school at Oxford, he remarks despairingly that 'No Italian architecture can be properly represented unless when painted of its own size.'(21.123) Ruskin in fact made many attempts to approach the scale of his subject matter in drawings meant to give an impression of what architectural detail actually looks like. Note the instructions given for viewing one such drawing, reproduced in ill. 13.

One of Ruskin's chief quarrels with the architects of his day was that most of them did not know how to draw and thus, in his opinion, lacked the visual discipline necessary for the mere appreciation, let alone creation, of aesthetically satisfying ornament. The agonized frustration with which he regarded their bungling regularizations of detail during 'restoration' of medieval buildings was an inevitable consequence of his superior visual sensitivity. Writing to his friend C. E. Norton in 1882 concerning the 'Liberty of line' which he had taught, in 'The Nature of Gothic', to be the life-giving force behind medieval craftsmanship, he states that

Nearly all our early English Gothic is free hand in the curves, and there is no possibility of drawing even the apparent circles with compasses. Here [at Pisa], and I think in nearly all work with Greek roots in it, there is a spiral passion which drifts everything like the temple of the winds; this is the first of all subtle charms in the real work – the first of all that is ['corrected'] out of it by the restorer. Do you recollect . . . the quarrel we had about the patchwork of the Spina Chapel? I think you will recollect the little twisted trefoil there. Of course in the restoration they've put it square. And it isn't of the slightest use to point any of these things out to the present race of mankind. It is finally tramwayed, shamwayed, and eternally

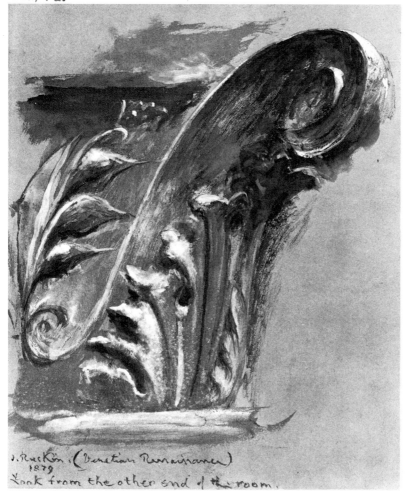

13 Ruskin *Venetian Renaissance capital* 1879

damnwayed, and I wish the heavens and the fates joy over it(37.414).[16]

Similar considerations lie behind his attack on the plates illustrating Henry Gally Knight's well-known *Ecclesiastical Architecture of Italy from the Time of Constantine to the Fifteenth Century* (2 vols, 1842 and 1844). Ruskin points out that in Knight's plate of the façade of San Michele in Lucca, the ornament between the arches of the decorative arcades has 'been drawn entirely out of the draughtsman's head; flourishes of the

14 (*left*) Ruskin *Part of the façade of San Michele, Lucca*

15 (*right*) H. G. Knight *San Michele, Lucca* 1844

pencil being substituted for the monochrome figures'.(8.277) Though the plate may serve to give a general impression of the façade, and though its finished appearance gives it an air of accuracy, 'every bit of the ornament on it *is drawn out of the artist's head*. There is not *one line* of it that exists on the building'.(9.431) The justice of Ruskin's remarks can be judged by comparison of one of his own sketches of part of the façade and Knight's engraving (ills 14 and 15). For the inlaid monochrome figures actually to be found on the façade, Knight substitutes a vague jumble of lines that could be meant to represent anything from acanthus leaves to ostrich feathers, but certainly not a flat surface enriched by marble inlaying. Defending the rather carelessly etched plates which he had

26

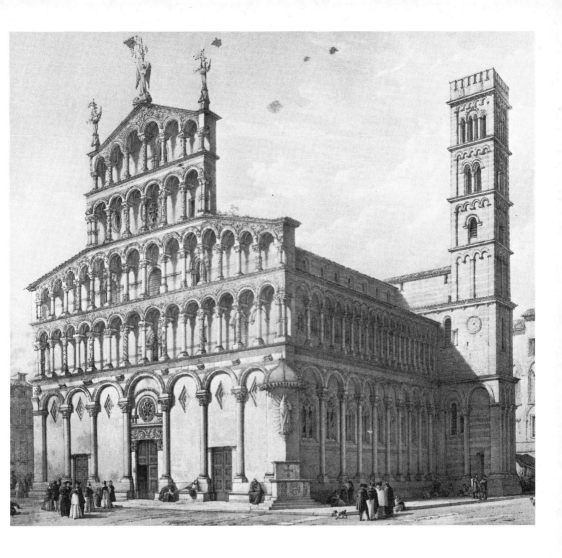

prepared for the first edition of *The Seven Lamps*, Ruskin admits that they were hurriedly produced, but insists that in representation of detail 'their truth is carried to an extent never before attempted in architectural drawing' and that

It is not so easy as the reader, perhaps, imagines, to finish a drawing altogether on the spot, especially of details seventy feet from the ground; and any one who will try the position in which I have had to do some of my work – standing, namely, on a cornice or window sill, holding by one arm round a shaft and hanging over the street (or canal, at Venice), with my sketch-book supported against the wall from which I was drawing, by my breast, so as to leave my right hand free – will not thenceforward wonder that shadows should be occasionally carelessly laid in, or lines drawn with some unsteadiness.

But, steady or infirm, the sketches of which those plates in the *Seven Lamps* are facsimiles, were made from the architecture itself, and represent that architecture with its actual shadows at the time of day at which it was drawn, and with every fissure and line of it as they now exist(9.431).

As a result of this obsession for drawing architecture exactly as it appeared to him, Ruskin's mature architectural drawings, in the words of Paul Walton,

create something quite different from the usual kinds of architectural illustration in the nineteenth century, like the picturesque views by Prout and other travel illustrators, the Piranesi-like drama of Cotman's antiquarian book illustrations, or the mechanical line-drawings of architectural historians like A. C. Pugin. Only Ruskin tried to surrender himself without preconception or artifice to his impression of a building as it actually appeared at a particular moment.[17]

We are dealing, then, with a writer of unusual visual acuity to whom the details of a building are of passionate concern. It has often been stated or implied that the delight with which he observes the smaller-scale intricacies of design is due to an inability to respond to more large-scale features of architecture. A recent study goes so far as to maintain that 'it is extremely important both to assessments of his criticism and of his influence to realize how totally Ruskin's architectural analysis was in fact devoted to architectural detail'.[18] The validity of this claim will be questioned in the course of the first two chapters.

Three dimensions

Space

ONE OF THE truisms of modern architectural discussion is the notion that architecture is fundamentally the shaping of space:

What distinguishes architecture from painting and sculpture is its spatial quality. In this, and only in this, no other artist can emulate the architect. Thus the history of architecture is primarily a history of man shaping space. . . .[1]

This emphasis on space as 'the basic material of architecture',[2] on the 'feeling for space' as 'the basis and the strongest impulse for original architectonic creation',[3] finds little explicit counterpart in Ruskin's analysis of buildings. As we have already seen, however, he certainly responded 'spatially' to the interior of Amiens Cathedral. His brief evocation of the interior of St Mark's tells the same story:

. . . let us enter the church itself. It is lost in still deeper twilight, to which the eye must be accustomed for some moments before the form of the building can be traced; and then there opens before us a vast cave, hewn out into the form of a Cross, and divided into shadowy aisles by many pillars. Round the domes of its roof the light enters only through narrow apertures like large stars; and here and there a ray or two from some far-away casement wanders into the darkness, and casts a narrow phosphoric stream upon the waves of marble that heave and fall in a thousand colours along the floor. What else there is of light is from torches, or silver lamps, burning ceaselessly in the recesses of the chapels; the roof sheeted with gold, and the polished walls covered with alabaster, give back at every curve and angle some feeble gleaming to the flames; and the glories

round the heads of the sculptured saints flash out upon us as we pass them, and sink again into the gloom.(10.88)

The mood transmitted to the responsive reader is surely that of a fascinating spatial mystery. Those glimmers of light, wandering from far away through the darkness before striking the uneven floor (Ruskin was writing before the levelling out of the left aisle which took place in 1870), give a powerfully three-dimensional effect to the description, and the last sentence is almost startling in its suggestion of the spectator's movement through the building. Ruskin does not attempt an analysis of the spatial shaping of St Mark's in his published works, however, and no ground plan is provided to accompany the text.

Indeed, the almost total absence of ground plans from Ruskin's publications might lead one to conclude that he had no interest in analysing his spatial impressions of buildings. The use he does make of the ground plans provided of the cathedral of Torcello and the church of San Donato at Murano in *The Stones of Venice*(10.22, 46–48, pl. 1) seems to confirm that conclusion. Referring to Torcello, he informs us merely that the church is built on the plan of a basilica, and that its nave is nearly twice as wide as the aisles. The remainder of his discussion of the church is devoted to its capitals, its pulpit, and its inlaid wall decorations. The plan of San Donato is discussed at somewhat greater length, but though Ruskin gives measurements which indicate that the widths of aisles, transept, and nave of the church are all simple multiples of the distance between the shafts of the nave arcade, he is content to suggest that such proportions 'might have been dictated by a mere love of mathematical precision', and proceed to matters of greater interest to him. One wonders why he bothered to provide ground plans of these buildings at all.

But tucked away in a brief appendix are some intriguing observations which indicate that the builders at Torcello, provided with solid columns (no doubt spoils) of unequal diameter, seem to have employed a scheme of optical adjustments to turn these inequalities to visual advantage. The apparent perspective length of the church is increased by placing the narrower columns nearer the apse, while at the same time the decreasing diameter of those columns is matched by a diminution of the diameter of their bases, thus preventing 'the eye from feeling the greater narrowness of the shafts in that part

of the nave'. Ruskin declares that whether the illusion of increased length in the building is intentional or not,

the delicate adaptation of this diminished base to the diminished shaft is a piece of fastidiousness in proportion which I rejoice in having detected; and this the more, because the rude contours of the bases themselves would little induce the spectator to anticipate any such refinement.(10.444)

It is surprising that he should have relegated such observations to an appendix. Perhaps his apprehension, expressed more than once, that he might 'weary the reader with anatomical criticism'(10.78), influenced this playing down of material that to modern readers would appear to be the very stuff of architectural analysis.

Fortunately, there is a published example of enquiry by Ruskin into the reasons for the differing spatial impressions made on him by two buildings. In his little-known *Mornings in Florence* (1875–77) he discusses the varying impressions of spaciousness made upon him by the vaults of the Duomo, and of the chapter house or so-called Spanish Chapel of Santa Maria Novella, in Florence(23.363–68). Ruskin first places the traveller under the vault of the third bay (counting from the west end) of the Duomo (ill. 16) and asks him to look up at the vaulting compartment nearest the west end. The observer is told to look up steadily 'for a minute or so', and is informed that when he becomes used to the form of the arch employed in the vault, the vault 'seems to become so small that you can almost fancy it the ceiling of a good-sized lumber-room in an attic'. The observer is asked to perform the same experiment on the second vaulting compartment, and is told to expect the same result. Ruskin then urges his reader ('resolving to bear, if possible – for it is worth while, – the cramp in your neck for another quarter of a minute') to look up directly into the third vault overhead: again, the vault seems to shrink 'into the semblance of a common arched ceiling, of no serious magnitude or majesty'. The reader is then directed to

glance quickly down from it to the floor, and round at the space (included between the four pillars) which that vault covers.
It is sixty feet square, – four hundred square yards of pavement, – and I believe you will have to look up again more than once or twice, before you can convince yourself that the mean-looking roof is swept

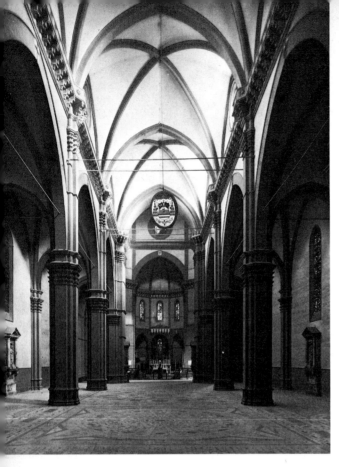

16 (*left*) *Florence Cathedral: interior looking east*

17 (*right*) *The Spanish Chapel, Santa Maria Novella, Florence*

indeed over all that twelfth part of an acre. And still less, if I mistake not, will you, without slow proof, believe, when you turn yourself round towards the east end, that the narrow niche (it really looks scarcely more than a niche) which occupies, beyond the dome, the position of our northern choirs, is indeed the unnarrowed elongation of the nave, whose breadth extends round you like a frozen lake. From which experiments and comparisons, your conclusion, I think, will be, and I am sure it ought to be, that the most studious ingenuity could not produce a design for the interior of a building which should more completely hide its extent, and throw away every common advantage of its magnitude, than this of the Duomo of Florence.(23.364–65)

Ruskin leaves his conclusion at that, without considering the sense of contrast produced in the Duomo between this damping down of verticality in the nave and the expansiveness of the cupola,[4] but his observations in the nave are verifiable by any visitor to the Duomo. Visual psychologists such as Arnheim provide some explanation of the phenomena he describes.[5]

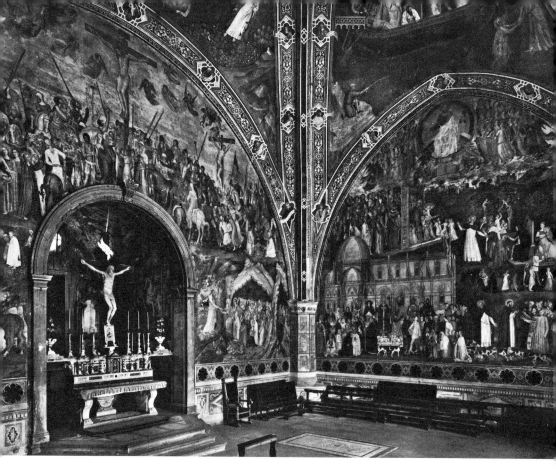

The traveller is next hurried to a position in the cloister of Santa Maria Novella across from the entrance to the chapter house. While one can see the entrance to the chapter house within the opposite cloister, there is no building to be seen 'externally manifesting itself as worth entering'. There are 'No walls, or gable, or dome, raised above the rest of the outbuildings – only two windows with traceries opening into the cloister; and one story of inconspicuous building above.' On entering, however, the observer feels (ill. 17) a surprising sensation of height in the building: he will be 'disposed to fancy that the circular window cannot surely be the same you saw outside, looking so low. I had to go out again, myself, to make sure that it was'. Gradually, Ruskin continues,

as you let the eye follow the sweep of the vaulting arches, from the small central keystone-boss, with the Lamb carved on it, to the broad capitals of the hexagonal pillars at the angles, there will form itself in your mind, I think, some impression not only of vastness in the building, but of great daring in the builder; and at last, after closely

following out the lines of a fresco or two, and looking up and up again to the coloured vaults, it will become to you literally one of the grandest places you ever entered, roofed without a central pillar. You will begin to wonder that human daring ever achieved anything so magnificent.

But just go out again into the cloister, and recover knowledge of the facts. It is nothing like so large as the blank arch which at home we filled with brickbats or leased for a gin-shop under the last railway we made to carry coals to Newcastle. And if you pace the floor it covers, you will find it is three feet less one way, and thirty feet less the other, than that single square of the cathedral which was roofed like a tailor's loft(23.365–66).

Ruskin then devotes a brief but penetrating passage to elucidation of the reasons for this appearance of great spaciousness in the Spanish Chapel:

The first secret in getting the impression of size in this chapel is the *dis*proportion between pillar and arch. You take the pillar for granted, – it is thick, strong, and fairly high above your head. You look to the vault springing from it – and it soars away, nobody knows where.(23.367)

Another important, but more subtle, factor is the '*in*equality and immeasurability of the curved lines' of the vault. The dimensions of the chapel are, according to Ruskin, $32' \times 57'$. This 'gives to every arch, pointed and round, throughout the roof, a different spring from its neighbours'. The third factor to be taken into consideration is the disguising of the form of the vault by means of painting. For example,

Look how the ornamental borders fall on the capitals! The plaster receives all sorts of indescribably accommodating shapes – the painter contracting and stopping his design upon it as it happens to be convenient. You can't measure anything; you can't exhaust; you can't grasp(23.367–68).

Visual psychologists have observed that if we know the size of an object, experience will dictate our estimate of distance; conversely, knowledge of the distance of an object enables us to estimate size. False perception results whenever the normal process of estimation is disrupted.[6] Ruskin demonstrates how, because of the continuously variable spring of the arches of the vault, and the camouflaging effects of painted decoration, visual

concentration, and hence estimation of the size of the vault, is made extremely difficult. At the same time, the unusual disproportion between the vaulting ribs and their supporting shafts upsets the viewer's ability to gauge the true height of the vault on the basis of his previous experience of more normally proportioned Gothic vaults.

This study by Ruskin of simple spatial problems offers explicit proof that he could, when so inclined, analyse his spatial impressions. The recent claim that 'he did not conceive of buildings as enclosing and molding spaces; apparently, he did not even see structures as *occupying* space'[7] is clearly indefensible.

Disposition of masses

The reader of modern works on architecture is accustomed to considering buildings as if they were large pieces of sculpture:

the treatment of the exterior of a building as a whole is aesthetically significant, its contrasts of block against block, the effect of a pitched or flat roof or a dome, the rhythm of projections and recessions.[8]

It is this aspect of the building that seems of greatest concern to Le Corbusier.

Ruskin also displays considerable interest in the large-scale volumetric composition of buildings, as one would expect in view of his lengthy discussion in *Modern Painters* of 'The Sculpture of Mountains'(6.174–364), and his frequent assertion that the greatest architects have also been great sculptors(8.10, 12.85). In 'The Lamp of Power' he goes so far as to state that 'the relative majesty of buildings depends more on the weight and vigour of their masses, than on any other attribute of their design'(8.134). Many of Ruskin's drawings register an intense response to the weight and vigour of the large-scale masses of buildings (see, for example, ills 18, 19, 32, 91, 95, 97).

Several questions involving the arrangement of mass arouse Ruskin's curiosity. Of particular interest is the disparity he often discerns between the real and apparent magnitude of buildings. Mere size, he argues, may not 'ennoble a mean design, yet every increase of magnitude will bestow upon it a certain degree of nobleness'. Arguing that there 'is a crust about the impressible

35

part of men's minds, which must be pierced through before they can be touched to the quick', he maintains that

mere weight will do this; it is a clumsy way of doing it, but an effectual one, too; and the apathy which cannot be pierced through by a small steeple, nor shone through by a small window, can be broken through in a moment by the mere weight of a great wall.(8.104–05)

Ruskin further maintains (and this statement has been ignored by modern commentators) that, if an architect feels sheer massiveness to be essential to the success of his design, and if he is

18 Ruskin *Town Hall, Aix-la-Chapelle*

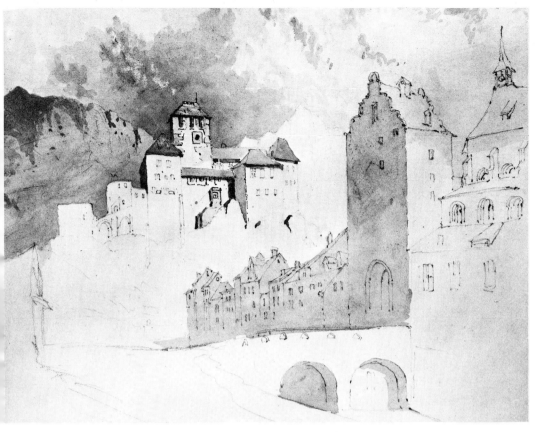

19 Ruskin *Entrance to Feldkirch, Tyrol*

working under strict limitations of cost, he is justified in abandoning fine details altogether in order to increase the scale of his building:

for, unless they are concentrated, and numerous enough to make their concentration conspicuous, all his ornaments together will not be worth one huge stone. . . . a yard more across the nave will be worth more to him than a tessellated pavement; and another fathom of outer wall, than an army of pinnacles.(8.105–06)

The advantages of magnitude can, however, be dissipated unless basic visual considerations are taken into account. An architect who ignores the influence of setting does so at his own risk. Ruskin feels that the immensity of St Peter's in Rome, for example, is largely lost in visual effect because of 'its position on the slope of an inconsiderable hill. . . . imagine it placed on the plain of Marengo, or like the Superga of Turin, or like La Salute at Venice!'(8.103)

Even more deadly, however, is the ignoring of certain optical factors in arrangement of the large-scale components of the building itself. One of the most important of these concerns the management of its bounding lines. To exhibit its true magnitude, a large building

must be bounded as much as possible by continuous lines, and . . . its extreme points should be seen all at once; or we may state, in simpler terms still, that it must have one visible bounding line from top to bottom, and from end to end. This bounding line from top to bottom may either be inclined inwards, and the mass therefore, pyramidical; or vertical, and the mass form one grand cliff; or inclined outwards, as in the advancing fronts of old houses, and, in a sort, in the Greek temple, and in all buildings with heavy cornices or heads. Now, in all these cases, if the bounding line be violently broken; if the cornice project, or the upper portion of the pyramid recede, too violently, majesty will be lost; not because the building cannot be seen all at once, – for in the case of a heavy cornice no part of it is necessarily concealed – but because the continuity of its terminal line is broken, and the *length of that line*, therefore, cannot be estimated. But the error is, of course, more fatal when much of the building is also concealed; as in the well-known case of the recession of the dome of St Peter's(8.106–07).

The importance of the bounding line is particularly felt when one is looking at

churches whose highest portions, whether dome or tower, are over their cross. Thus there is only one point from which the size of the Cathedral of Florence is felt; and that is from . . . opposite the south-east angle, where it happens that the dome is seen rising instantly above the apse and transepts. In all cases in which the tower is over the cross, the grandeur and height of the tower itself are lost, because there is but one line down which the eye can trace the whole height, and that is in the inner angle of the cross, not easily discerned. Hence, while, in symmetry and feeling, such designs may often have pre-eminence, yet, where the height of the tower itself is to be made apparent, it must be at the west end, or, better still, detached as a campanile.(8.107)

Ruskin's preference for the roof of undivided mass(9.402) is of course fully in keeping with his desire for continuous bounding lines. Considerations of the bounding line enter into his assessment of the eastern terminations of churches as well. His

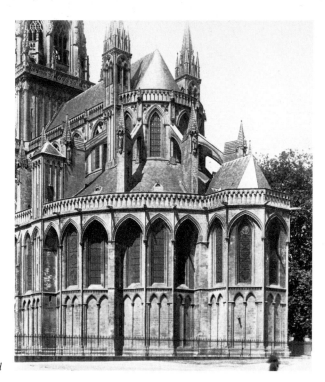

20 *Bayeux Cathedral: east end*

strong dislike for the east end of Bayeux Cathedral, for
example, is largely prompted by its lack of a continuous line
binding the apse visually to the lower radiating chapels (ill. 20).
In a notebook entry for 1848 he describes the arrangement as

excessively bad – the parapet being continuous round above the
chapels – overleaping their gaps by arches supported by a great blank
buttress. . . . [which is] vertical, of course – like the shafts, utterly
mean and blank. The one storied look of the whole, and its want of
projection towards the ground is to be contrasted vigorously with
such sloping east ends as those of Notre Dame de Paris . . . on the one
hand, and with the vertical symmetry of Pisa on the other.[9]

Optical factors must also help determine the architect's
choice of the overall shape into which his building is gathered.
A sense of massiveness is most easily attained in buildings which
seem to approximate a huge cube in shape (8.108). Several
presuppositions about how the eye and mind work when a
building is viewed underlie Ruskin's argument:

in whatever direction the building is contracted, in that direction the
eye will be drawn to its terminal lines; and the sense of surface will
only be at its fullest when those lines are removed, in every direction,
as far as possible. Thus the square and circle are pre-eminently the

39

areas of power among those bounded by purely straight or curved lines; and these, with their relative solids, the cube and sphere, and relative solids of progression, . . . the square and cylindrical column, are the elements of utmost power in all architectural arrangements.(8.110)

Where grace and beautiful proportion are desired, the elongation of the building in one direction is often required. Nonetheless, a

sense of power may be communicated to this form of magnitude by a continuous series of any marked features, such as the eye may be unable to number; while yet we feel, from their boldness, decision, and simplicity, that it is indeed their multitude which has embarrassed us, not any confusion or indistinctness of form. This expedient of continued series forms the sublimity of arcades and aisles, of all ranges of columns(8.110).

These considerations are exemplified in one of Ruskin's favourite buildings, the Duomo of Pisa (ill. 21), where 'the whole arrangement', though 'not perhaps the fairest', is yet 'the mightiest type of form which the mind of man has ever conceived', and is 'based exclusively on associations of the circle and the square'(8.111–12).

The visual means whereby a building generates a sense of massiveness are thus of great interest to Ruskin. He is also interested in more strictly aesthetic questions involving the volumetric composition of buildings. Arguing that it is impossible to give recipes for the beautiful composition of mass, he nonetheless claims that 'one or two general laws' are worth remembering as 'preventives of gross mistakes'. One of these is that 'wherever Proportion exists at all, one member of the composition must be either larger than, or in some way supreme over, the rest'(8.163). The ignoring of this rule has had unhappy consequences in much English Gothic:

Don't put the pinnacles without the spire. What a host of ugly church towers have we in England, with pinnacles at the corners, and none in the middle! How many buildings like King's College Chapel at Cambridge, looking like tables upside down, with their four legs in the air! What! it will be said, have not beasts four legs? Yes, but legs of different shapes, and with a head between them. So they have a pair of ears: and perhaps a pair of horns: but not at both ends. Knock down a couple of pinnacles at either end in King's College Chapel, and you will have a kind of proportion instantly.(8.164)

40

The arrangement of the towers of a cathedral, similarly, is subject to this rule of supremacy:

in a cathedral you may have one tower in the centre, and two at the west end; or two at the west end only, though a worse arrangement: but you must not have two at the west and two at the east end, unless you have some central member to connect them; and even then, buildings are generally bad which have large balancing features at the extremities, and small connecting ones in the centre, because it is not easy then to make the centre dominant. . . . In fine west fronts with a pediment and two towers, the centre is always the principal mass, both in bulk and interest (as having the main gateway), and the towers are subordinated to it, as an animal's horns are to its head. The moment the towers rise so high as to overpower the body and centre, and become themselves the principal masses, they will destroy the proportion, unless they are made unequal, and one of them the leading feature of the cathedral, as at Antwerp and Strasburg. But the purer method is to keep them down in due relation to the centre, and to throw up the pediment into a steep connecting mass, drawing the eye to it by rich tracery.(8.164–65)

Note Ruskin's assumption that ornamental detail such as tracery can have an important part to play in leading the eye to make connections between the principal masses of the building. In his studies of ornament, he is constantly on the lookout for this kind of modification of large-scale composition by small details.

An important consideration in subdividing the overall mass of the building is

the connection of Symmetry with horizontal, and of Proportion with vertical, division. Evidently there is in symmetry a sense not merely of equality, but of balance: now a thing cannot be balanced by another on the top of it, though it may by one at the side of it. Hence, while it is not only allowable, but often necessary, to divide buildings, or parts of them, horizontally into halves, thirds, or other equal parts, all vertical divisions of this kind are utterly wrong; worst into half, next worst in the regular numbers which more betray the equality.(8.167)

Ruskin points out the neglect of this principle in the many Gothic Revival spires which are divided by a band of ornament halfway up. Equality of vertical subdivision should be left to 'children and their card houses'. The Tower of Pisa, which

presents to the eye 'an apparent equality in five out of the eight tiers', is the 'one thoroughly ugly tower in Italy'(8.167–68, 168n.). He discusses several examples which might be thought to infringe his principle, but points out that the infringement is only apparent. At Salisbury,

The ornamented portion of the tower is . . . cut in half, and allowably, because the spire forms the third mass to which the other two are subordinate: two storeys are also equal in Giotto's campanile, but dominant over smaller divisions below, and subordinated to the noble third above.(8.167)

Another factor to be borne in mind in arrangement of the chief masses of a building is, though 'equally simple, equally neglected'. This is the principle that proportioned composition requires

three terms at *least*. Hence, as the pinnacles are not enough without the spire, so neither the spire without the pinnacles. All men feel this, and usually express their feeling by saying that the pinnacles conceal the junction of the spire and tower. This is one reason; but a more influential one is, that the pinnacles furnish the third term to the spire and tower. So that it is not enough, in order to secure proportion, to divide a building unequally; it must be divided into at least three parts; it may be into more (and in details with advantage), but on a large scale I find three is about the best number of parts in elevation, and five in horizontal extent, with freedom of increase to five in the one case and seven in the other; but not to more without confusion(8.168).

The treatment of the exterior angles of many of the Gothic palaces in Venice involves interesting three-dimensional questions. Ruskin points out that the angles are chamfered and filled by small twisted shafts (ills 22 and 53), and then combines structural and visual considerations in explaining the practice. The twisted shafts

are of essential importance in giving an aspect of firmness to the angle; a point of peculiar necessity in Venice, where, owing to the various convolutions of the canals, the angles of the palaces are not only frequent, but often necessarily *acute*, every inch of ground being valuable. In other cities, the appearance as well as the assurance of stability can always be secured by the use of massy stones, as in the fortress palaces of Florence; but it must have been always desirable at

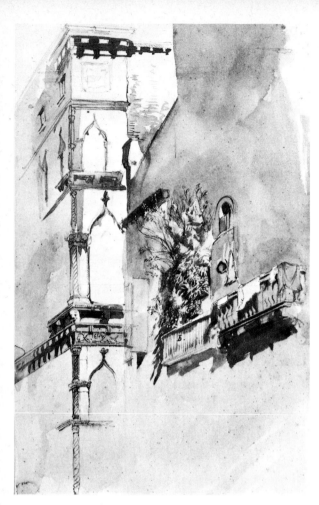

22 (*left*) Ruskin *Architectural study, Venice*

23 (*right*) Ruskin *Doge's Palace, Venice: the vine angle* 1869

Venice to build as lightly as possible, in consequence of the comparative insecurity of the foundations. . . . And so in all the . . . palaces built at the time, consummate strength was joined with a lightness of form and sparingness of material which rendered it eminently desirable that the eye should be convinced, by every possible expedient, of the stability of the building; and these twisted pillars at the angles are not among the least important means adopted for this purpose, for they seem to bind the walls together as a cable binds a chest.(10.279–80)

Ruskin's explanation of the aesthetic importance of the angle sculptures in modifying the three dimensional bulk of the Doge's Palace (ills 23 and 53) is also worthy of notice:

as the building was very nearly square on the ground plan, a peculiar prominence and importance were given to its angles, which rendered it necessary that they should be enriched and softened by sculpture. I

44

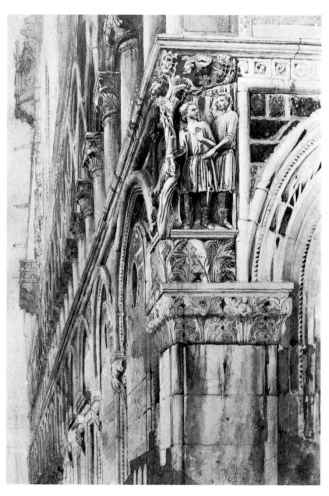

do not suppose that the fitness of this arrangement will be questioned; but if the reader will take the pains to glance over any series of engravings of church towers or other four-square buildings in which great refinement of form has been attained, he will at once observe how their effect depends on some modification of the sharpness of the angle, either by groups of buttresses, or by turrets and niches rich in sculpture. It is to be noted also that this principle of breaking the angle is peculiarly Gothic, arising partly . . . out of the natural dislike of the meagreness of effect in buildings which admitted large surfaces of wall, if the angle were entirely unrelieved.(10.356–57)

Despite the insight and thought manifest here, and many references in the diaries and notebooks to the visual effects produced by the combination of different kinds of architectural mass,[10] it cannot be denied that Ruskin is sometimes impatient of analysing this aspect of architectural composition. Thus in 'The Lamp of Power' he finds that he

45

cannot here enter into the curious questions connected with the management of larger curved surfaces; into the causes of the difference in proportion necessary to be observed between round and square towers; nor into the reasons why a column or ball may be richly ornamented, while surface decoration would be inexpedient on masses like the Castle of St Angelo, the tomb of Cecilia Metella, or the dome of St Peter's(8.123)

– even though such questions are strictly relevant to his discussion of 'power' in architecture. Despite his insistence at the beginning of the same chapter that the impressive disposition of large-scale masses may be of greater importance in determining the ultimate effect of a building than 'characters of less enduring nobility' such as 'value of material, accumulation of ornament, or ingenuity of mechanical construction'(8.101), his own attention is frequently directed elsewhere.

Ruskin's assertion, in the preface to the second edition of *The Seven Lamps*, that 'Artistical and rational Admiration' attaches itself '*wholly* to the meaning of the sculpture and colour on the building' and is 'very regardless of general form and size'(8.10), is of course blatantly inconsistent with the argument of a good deal of 'The Lamp of Power' (8.103–12). It has been made the basis for many sweeping generalizations about Ruskin's inability to respond aesthetically to large-scale composition in architecture. Like so many of Ruskin's most emphatic pronouncements, however, it is misleading if treated as an infallible index of his aesthetic reactions. In fact, he is perfectly ready to concede that what he somewhat patronizingly calls 'Workmanly Admiration' involves a kind of perception 'belonging to incipient developments of taste; as, for instance, a perception of proportion in lines, masses, and mouldings'(8.8). However, he goes so far as to reject the notion that there is something specifically 'architectural' about such perception:

a delight in the intelligent observance of the proportions of masses . . . is good in all the affairs of life, whether regulating the disposition of dishes at a dinner table, of ornaments on a dress, or of pillars in a portico. But it no more constitutes the true power of an architect, than the possession of a good ear for metre constitutes a poet; and every building whose excellence consists merely in the proportion of masses is to be considered as nothing more than an architectural doggrel, or rhyming exercise.(8.9–10)

46

Far from Ruskin being blind to the importance of the proportions of masses, he would appear to be suggesting here that sensitivity to such matters is a prior condition for even the most rudimentary of aesthetic responses to architecture – something to be taken for granted in a sophisticated observer, who will want to go on and look for something more interesting in the design of a building.

Readers whose study of architecture is limited to analysis of large-scale layout of mass have of course been stung by this attitude. His reply to one angry (but timid) architect, who had stated in an anonymous pamphlet in 1851 that Ruskin was 'obnoxious to the members of the architectural profession, one and all', and that 'the present race of architects . . . cannot but regard him as a common enemy, and a "malevolent" of the worst description'(12.86n.), seems a calculated attempt to vex his opponents into broadening their aesthetic responsiveness. Scoffing at the notion that architecture is pre-eminently the art of proportionate design, he retorts:

It is difficult to overstate the enormity of the ignorance which this popular statement implies. For the fact is, that *all* art, and all nature, depend on the 'disposition of masses'. Painting, sculpture, music, and poetry depend all equally on the 'proportion', whether of colours, stones, notes, or words. Proportion is a principle, not of architecture, but of existence. . . . And in the fine arts, it is impossible to move a single step, or to execute the smallest and simplest piece of work, without involving all those laws of proportion in their full complexity. To arrange (by invention) the folds of a piece of drapery, to dispose the locks of hair on the head of a statue, requires as much sense and knowledge of the laws of proportion, as to dispose the masses of a cathedral. The one are indeed smaller than the other, but the relations between 1, 2, 4, and 8, are precisely the same as the relations between 6, 12, 24, and 48. So that the assertion that 'architecture is *par excellence* the art of proportion', could never be made except by persons who know nothing of art in general; and, in fact, never *is* made except by those architects, who, not being artists, fancy that the one poor aesthetic principle of which they *are* cognizant is the whole of art. They find that the 'disposition of masses' is the only thing of importance in the art with which they are acquainted, and fancy therefore that it is peculiar to that art; whereas the fact is, that all great art *begins* exactly where theirs *ends*, with the 'disposition of masses'.(12.86–87)

When we turn to Ruskin's commentary on individual buildings, we find him willing to point out the attractions of works that are effectively designed from an overall three-dimensional point of view. But he is sometimes reluctant to admit that such qualities constitute important claims on the viewer's admiration. His remarks about the church of Santa Maria della Salute in Venice (ill. 24) illustrate this reaction with particular force. The building, he writes, is

rendered impressive by its position, size, and general proportions. These latter are exceedingly good; the grace of the whole building being chiefly dependent on the inequality of size in its cupolas, and pretty grouping of the two campaniles behind them. It is to be generally observed that the proportions of buildings have nothing whatever to do with the style or general merits of their architecture. An architect trained in the worst schools, and utterly devoid of all meaning or purpose in his work, may yet have such a natural gift of massing and grouping as will render all his structures effective when seen from a distance: such a gift is very general with the late Italian builders, so that many of the most contemptible edifices in the country have good stage effect so long as we do not approach them.(11.428)

Similarly, he describes the Palazzo Pisani at Santo Stefano in Venice as 'of no merit, but grand in its colossal pro-portions'(11.398).

No simple explanation can be given for Ruskin's occasional dismissal of large-scale massing as a determinant of architectural excellence – a dismissal which is strikingly inconsistent not only with many of the passages quoted earlier in this chapter, but with his grasp in as early a work as *The Poetry of Architecture* (1837–38) of important factors in the visual relationship of buildings to an even greater whole, that of landscape, and with his sensitivity to the three-dimensional shaping of mountains. One consideration, undoubtedly, is his requirement (see chapters 3 and following) that a building be as interesting when viewed from intermediate and close range as when seen from a distance. Secondly, the fact that almost all the buildings he dismisses as uninteresting despite fine disposition of large-scale mass are Renaissance or Baroque examples, suggests that his well-known ethical bias against those periods is affecting his judgment. But ethical objections to any particular building

48

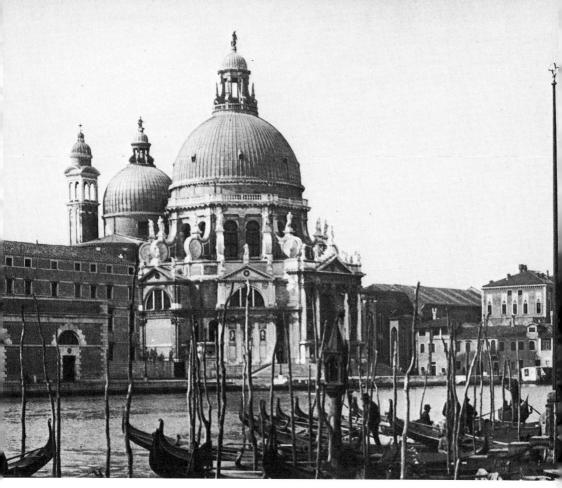

24 *Santa Maria della Salute, Venice*

often dissolve rather easily when Ruskin is actually looking at it.
Santa Maria della Salute is a case in point. Against the passage
just quoted can be placed many others which indicate the extent
to which the overall shaping of Longhena's masterpiece affected
him. In 1841 he writes in his diary: 'Such a morning as this on
the white Salute is enough to raise one from the gates of
death.'[11] Watching the dawn breaking on New Year's Day,
1877, he dwells lovingly upon the 'Salute Dome beautiful in
visionary outline, dark against light'.[12]

Such inconsistencies might cause some readers – especially
those of a solemn systematizing tendency – to abandon Ruskin
in despair. It is important to maintain a sense of humour in
reading him, particularly since he sometimes – as, surely, in
much of his preface to the second edition of *The Seven Lamps*

49

and the addenda to the *Lectures on Architecture* – indulges in deliberate exaggeration of various positions in order to provoke his opponents. Charges of self-contradiction cause him not a moment's unease. Addressing a distinguished audience in his *Inaugural Address* at the Cambridge School of Art (1858), he suggests with malicious solemnity that

Perhaps some of my hearers this evening may occasionally have heard it stated of me that I am rather apt to contradict myself. I hope I am exceedingly apt to do so. I never met with a question yet, of any importance, which did not need, for the right solution of it, at least one positive and one negative answer. . . . Mostly, matters of any consequence are three-sided, or four-sided, or polygonal; and the trotting round a polygon is severe work for people any way stiff in their opinions. For myself, I am never satisfied that I have handled a subject properly till I have contradicted myself at least three times. . . .(16.187)

Ruskin's affinities with Swift, noted by himself more than once, have not been as apparent to some of his readers as they might have been. Those who have concluded, from the famous preface and addenda cited above, that he was insensitive to large-scale mass and proportion in architecture, have made a mistake which more thorough reading of his works, and an examination of his drawings, would have prevented. When Ruskin is belittling large-scale disposition of mass as a determinant of a building's claim to admiration, he is in part over-reacting rhetorically to what he considers the simple-mindedness of observers who can think of nothing else to discuss when analysing architectural composition.

CHAPTER TWO

Irregularities in two-dimensional composition

RUSKIN's notebooks and diaries reveal strong interest in the large-scale composition of lines and shapes considered as if they lay in one plane. He is particularly attentive to the composition of façades, and has original things to say about examples from almost every period of European architecture. Nonetheless, he seems wary of spending too much time in his publications on this subject, and characteristically concludes a brief but brilliant analysis of the façades of certain early palaces in Venice by remarking that he 'must not . . . weary the reader with this subject, which has always been a favourite one with me, and is apt to lead me too far'(10.155).

The curious ambiguity of his attitude toward the importance of 'disposition of masses' does not prevent him from taking the role of proportion very seriously in two-dimensional analysis. He is in fact strongly attracted by a number of buildings whose chief merit – on his own admission – lies in the beautiful proportions observed in their façades. In a lecture of 1857 he states emphatically:

Not by rule, nor by study, can the gift of graceful proportionate design be obtained; only by the intuition of genius can so much as a single tier of façade be beautifully arranged; and the man has just cause for pride . . . who finds himself able, in a design of his own, to rival even the simplest arrangement of parts in one by Sanmicheli, Inigo Jones, or Christopher Wren.(16.350)

The architects of the Renaissance, he writes, are pre-eminent in their management of the superimposition of storeys,

sometimes of complete courses of external arches and shafts one above the other; sometimes of apertures with intermediate cornices at

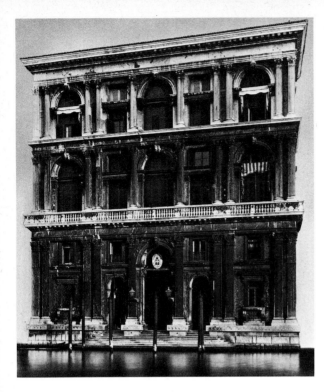

25 (*left*) *Casa Grimani, Venice*

26 (*right*) *The Banqueting House, Whitehall*

the levels of the floors, and large shafts from top to bottom of the building; always observing that the upper stories shall be at once lighter and richer than the lower ones. The entire value of such buildings depends upon the perfect and easy expression of the relative strength of the stories, and the unity obtained by the varieties of their proportions, while yet the fact of superimposition and separation by floors is frankly told.(9.244)

One of the most impressive examples of such large-scale design is, in Ruskin's opinion, the Casa Grimani in Venice (ill. 25):

It is composed of three stories of the Corinthian order, at once simple, delicate, and sublime; but on so colossal a scale, that the three-storied palaces on its right and left only reach to the cornice which marks the level of its first floor [see ill. 92]. Yet it is not at first perceived to be so vast; and it is only when some expedient is employed to hide it from the eye, that by the sudden dwarfing of the whole reach of the Grand Canal, which it commands, we become aware that it is to the majesty of the Casa Grimani that the Rialto itself, and the whole group of neighbouring buildings, owe the greater part of their impressiveness. Nor is the finish of its details less notable than the grandeur of their scale. There is not an erring line, nor a mistaken proportion, throughout its noble front; and the exceeding fineness of the chiselling gives an appearance of lightness to the vast blocks of stone

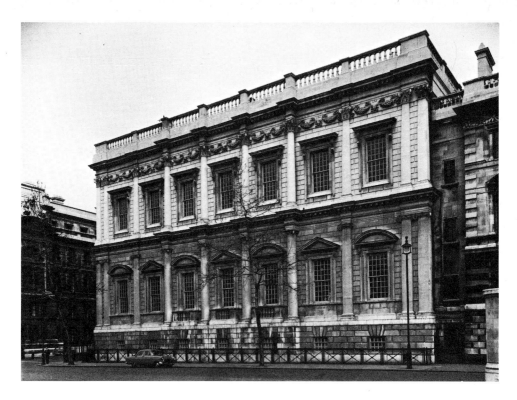

out of whose perfect union that front is composed. The decoration is
sparing, but delicate: the first story only simpler than the rest, in that
it has pilasters instead of shafts, but all with Corinthian capitals, rich in
leafage, and fluted delicately; the rest of the walls flat and smooth, and
their mouldings sharp and shallow, so that the bold shafts look like
crystals of beryl running through a rock of quartz.(11.43–44)

Sanmicheli himself would have been content with such praise of
his building. The mere capacity to appreciate – to say nothing of
the ability to design – such a masterpiece, or the Banqueting
House by Inigo Jones (ill. 26), can, Ruskin believes, be achieved
only by a few:

> The sense of abstract proportion . . . is one of the aesthetic faculties
> which nothing can develop but time and education. It belongs only to
> highly trained nations; and, among them, to their most strictly
> refined classes, though the germs of it are found, as part of their innate
> power, in every people capable of art. It has for the most part vanished
> at present from the English mind . . . so that, I suppose, there are very
> few now even of out best-trained Londoners who know the
> difference between the design of Whitehall and that of any modern
> club-house in Pall Mall.(20.217–18)

Clearly, Ruskin's teasing claim of a few years earlier that the

appreciation of fine proportion is merely an attribute of 'Workmanly Admiration' is by no means his settled opinion on the matter.

The surest symptom of an atrophied sense of proportion is, in Ruskin's opinion, the attempt to develop formulae for the attainment of fine composition. Thus he writes in *The Seven Lamps* that 'all beautiful proportions are unique, they are not general formulae'(8.169). It follows that mathematical studies of beautiful buildings will not teach one how to compose beautifully oneself:

it is just as rational an attempt to teach a young architect how to proportion truly and well by calculating for him the proportions of fine works, as it would be to teach him to compose melodies by calculating the mathematical relations of the notes in Beethoven's 'Adelaïde' or Mozart's 'Requiem'.(8.163)

Ruskin's distaste for a formulaic approach to composition is in part connected with his aversion for some Renaissance and later theorists, whose attempt, 'with the help of Vitruvius, to assign to each of their so-called orders an invariable proportion of its own may be classed among the maxima stupidities ever displayed by the human race out of a savage state'(9.147n.).

More important, however, in confirming Ruskin in such views is his excited discovery that many of his favourite façades display a subtle variation from apparent regularity of sub-division which makes a mockery of all attempts to reduce their design to formulae. Perhaps his most outstanding discussions of large-scale composition are those in which he analyses the visual effects of such irregularities on the observer. These studies involve Byzantine, Romanesque, and Gothic buildings, and form part of the basis for his conviction that the restoration of medieval buildings by precision-minded Victorian architects is doomed to failure.

In a discussion of the façade of the Duomo of Pisa (ill. 27), Ruskin analyses the composition of the four tiers of arches above the seven arched compartments – which themselves, according to his measurements, exhibit a subtle alternating proportion – of the ground storey of the façade. He finds that, though these four arcades appear to be of equal height, and to contain arches of equal width, the façade is not regular at all:

Not one of its four arcades is of like height with another. The highest

54

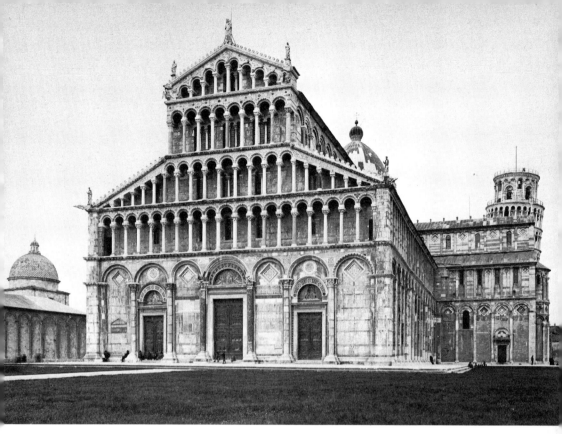

27 *Pisa Cathedral: west front*

is the third, counting upwards; and they diminish in nearly
arithmetical proportion alternately; in the order 3rd, 1st, 2nd, 4th.
The inequalities in their arches are not less remarkable: they at first
strike the eye as all equal; but there is a grace about them which
equality never obtained: on closer observation, it is perceived that in
the first row of nineteen arches, eighteen are equal, and the central one
larger than the rest; in the second arcade, the nine central arches stand
over the nine below, having, like them, the ninth central one largest.
But on their flanks, where is the slope of the shoulder-like pediment,
the arches vanish, and a wedge-shaped frieze takes their place,
tapering outwards, in order to allow the columns to be carried to the
extremity of the pediment; and here, where the heights of the shafts
are so fast shortened, they are set thicker; five shafts, or rather four
and a capital, above, to four of the arcade below, giving twenty-one
intervals instead of nineteen. In the next or third arcade, – which,
remember, is the highest, eight arches, all equal, are given in the space
of the nine below, so that there is now a central shaft instead of a
central arch, and the span of the arches is increased in proportion to
their increased height. Finally, in the uppermost arcade, which is the

lowest of all, the arches, the same in number as those below, are narrower than any of the façade; the whole eight going very nearly above the six below them. . . .

From this doggedly detailed investigation, Ruskin concludes that the whole façade exhibits a 'determined variation in arrangement, which is exactly like the related proportions and provisions in the structure of organic form'(8.203–04).

It is not only because of similarities to organic arrangement that Ruskin finds such subleties of composition intriguing. The decorative arcades on one side of the church of San Giovanni at Pistoia (ill. 28) delight him by an even greater irregularity in proportion and size of arches which to a careless observer might seem uniform. His analysis of this composition must be quoted at length:

The side of that church has three storeys of arcade, diminishing in height in bold geometrical proportion, while the arches, for the most part, increase in number in arithmetical, *i.e.* two in the second arcade, and three in the third, to one in the first. Lest, however, this arrangement should be too formal, of the fourteen arches in the lowest series, that which contains the door is made larger than the rest, and is not in the middle, but the sixth from the West, leaving five on one side and eight on the other. Farther: this lowest arcade is terminated by broad flat pilasters, about half the width of its arches; but the arcade above is continuous; only the two extreme arches at the west end are made larger than all the rest, and instead of coming, as they should, into the space of the lower extreme arch, take in both it and its broad pilaster. Even this, however, was not out of order enough to satisfy the architect's eye; for there were still two arches above to each single one below: so, at the east end, where there were more arches, and the eye might be more easily cheated, what does he do but *narrow* the two extreme *lower* arches by half a braccio; while he at the same time slightly enlarged the upper ones, so as to get only seventeen upper to nine lower, instead of eighteen to nine. The eye is thus thoroughly confused, and the whole building thrown into one mass, by the curious variations in the adjustments of the super-imposed shafts, not one of which is either exactly in, or positively out of, its place; and to get this managed the more cunningly, there is from an inch to an inch and a half of gradual gain in the space of the four eastern arches, besides the confessed half braccio. . . .

The upper arcade is managed on the same principle: it looks at first as if there were three arches to each under pair; but there are, in reality, only thirty-eight . . . to the twenty-seven below; and the

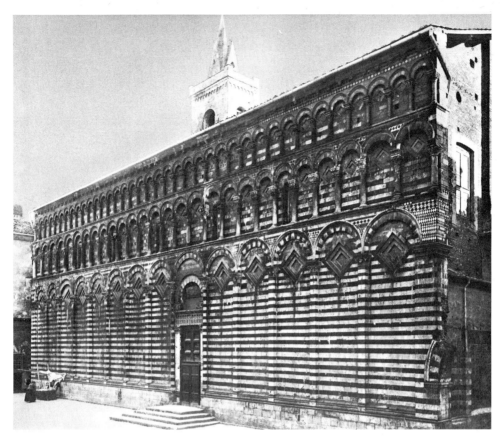

28 *San Giovanni Fuorcivitas, Pistoia*

columns get into all manner of relative positions. Even then, the builder was not satisfied, but must needs carry the irregularity into the spring of the arches, and actually, while the general effect is of a symmetrical arcade, there is not one of the arches the same in height as another; their tops undulate all along the wall like waves along a harbour quay, some nearly touching the string course above, and others falling from it as much as five or six inches.(8.204–06)

This fascinating discussion anticipates by over half a century a kind of analysis of works of art sometimes undertaken by Gestalt psychologists. In *Art and Visual Perception* Rudolf Arnheim, discussing a much simpler composition (a picture by Ben Nicholson) than the one which engages Ruskin at Pistoia, attempts to explain how a few simple elements of form 'may combine into a complex pattern'. It is interesting to find that Arnheim discovers in Nicholson's picture some of the very factors making for visual tension, and consequent perceptual unification of composition, that Ruskin points out at Pisa and

57

Pistoia. Throughout the picture, the 'close approximation of proportion and location produces considerable tension in that it compels the observer to call on his sensitivity for subtle distinctions'.[1] This is precisely Ruskin's experience at Pisa and Pistoia, though he does not hazard an explanation of his finding that the 'confusion of the eye' by the subtle approximations at Pistoia throws 'the whole building into one mass'. Visual psychologists are still far from being able to explain such phenomena.

In the second volume of *The Stones of Venice* Ruskin measures and comments upon the proportions of many structures in Venice and its environs, praising 'the peculiar subtlety of the early Venetian perception for ratios of magnitude' which, he feels, 'could only have resulted from a true love of harmony'(10.47–48). Beginning with measurements of the apse of San Donato at Murano, and continuing with the façades of five of the palaces classified by Ruskin as Byzantine, as well as St Mark's, he demonstrates the tendency of the early Venetian builders, when erecting a series of arches or apertures, to vary the placing of these elements according to definite patterns of seeming imprecision.

Ruskin's rough diagram of the elevation of one half of the front of the Fondaco dei Turchi (omitting the foundation) is given in ill. 29. He gives the following measurements:

the small arches *a* are, from shaft to shaft, . . . 4′5″
the interval *b* is 7′6½″
the interval *c* is 7′11″
intervals *d, e, f*, etc., are 8′1″

Ruskin argues that the

difference between the width of the arches *b* and *c* is necessitated by the small recess of the cornice on the left hand as compared with that of the great capitals; but this sudden difference of half a foot between the two extreme arches of the centre offended the builder's eye, so he diminished the next one, *unnecessarily*, two inches, and thus obtained the gradual cadence to the flanks, from eight feet down to four and a half in a series of continually increasing steps.(10.148)

The upper arcade, in its relation to the lower storey and also in its own internal composition, interests him even more:

a a a b c d e f

29 Ruskin *Diagram of the façade of the Fondaco dei Turchi, Venice*

Its twenty-six arches are placed, four small ones above each lateral three of the lower arcade, and eighteen larger above its central ten; thus throwing the shafts into all manner of relative positions, and completely confusing the eye in any effort to count them: but there is an exquisite symmetry running through their apparent confusion; for it will be seen that the four arches in each flank are arranged in two groups, of which one has a large single shaft in the centre, and the other a pilaster and two small shafts. The way in which the large shaft is used as an echo of those in the central arcade, dovetailing them, as it were, into the system of the pilasters, – just as a great painter, passing from one tone of colour to another, repeats, over a small space, that which he has left, – is highly characteristic of the Byzantine care in composition.(10.148)

The Casa Loredan's lower arcade (shown on the left in ill. 30) displays an arrangement somewhat similar to that of the Fondaco dei Turchi. Here Ruskin's measurements are:

59

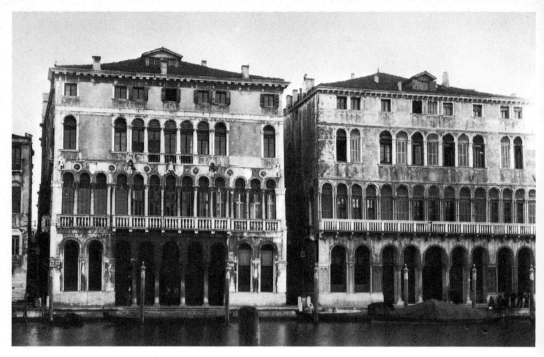

30 *Casa Loredan and Casa Farsetti, Venice*

the central interval, from shaft to shaft. . . .	6'1"
the two on each side of central one	5'2"
the two extremes of central five	4'9"
the inner arches of the wings	4'4"
the outer arches of the wings	4'6"

He comments:

The gradation of these dimensions is visible at a glance; the boldest step being here taken nearest the centre, while in the Fondaco it is farthest from the centre. The first loss here is of eleven inches, the second of five, the third of five, and then there is a most subtle increase of two inches in the extreme arches, as if to contradict the principle of diminution, and stop the falling away of the building by firm resistance at its flanks.(10.149–50)

Similar patterns of variation are found in the arcades of the Casa Farsetti (on the right in ill. 30) and two smaller Byzantine palaces. A mass of detailed analysis and measurement in manuscript notes for *The Stones of Venice*, and a brief discussion in *The Seven Lamps*, demonstrate similar but more complex patterns of variation in the façade of St Mark's.[2] Ruskin maintains, on the basis of these findings, that the early architects

of Venice possessed 'an intense perception of harmony in the relation of quantities . . . which we have at present lost so utterly as hardly to be able even to conceive it'(10.153). He then states the basic assumption about visual perception upon which his studies of the subtleties of these early Venetian buildings, and those of Pisa and Pistoia, are founded:

let it not be said, as it was of the late discoveries of subtle curvature in the Parthenon, that what is not to be demonstrated without laborious measurement, cannot have influence on the beauty of the design. The eye is continually influenced by what it cannot detect; nay, it is not going too far to say, that it is most influenced by what it detects least. Let the painter define, if he can, the variations of lines on which depend the changes of expression in the human countenance. The greater he is, the more he will feel their subtlety, and the intense difficulty of perceiving all their relations, or answering for the consequences of a variation of a hair's breadth in a single curve. Indeed, there is nothing truly noble either in colour or in form, but its power depends on circumstances infinitely too intricate to be explained, and almost too subtle to be traced. And as for these Byzantine buildings, we only do not feel them because we do not *watch* them. . . .(10.153–54)[3]

The claims made by Ruskin in this beautiful passage have received a great deal of support from recent studies of subliminal perception. A. Ehrenzweig, for instance, states that

Subliminal vision apparently excels normal vision by its scanning power and can search the entire visual field with equal acuity. In a split second it gathers in more details than prolonged conscious examination can in a time perhaps two hundred times longer. The artist who must control the diffuse impact which every single brush stroke has on the over-all structure of his work has to rely on his unconscious sensibilities to scan the complex interrelations concealed in the structure of any work of art.[4]

Twentieth-century architectural analysis has not often come to serious grips with the kind of visual complexity discerned by Ruskin in some of the examples we have been discussing. Bearing in mind Ruskin's detection of 'sensation in every inch' of the façade of the Duomo of Pisa(8.204), of the unification of composition brought about at San Giovanni at Pistoia by its pattern of approximations, and of the complex rhythms in the arcades of Byzantine structures in Venice, it is interesting to read

Arnheim's statement that up until 1954 'No attempt experim-
entally to explore the nature and conditions of directed tension
in immobile patterns seems to have been made. We must rely
on the eyes of the individual observer'. Arnheim suggests that
Wölfflin's studies of Baroque architecture provide materials for
such investigation.[5] The keen-eyed studies by Ruskin briefly
touched upon here (and there are many others in his notebooks)
might prove just as interesting to visual psychologists.

Ruskin's discoveries were so revolutionary, so out of step
with the precision-mindedness of his age, that the majority of
architects who bothered to consider them at all dismissed them
out of hand. Such variations from precision of measurement,
they felt, must be accidental, or due to the sheer sloppiness of
less enlightened ages. Anthony Trollope, too, wrote in his
autobiography:

I spent several mornings in carefully hunting out all the specimens of
Byzantine architecture which Ruskin registers as still existing in
Venice, and can testify to the absolute exactitude of his topographical
and architectural statements. I carefully examined also the examples
which he cites as indications of subtle design on the part of the old
architects in cases where abnormality and carelessness might be
suspected. His facts and measurements I found invariably correct, but
am disposed to think that he lets his hobby somewhat run away with
him in the imputation of far-fetched and subtle design.(9.xxv,n.4)

Ruskin had foreseen this reaction. Referring to the evidence he
had accumulated of optical wizardry in these early Venetian
façades, he remarks:

No modern builder has any idea of connecting his arches in this
manner, and restorations in Venice are carried on with too violent
hands to admit of the supposition that such refinements would be
even noticed in the progress of demolition, much less imitated in
heedless reproduction.(10.152)

In the *Lectures on Architecture and Painting* he harangues his
audience on the visual obtuseness of nineteenth-century
architects: 'You know how fond modern architects . . . are of
their equalities, and similarities; how necessary they think it that
each part of a building should be like every other part. Now
Nature abhors equality, and similitude, just as much as foolish
men love them.'(12.25. See also 16.416n.) The great medieval

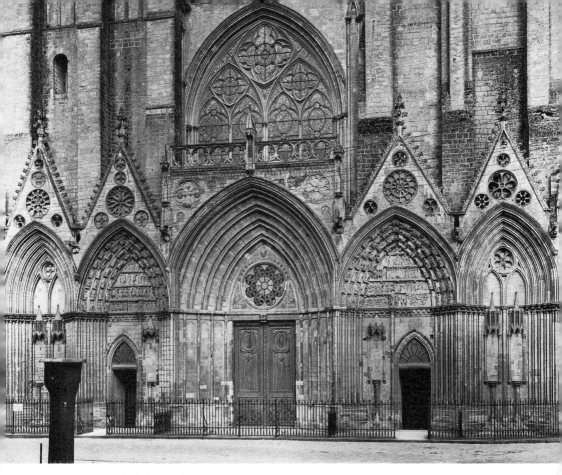

31 *Bayeux Cathedral: west front*

designers, he maintains, possessed a visual sensitivity far
superior to that of the moderns, and in the third volume of
Modern Painters (1856) he distinguishes from the modern,
mechanical, sense of symmetry an organic medieval concept of
the

symmetrical in the noble and free sense: for what we moderns call
'symmetry,' or 'balance,' differs as much from mediaeval symmetry
as the poise of a grocer's scales . . . does from the balance of a knight
on his horse, striking with the battle-axe, at the gallop(5.257).

The façade of Bayeux Cathedral (ill. 31) is one further
example given by Ruskin of what he means by such a claim.
Apart from the immense number of small variations occurring
in the composition of its two towers, we find an even more
'daring variation of pretended symmetry' in the layout of its
porches. Ruskin finds that despite close correspondence in

treatment of decorative detail on both portals flanking the central doorway, which might lead the viewer 'to expect a correspondence in dimension', measurement proves something strikingly different:

The small inner northern entrance measures, in English feet and inches, 4 ft. 7 in. from jamb to jamb, and the southern, 5 ft. exactly. Five inches in five feet is a considerable variation. The outer northern porch measures, from face shaft to face shaft, 13 ft. 11 in., and the southern, 14 ft. 6 in.; giving a difference of 7 in. on $14\frac{1}{2}$ ft. There are also variations in the pediment decorations not less extraordinary.(8.210)

It is Ruskin's steady contention that such variations are 'not mere blunders, nor carelessnesses', but the outcome of a 'determined resolution to work out an effective symmetry by variations as subtle as those of Nature'(8.210). Defending the irregularity in size of arches perpetrated in a drawing by Turner of a bridge at Koblenz, he tells readers of *The Elements of Drawing* that

it is . . . as a necessity of all noble composition, that this irregularity is introduced by Turner. It at once raises the object thus treated from the lower or vulgar unity of rigid law to the greater unity of clouds, and waves, and trees, and human souls, each different, each obedient, and each in harmonious service.(15.176)

These last remarks carry me dangerously near the shoals of Ruskinian metaphysics I have chosen to avoid in this book. They help explain, however, why he refuses to look at the composition of a medieval building with less acuity than he would at the composition of a plant, an animal, a mountain or a human face. Beauty in all of these coexists with, and is in part dependent upon, irregularities of composition. Exact precision, symmetry, or duplication of parts, in any of them, will be discerned only by an observer who is, deliberately or in ignorance, oversimplifying the evidence of his senses.

CHAPTER THREE

Ornament: preliminary considerations

Ornament subordinate to the visual whole

PROBABLY no statement made by Ruskin has caused more consternation among architectural readers than one sentence from the *Lectures on Architecture and Painting*:

Ornamentation is the principal part of architecture.(12.83)

It is easy to sympathize with Nikolaus Pevsner's suggestion that Ruskin 'might have known better'.[1] Certainly it was silly of him to sum up his wide-ranging and subtle analysis of architectural ornament with a dogmatic catch-cry that has effectively repelled generations of readers from making a serious attempt to find out if there was any substance behind the bluster.

The problems of deciding what one means by ornament, and then of determining its visual significance in architecture, are most complex and intriguing, and yet are often dismissed as scarcely warranting attention in face of the profundities of spatial organization and disposition of large-scale mass. Ruskin's discussion of ornament, taken as a whole, is one of the few attempts to date that do justice to the complexity of the subject, and has seldom been understood and digested, let alone superseded, by subsequent criticism. His ideas have often been grossly misinterpreted, mainly because it has seldom been noticed that Ruskin usually implies a much wider definition of 'ornament' than the modern reader – the inheritor of nineteenth-century oversimplifications which appalled Ruskin – tends to expect.

The twenty-first chapter of the first volume of *The Stones of Venice*, virtually ignored by previous commentators, is central to the understanding of Ruskin's concept of ornament. Paragraphs 25 to 27 suggest the subtlety of his approach to what he calls the treatment of ornament 'with reference to the sight'. It is worth quoting at some length:

the distance of ornament is never fixed to the *general* spectator. The tower of a cathedral is bound to look well, ten miles off, or five miles, or half a mile, or within fifty yards. The ornaments of its top have fixed distances, compared with those of its base; but quite unfixed distances in their relation to the great world: and the ornaments of the base have no fixed distance at all. They are bound to look well from the other side of the cathedral close, and to look equally well, or better, as we enter the cathedral door. How are we to manage this?

As nature manages it . . . for every distance from the eye there [is] a different system of form in all natural objects: this is to be so then in architecture. The lesser ornament is to be grafted on the greater, and third or fourth orders of ornaments upon this again, as need may be, until we reach the limits of possible sight; each order of ornament being adapted for a different distance: first, for example, the great masses, – the buttresses and stories and black windows and broad cornices of the tower, which give it make and organism, as it rises over the horizon, half a score of miles away: then the traceries and shafts and pinnacles, which give it richness as we approach: then the niches and statues and knobs and flowers, which we can only see when we stand beneath it. At this third order of ornament, we may pause, in the upper portions; but on the roofs of the niches, and the robes of the statues, and the rolls of the mouldings, comes a fourth order of ornament, as delicate as the eye can follow, when any of these features may be approached.

All good ornamentation is thus arborescent, as it were, one class of it branching out of another and sustained by it; and its nobility consists in this, that whatever order or class of it we may be contemplating, we shall find it subordinated to a greater, simpler, and more powerful; and if we then contemplate the greater order, we shall find it again subordinated to a greater still; until the greatest can only be quite grasped by retiring to the limits of distance commanding it.

And if this subordination be not complete, the ornament is bad: if the figurings and chasings and borderings of a dress be not subordinated to the folds of it, – if the folds are not subordinated to the action and mass of the figure, – if this action and mass, not to the divisions of the recesses and shafts among which it stands, – if these,

66

not to the shadows of the great arches and buttresses of the whole building, in each case there is error; much more if all be contending with each other and striving for attention at the same time.(9.301–02)

A number of interesting considerations arise from this passage. First of all, Ruskin is using the term 'ornament' in an unusually broad sense. Depending upon the distance of the viewer from the building, almost any major subdivision of structure might be considered ornamental. Ruskin would, it appears, regard as ornamental all elements of the building which, at the specific distance from which one is viewing it, are treated in such a way that they contribute to its aesthetic articulation. Secondly, even the smallest details must be considered visually in relation to the larger schemes of ornamental subdivision within which they are comprehended; which, in turn, must be considered in terms of the total effect of the building as viewed from varying distances.

Ruskin insists in this same chapter that

The especial condition of true ornament is, that it be beautiful in its place, and nowhere else, and that it aid the effect of every portion of the building over which it has influence; that it does not, by its richness, make other parts bald, or by its delicacy, make other parts coarse. Every one of its qualities has reference to its place and use. . . .(9.284–85)

It would be difficult to conceive of a more forceful affirmation of the necessity of considering detail as subordinate to the visual whole. Ruskin claims that the problems of trying to understand

How far this subordination is in different situations to be expressed, or how far it may be surrendered, and ornament, the servant, be permitted to have independent will; and by what means the subordination is best to be expressed when it is required, are by far the most difficult questions I have ever tried to work out respecting any branch of art(9.285).

But he is certain that ornament lacking subordination to total design will inevitably lead to aesthetic disaster:

As an architect, therefore, you are modestly to measure your capacity of governing ornament. Remember, its essence, – its being ornament at all, consists in its being governed. Lose your authority over it, let it command you, or lead you, or dictate to you in any wise, and it is an offence, an incumbrance, and a dishonour.(9.308)

If architectural ornament is to be considered subordinate to the total effect of the building, it follows that, to be successful, it must be designed as an integral part of the composition, not added to a building after the large-scale masses and structures have been determined. This is in fact Ruskin's position, yet his critics persist in attributing attitudes to him which he does not hold. A recent study contends that 'sculptured details, as he treats them, are considered solely as ornament to be *applied to a building* relatively freely'.[2] But in an appendix to the first volume of *The Stones of Venice* Ruskin singles out for heated attack precisely the point of view thus attributed to him:

The fact is, I never met with the architect yet who did not think ornament meant a thing to be bought in a shop, and pinned on, or left off, at architectural toilets, as the fancy seized them. . . . Architects . . . do not understand . . . that a noble building never has any extraneous or superfluous ornament; that all its parts are necessary to its loveliness, and that no single atom of them could be removed without harm to its life. You do not build a temple and then dress it. You create it in its loveliness, and leave it, as her Maker left Eve. Not unadorned, I believe, but so well adorned as to need no feather crowns. And I use the words ornament and beauty interchangeably, in order that architects may understand this: I assume that their building is to be a perfect creature, capable of nothing less than it has, and needing nothing more. It may, indeed, receive additional decoration afterwards, exactly as a woman may gracefully put a bracelet on her arm, or set a flower in her hair: but that additional decoration is *not* the *architecture*. It is of curtains, pictures, statues, things which may be taken away from the building, and not hurt it. What has the architect to do with these? He has only to do with what is part of the building itself, that is to say, its own inherent beauty.(9.451–52)

Seen in the light of such passages, Ruskin's claim that '*Ornamentation is the principal part of architecture*' can be read with some hope of understanding the serious intentions behind his verbal shock tactics. (He modifies the claim in subsequent discussion to 'the principal part of architecture, considered as a subject of fine art'.) Ornament is not something extra which is added to a building to beautify it – 'Whatever has nothing to do, whatever could go without being missed, is not ornament; it is deformity and encumbrance. Away with it'(9.307). Rather, it is something inherent in the original design, and not to be

68

32 Ruskin *St Wulfran, Abbeville* 1868

judged without taking its entire visual context into considera-
tion. At some distances, the most prominent visual determinants
of this scheme may be buttresses and windows (ill. 32). At nearer
distances, features such as mouldings, pinnacles and large-scale
statuary may become dominant in securing visual 'make and
organism' for the building. At close range, one may be able to
comprehend within one's visual field no more than part of a
buttress, parts of several gables, part of a window, fragments of
mouldings and tracery, and a host of smaller details (ill. 33). The
buttress or gable which had been a mere detail at long range,
subordinate to a larger visual scheme, now fills much of the
viewer's field of vision, and subordinates a good deal of minute
intricacy to itself. What one sees at each of these distances is, in
Ruskin's opinion, equally 'architectural', and equally valid as a
subject for aesthetic response and analysis.

It so happens that a good deal of Ruskin's own viewing and
analysis takes place at close range. It does not at all follow, as
hasty readers have been ready to assume, that he must therefore
be treating the details he discerns at such distances without
consideration of their architectural context.[3] Before we can

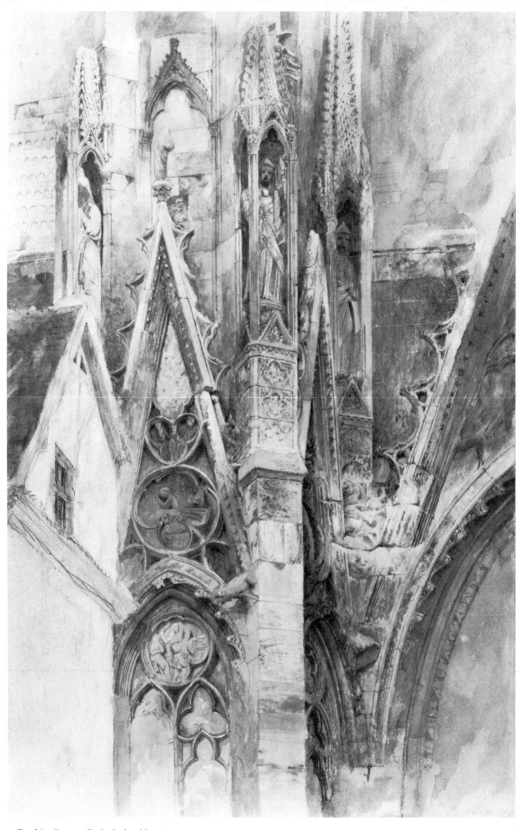

33 Ruskin *Rouen Cathedral gables* 1854

approach Ruskin's work in this area fair-mindedly, and free from the preconceptions he tried to battle against in the architectural profession of his day, we must, as he tells his audience in a lecture of 1859,

Get rid, then, at once of any idea of Decorative art being a degraded or a separate kind of art. Its nature or essence is simply its being fitted for a definite place; and, in that place, forming part of a great and harmonious whole(16.320).

Some consequences of this subordination

In a fine building every detail must be visually integrated within whatever ornamental scheme is dominant at the distance from which that detail is viewed. Certain consequences, in Ruskin's opinion, follow from this consideration.

To begin with, it becomes necessary to distinguish clearly between independent sculpture and what Ruskin calls 'architectural sculpture'(23.168). The latter includes the

immense quantity of sculpture of all times and styles [which] may be generally embraced under the notion of a mass hewn out of, or, at least, placed in, a panel or recess, deepening, it may be, into a niche; the sculpture being always designed with reference to its position in such recess: and, therefore, to the effect of the building out of which the recess is hewn.(20.318)

All such 'architectural sculpture' displays characteristics which would be considered flaws if it were viewed away from its intended visual context. The problem is brilliantly outlined by Ruskin in the first volume of *The Stones of Venice*:

If, to produce a good or beautiful ornament, it were only necessary to produce a perfect piece of sculpture, and if a well-cut group of flowers or animals were indeed an ornament wherever it might be placed, the work of the architect would be comparatively easy. Sculpture and architecture would become separate arts: and the architect would order so many pieces of such subject and size as he needed, without troubling himself with any questions but those of disposition and proportion. But this is not so. *No perfect piece either of painting or sculpture is an architectural ornament at all*, except in that vague sense in which any beautiful thing is said to ornament the place it is in. Thus we say that pictures ornament a room; but we should not

34 *St Paul's Cathedral, London: panel under a window of the south wall of the choir*

thank an architect who told us that his design, to be complete, required a Titian to be put in one corner of it, and a Velasquez in the other; and it is just as unreasonable to call perfect sculpture, niched in, or encrusted on a building, a portion of the ornament of that building, as it would be to hang pictures by way of ornament on the outside of it. . . . And so far from the perfection of the work conducing to its ornamental purpose, we may say, with entire security, that its perfection, in some degree, unfits it for its purpose, and that no absolutely complete sculpture can be decoratively right.(9.284)

Ruskin notes, as an example of the failure to observe this principle, the 'flower-work of St Paul's, which is probably, in the abstract, as perfect flower sculpture as could be produced at the time'. That sculpture, however (ill. 34), 'is just as rational an ornament of the building as so many valuable Van Huysums, framed and glazed, and hung up over each window.'(9.284)

Ruskin's refusal to allow an essential distinction between the roles of sculptor and architect on a building arises from his conviction that in all great architectural work of the past the ornamental sculpture has been designed and carved with a continuous awareness of large-scale effect in mind. Thus, in spite of the delight Ruskin takes in naturalistic carving, he cautions the architect/sculptor against allowing himself to work for a moment without bearing in mind the effect his carving will have on the aesthetic qualities of the building when seen as a whole:

the moment the architect allows himself to dwell on the imitated portions, there is a chance of his losing sight of the duty of his

72

ornament, of its business as a part of the composition, and sacrificing its points of shade and effect to the delight of delicate carving. And then he is lost. His architecture has become a mere framework for the setting of delicate sculpture, which had better be all taken down and put into cabinets.(8.174)

A crude piece of carving (considered as museum sculpture) may yet be far better calculated for architectural effect than a highly finished work. Thus, at the Doge's Palace in Venice,

> The figures of Adam and Eve, sculptured on each side of the Fig-tree angle, are more stiff than those of Noah and his sons [on the Vine angle], but are better fitted for their architectural service; and the trunk of the tree, with the angular body of the serpent writhed around it, is more nobly treated as a terminal group of lines than that of the vine.(10.363)[4]

The aesthetic consequences of the almost total division of labour between architect and sculptor in nineteenth-century England are at the root of Ruskin's contempt for most of the revival architecture (whether 'medieval', 'classical', or 'Renaissance') and restoration of medieval buildings undertaken during his lifetime. Figure sculpture not carved on the spot, and not subordinated to its specific architectural context, was particularly irritating to him. Thus, commenting in 1879 on a famous passage in *The Stones of Venice* in which he had celebrated the visual effect of an English medieval façade, he laments:

Alas! All this was described from things now never to be seen more. Read, for 'the great mouldering wall,' and the context of four lines, 'the beautiful new parapet by Mr Scott, with a gross of kings sent down from Kensington.'(10.79n.)[5]

But, protested the architects of the day, Ruskin is confusing architecture and sculpture, which are surely two different arts:

learn to carve or paint organic form ourselves! How can such a thing be asked? We are above all that. The carvers and painters are our servants – quite subordinate people. They ought to be glad if we leave room for them.(16.252)

Such an attitude is indicative of an unfortunate inability, or unwillingness, to recognize the complete interdependence of all parts of a successful building, down to the smallest detail, in

determining its aesthetic character from any particular vantage point. To a viewer with even a small portion of Ruskin's visual sensitivity, the attempt to draw sharp lines of division between 'architecture' and 'decorative sculpture' will seem a totally arbitrary exercise, which ignores the actual look of almost all fine medieval buildings.

Anyone standing near the porch of Rouen drawn by Ruskin in ill. 54, and imagining it suddenly denuded of its carved figures and lesser sculpture, must surely agree with him in thinking that those carvings have at least as important a visual role to play in giving the building aesthetic 'make and organism' as any other features visually dominant at that distance. They contribute lines, masses, shadows, and modifications of texture that help determine the quality of the building's aspect as surely as details such as eyebrows, eyelashes, and the curvature of the lips help determine the individuality of the human face.

Ruskin's insistence that 'though architecture and sculpture are not separate arts, there is an architectural *manner* of sculpture'(16.361) follows logically from his concept of ornamentation as an integral part of the whole building. This 'architectural' manner is just as evident in small–scale detail as in large carved figures. Referring, for example, to his illustration of a capital from the tomb of Can Signorio in Verona(21.197), he notes the

different inclination of the leaves at the angles, those towards the front of the niche being thrown forward, and those at the back kept vertical – but this with so delicate a difference that any modern architect would think it the effect of accident and clumsiness. But it is a part of a great system throughout all the Veronese monuments, under which the action of the foliage, in every minor ornament, has reference to its position on the building.(21.197–98)

The mosaic decorations of St Mark's in Venice, too, were designed with a view to their contribution to total architectural effect. Concerning the mosaic of the principal dome (representing the Ascension, ill. 35), Ruskin remarks:

There are one or two circumstances in the mode of decoration itself, considered as such, which we ought not to pass without notice. Trees, much smaller in size and much less conspicuous in position, would as well or better have indicated that the scene was on the

35 *St Mark's, Venice: looking up into the principal dome*

Mount of Olives, but their tall stems and dark foliage are of admirable service in dividing, like so many slender pillars, the golden field of the vaults. In order to fit them for this architectural service, the branches are lopped off all up the trunks, and the foliage is only represented in the clustering heads. . . .

Another remarkable point is the interruption of the general aspect of the circle by the figure of the Madonna. A modern architect required to decorate a dome would assuredly have made it with the

figures in all its compartments as nearly alike as might be; but in this case the twelve figures of the Apostles are arranged in unbroken series, with drapery in finely divided folds and of light colours; then come the two angels in white, with their wings bedropped with gold, and between these, that is to say, in the whitest part of the whole circle, is placed the Madonna, in a solid mass of dark blue drapery nearly black, and relieved only by three small golden crosses, one on each shoulder, and one on the part of the dress which falls over the forehead; this figure fronts the west door of the church, and its darkness gives light and brilliancy to all the rest of the dome.(10.136n.–37n.)

Ruskin pronounces this an 'exquisite decorative arrangement'. It is designed with a view to 'architectural service', and satisfies his demand that ornament should be subservient to the entire composition seen from any position. The treatment of the olive trees and figure of the Madonna plays its own subtle part in determining the unique character of the architecture of St Mark's.

This fact might not be apparent to an observer trained to impose on his experience of architecture an arbitrary distinction between its three-dimensional qualities and its supposedly added 'details'.[6] Ruskin's concept of ornamentation is sufficiently comprehensive to allow him to avoid such oversimplifying abstraction.

CHAPTER FOUR

Adaptation of detail to position of viewer

PERHAPS the surest indication of Ruskin's conviction that good ornament must be subordinate to specifically architectural considerations is his insistence upon 'the various modifications of treatment which are rendered necessary by the variation of its distance from the eye'(9.292). His analyses of mouldings, cornices, clustered shafts, foliation, tracery bars and other details frequently touch on this question, but it is in his discussions of carved detail that we find his clearest statements on the subject. He is appalled by the fact that most nineteenth-century carving seems designed without reference to the distance from which it will normally be seen:

It is foolish to carve what is to be seen forty feet off with the delicacy which the eye demands within two yards; not merely because such delicacy is lost in the distance, but because it is a great deal worse than lost: – the delicate work has actually worse effect in the distance than rough work.(9.292)

The citizens of Edinburgh are harangued in a lecture of 1853 on the aesthetic and financial consequences of their ignorance of this principle:

you increase the price of your buildings by one-half, in order to mince their decoration into invisibility. Walk through your streets, and try to make out the ornaments on the upper parts of your fine buildings. . . . Don't do it long, or you will all come home with inflamed eyes, but you will soon discover that you can see nothing but confusion in ornaments that have cost you ten or twelve shillings a foot.(12.59)

The Houses of Parliament at Westminster, furthermore, which

are described in a lecture of 1872 as 'the absurdest and emptiest piece of filigree, – and, as it were, eternal foolscap in freestone, – which ever human beings disgraced their posterity by'(22.261), are abhorrent to Ruskin partly because almost all their carved ornament is worked too finely to exhibit any vigorous articulation at the distance from which it is normally viewed. This overfine working extends even to the inscriptions in black letter which, 'like all the rest of the work on that, I suppose, the most effeminate and effectless heap of stones ever raised by man . . . are utterly unfit for their position'(12.478).

The capitals of the Doge's Palace in Venice, on the other hand, illustrate how the detail of medieval buildings was often modified in accordance with its position relative to the viewer:

On my first careful examination of the capitals of the upper arcade of the Ducal Palace at Venice, I was induced, by their singular inferiority of workmanship, to suppose them posterior to those of the lower arcade. It was not till I discovered that some of those which I thought the worst above, were the best when seen from below, that I obtained the key to this marvellous system of adaptation; a system which I afterwards found carried out in every building of the great times which I had opportunity of examining.(9.292–93)

The treatment of good architectural detail frequently requires, in Ruskin's view, 'a particular method of handling which none but consummate artists reach, which has its effect at the intended distance,' but may be 'altogether hieroglyphical and unintelligible at any other'(9.292). Two techniques of carving ornament for *distant* effect exemplify what he means by this:

In the first, the same designs which are delicately worked when near the eye, are rudely cut, and have far fewer details when they are removed from it. In this method it is not always easy to distinguish economy from skill, or slovenliness from science. But, in the second method, a different kind of design is adopted, composed of fewer parts and of simpler lines, and this is cut with exquisite precision. This is of course the higher method, and the more satisfactory proof of purpose; but an equal degree of imperfection is found in both kinds when they are seen close: in the first, a bald execution of a perfect design; in the second, a baldness of design with perfect execution. And in these very imperfections lies the admirableness of the ornament.(9.293)

On the other hand, the composition of ornamental detail which is meant to be seen close will, unless it is designed also with an eye to its likely visual effect at greater distance, fail to stand up to Ruskin's demand that every detail of a building should be harmoniously comprehended within the ornamental order which is operative at any given distance:

When an ornamental work is intended to be seen near, if its composition be indeed fine, the subdued and delicate portions of the design lead to, and unite, the energetic parts, and those energetic parts form with the rest a whole, in which their own immediate relations to each other are not perceived. Remove this design to a distance, and the connecting delicacies vanish, the energies alone remain, now either disconnected altogether, or assuming with each other new relations, which, not having been intended by the designer, will probably be painful. There is a like, and a more palpable, effect, in the retirement of a band of music in which the instruments are of very unequal powers; the fluting and fifing expire, the drumming remains, and that in a painful arrangement, as demanding something which is unheard. In like manner, as the designer at arm's length removes or elevates his work, fine gradations, and roundings and incidents, vanish, and a totally unexpected arrangement is established between the remainder of the markings, certainly confused, and in all probability painful.(9.296–97)

This is a good description of what happens when one examines a great deal of nineteenth-century ornament which has been designed on the drawing board (as in the case of Pugin's ornament at Westminster) by an architect insufficiently attentive to the practical visual problems discerned by Ruskin. Northern Gothic detail, also, may occasionally suffer a similar process of compositional disintegration when examined as the viewer retires from the building. Because of the possibility of carving vegetal and animal forms in bold relief, the sculptor may have been tempted to 'render the representation . . . more complete than is necessary, or even to introduce details and intricacies inconsistent with simplicity of distant effect'. If he does so, and irrespective of the delightfulness of his carving when seen from close range, 'these knots of ornament, as we retire from them to contemplate the whole building, appear unconsidered or confused'(10.108).

Ruskin feels that the nobility of ornament 'consists in this, that whatever order or class of it we may be contemplating, we

shall find it subordinated to a greater, simpler, and more powerful'(9.301). The architect must therefore guard against the possible visual disintegration of his ornament when it is seen from a distance:

The art of architectural design is . . . the preparation for this beforehand . . . and the fixing the thought upon the arrangement of the features which will remain visible far away. Nor does this always imply a diminution of resource: for, while it may be assumed as a law that fine modulation of surface in light becomes quickly invisible as the object retires, there are a softness and mystery given to the harder markings, which enable them to be safely used as media of expression. . . .

By just calculation . . . of the means at our disposal, by beautiful arrangement of the prominent features, and by choice of different subjects for different places, choosing the broadest forms for the farthest distance, it is possible to give the impression, not only of perfection, but of an exquisite delicacy, to the most distant ornament.(9.297–98)

The influence of such thoughtful planning is discerned by Ruskin in much Italian Romanesque ornamentation, such as that of the west portal of San Zeno Maggiore in Verona (ills 36 and 37). Work of this kind is

divided first into large masses, and these masses covered with minute chasing and surface work which fill them with interest, and yet do not disturb nor divide their greatness. The lights are kept broad and bright, and yet are found on near approach to be charged with intricate design. This . . . is a part of the great system of treatment which I shall hereafter call 'Proutism;' much of what is thought mannerism and imperfection in Prout's work, being the result of his determined resolution that minor details shall never break up his large masses of light.(9.303)

Perfect illustration of the principle of 'Proutism' (the artist Samuel Prout, 1783–1852, was a friend and neighbour of the Ruskins') is to be found in the carved atrium piers of the cathedral of San Martino at Lucca, which were favourite subjects with Ruskin for close study (ill. 38):

the smooth round mass of the pillar is entirely undisturbed; into that, furrows are cut with a chisel as much under command and as powerful as a burin. The effect of the design is trusted entirely to the depth of these incisions – here dying out and expiring in the light of

36 *San Zeno Maggiore, Verona: west front*

37 *San Zeno Maggiore, Verona: west portal*

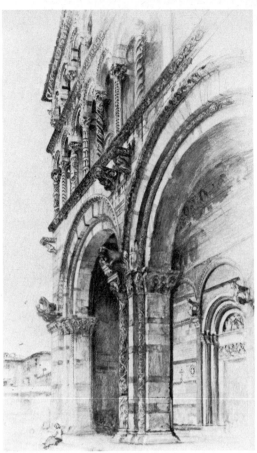

38 (*left*) Ruskin *Detail of atrium pier of San Martino, Lucca* 1882

39 (*right*) Ruskin *Part of the front of San Martino, Lucca* 1874

the marble, there deepened, by drill holes, into as definitely a black line as if it were drawn with ink; and describing the outline of the leafage with a delicacy of touch and of perception which no man will ever surpass(22.345).

Comparing this close look with the more distant view given in another Ruskin drawing (ill. 39), we can discern clearly how these carved shafts satisfy his demand that ornament must be effective at varying distances. The undulating line flowing around and half enclosing the leafage – scarcely noticed in the near view – stands out with increasing boldness at greater distance, giving pattern and interest to the shaft when the individual leaf forms which were so dominant at close range

82

have become virtually indistinguishable. These shafts exemplify Ruskin's principle that

All good ornament and all good architecture are capable of being put into shorthand; that is, each has a perfect system of parts, principal and subordinate, of which, even when the complemental details vanish in distance, the system and anatomy yet remain visible, so long as anything is visible: so that the divisions of a beautiful spire shall be known as beautiful even till their last line vanishes in blue mist; and the effect of a well-designed moulding shall be visibly disciplined, harmonious, and inventive, as long as it is seen to be a moulding at all.(3.208)

Thoughtful planning for distant effect is also seen in the design of many of the capitals of St Mark's and the Byzantine palaces of Venice. Referring to plates VII and VIII in the second volume of *The Stones of Venice*, Ruskin asks his readers to

note, in all these examples, the excessive breadth of the masses, however afterwards they may be filled with detail. Whether we examine the contour of the simpler convex bells, or those of the leaves which bend outwards from the richer and more Corinthian types, we find they are all outlined by grand and simple curves, and that the whole of their minute fretwork and thistle-work is cast into a gigantic mould which subdues all their multitudinous points and foldings to its own inevitable dominion.(10.161)

These capitals, exquisite when seen from close range, thus also retain bold articulation when seen from a distance at which the fine points of their carving become invisible (ills 11, 44 and 57).

Ruskin's notebooks are full of detailed studies of the adaptation of various ornamental features to the positions from which they are likely to be viewed. One of the more interesting occurs in some manuscript notes now at the Pierpont Morgan Library, New York. Referring to the apse of the church of San Donato, Murano (ills 40, 41 and 42), Ruskin comments:

The entire ornament is divided into two systems. Its main forms are first cut into flat relief about half an inch deep, and on their surface, the enrichment & drawing is given by mere incisions of the chisel. . . . As far off as the apse can be seen at Murano, the great first system of this decoration is clearly discernible. [Ruskin now places the reader at a distance of about 35 yards from the apse] . . . which is quite as far off as any one would be likely to stop to look at the apse at all. And at that

distance, supposing your eyesight of average power, you will see the great divisions of the circle with its bands & leaves with perfect clearness; and you will have a sense of richness in their surface, produced you do not know how, but satisfactory nevertheless – as the richness is in one of the surfaces of nature, as in the grass, or in the trees, when you cannot see the leaves by which it is produced. And when you go near the foot of the building you will find this richness produced by a system of lines, still exceedingly delicate at that distance (for you cannot get nearer so as to see them, than within twenty feet of the foot of the stone – it is 17 feet above the ground) and suggesting various strange involutions & relations of the parts of the larger system which before looked so simple. And if you get a ladder, and go up to the stone you will find that these lines are mere furrows in the surface – which the commonest workman could cut, when they were drawn for him in their places; and which in their manner, meaning, & result of enrichment to the white marble – are precisely correspondent to so many strokes of Prout's pencil on white paper – they are like Prout's, and no one else's: they are kept broad and coarse, like Prout's in order that they may be properly seen in the distance; they are kept quiet & even, like Prout's, that the idea of continuity and rest in the flow of the band may never be lost; they are kept clear & separate like Prout's, that there may be no appearance of weakness in them, but evident strength & decision and contentment with what they are – not struggling for something grander or finer.[1]

It should be stressed that in such studies of the adaptation of carved ornament to viewing distance, Ruskin is not addressing the question of whether or not the ornament in question can be 'read' – i.e. whether or not one can make out the narrative or symbolic significance of particular figures or patterns. He is talking in strictly aesthetic terms about the visual effects – whether patterned or chaotic, harmonious or inharmonious – which result when the ornament is viewed from a particular distance. Readers of his advice in 'The Nature of Gothic' that one should learn to '*Read* the sculpture' of Gothic buildings(10.269) have sometimes inferred that such advice implies a lack of interest in the purely aesthetic contribution made by ornamental sculpture to architecture. Nothing could be further from the truth. Since false mythology concerning Ruskin's views seems particularly persistent on this point, however, it may be as well to refer briefly to a passage in which he deals explicitly with the problem. Attempting to teach a lecture

84

40 Ruskin *Archivolt of San Donato, Murano*

41 *San Donato, Murano: part of the apse*

42 Ruskin *Sculptured decoration of the apse of San Donato, Murano*

audience in 1870 to distinguish clearly between aesthetic and representational qualities in art, he refers them to a photograph of the porch of San Zeno Maggiore in Verona (ill. 37):

You will find it impossible, without a lens, to distinguish in the bronze gates, and in great part of the wall, anything that their bosses represent. You cannot tell whether the sculpture is of men, animals, or trees; only you feel it to be composed of pleasant projecting masses; you acknowledge that both gates and wall are, somehow, delightfully roughened; and only afterwards, by slow degrees, can you make out what this roughness means(20.215).

The aesthetic pleasure derived from viewing the porch at this distance is thus independent of the subject-matter of the carving. It is the visual result of masses 'disposed with due discretion and order', and 'an abstract beauty of surface rendered definite by increase and decline of light – (for every curve of surface has its own luminous law, and the light and shade on a parabolic solid differs, specifically, from that on an elliptical or spherical one) – [which] it is the essential business of the sculptor to obtain'. At a distance from which 'the things represented become absolutely unintelligible', one should, therefore, be 'able to say, at a glance, "That is ... good carving."'(20.215)[2] Carving, in other words, which satisfies Ruskin's requirement that ornament make an aesthetic contribution to the whole composition from whatever position it is viewed.

Ruskin's interest in problems of adapting ornamental detail to viewing position is not confined to carved ornament. He makes many references to other components of buildings which, because they are normally viewed from particular angles, must be designed with that fact in mind. Discussing the bases of the piers of Bourges Cathedral (ill. 43), he suggests that, though there 'can be no question of the ineffable superiority of these Gothic bases, in grace of profile, to any ever invented by the ancients', they nonetheless suffer from two visual flaws:

They seem, in the first place, to have been designed without sufficient reference to the necessity of their being usually seen from above; their grace of profile cannot be estimated when so seen, and their excessive expansion gives them an appearance of flatness and separation from the shaft, as if they had splashed out under its pressure: in the second place, their cavetto is so deeply cut that it has the appearance of a black

43 *Bourges Cathedral: piers and pier bases* 44 *St Mark's, Venice: arcade supporting the gallery*

fissure between the members of the base; and . . . it is impossible to
conquer the idea suggested by it, that the two stones above and below
have been intended to join close, but that some pebbles have got in
and kept them from fitting; one is always expecting the pebbles to be
crushed, and the shaft to settle into its place with a thunder-
clap.(9.337–38)

Some unpublished notes intended for *The Stones of Venice*
contain an intriguing discussion of the shafts and arches which
sustain the galleries at St Mark's in Venice. Of these arches
(ill. 44) Ruskin states that their

curves are singularly studied: the object being to obtain as much
lightness of effect as possible, without sacrificing the circular curve
entirely. As the spectator regards them from below he will imagine
them to be stilted semicircles . . . but he will feel as if there were a
peculiar charm and grace in the spring of the circle – more than of
circles generally. If he ascends into the galleries opposite, he will
discover the reason: the curve is not circular – but [is] brought at the
apex into some approximation to that of a pointed arch, and there is
the slightest possible suggestion of the horse shoe form at the base –

the mouldings falling back a little as they first rise. This allowance for the perspective effect which in looking up at a round arch plainly stilted, flattens the upper part of the curve, and causes the perpendicular lines to appear slightly convergent, gives the peculiar charm to these arches as they are seen from below, and is a remarkable evidence of the subtle instinct of the Byzantine builders in the arrangement of ornamental lines.[3]

Here, as so often in reading Ruskin, one cannot help but marvel at the persistence of enquiry which enables him to explain subtle nuances of architectural composition.

However, Ruskin is too conscious of what it is actually like to look at a great building to pretend that his analyses, or even the best of drawings, could do justice to the sensations of an on-the-spot viewing. Thus, in his remarks about the painstaking drawing of the southern portico of St Mark's reproduced in his *Examples of the Architecture of Venice* (1851), he states that

it is seen from a distance of about twenty-five feet from the base of the westernmost pillar. . . . At a greater distance than this the sculpture of the capitals would become indistinct to the eyesight of most people; and the spectator is apt, therefore, to pause within this distance, in order to look at the decoration of the upper arches. The ornament of almost all good architecture is calculated for this kind of observation, and yet, strictly speaking, the resultant effect is incapable of being represented in a drawing, as the spectator's head is thrown back, and the angle of sight considerably elevated. I have long felt the difficulty of conveying a true impression of richly decorated buildings, in consequence of this(11.330–31 and accompanying plate).

Such caution in assessing the value of even his most careful drawings as evidence is typical of Ruskin's respect for the complexity of visual phenomena.[4]

The following three chapters will briefly survey a number of his remarks about the ornamentation of particular buildings, in an attempt to elucidate further his visual approach to architecture. Beginning with examples in which he is looking from a considerable distance, I will close gradually to those in which he is looking at, say, a single capital from within a few feet. It will be impossible to be entirely systematic in this discussion, since he seldom set out to analyse any ornamental scheme with total thoroughness: 'Analysis is an abominable business. I am quite sure that people who work out subjects thoroughly are disagreeable wretches.'(9.xxvii–xxviii)

Ornament viewed at long distance

SEEN FROM a distance at which the whole building can be comprehended at a glance, the ornament must subdivide and modify its chief masses in an aesthetically pleasing and harmonious manner. No matter how exquisite individual details may be when viewed from nearby, they will fail in accomplishing 'the great ends of decoration' if they coalesce or disintegrate into collective formlessness at a distance:

If the ornament does its duty – if it *is* ornament, and its points of shade and light tell in the general effect, we shall not be offended by finding that the sculptor in his fulness of fancy has chosen to give much more than these mere points of light, and has composed them of groups of figures. But if the ornament does not answer its purpose, if it have no distant, no truly decorative power; if, generally seen, it be a mere incrustation and meaningless roughness, we shall only be chagrined by finding when we look close, that the incrustation has cost years of labour, and has millions of figures and histories in it; and would be the better of being seen through a Stanhope lens [a kind of magnifying glass]. Hence the greatness of the northern Gothic as contrasted with the latest Italian [Ruskin is referring to the Certosa of Pavia]. It reaches nearly the same extreme of detail; but it never loses sight of its architectural purpose, never fails in its decorative power; not a leaflet in it but speaks, and speaks far off too(8.51–52).

If the ornament is to fulfil its function of giving aesthetic articulation to the building when seen as a whole, it must be distributed with discernment. A fine building is

a feast where there is nothing redundant. So, then, in distributing our ornament, there must never be any sense of gap or blank, neither any

sense of there being a single member, or fragment of a member, which could be spared. ... And, on the other hand, care must be taken either to diffuse the ornament which we permit, in due relation over the whole building, or so to concentrate it, as never to leave a sense of its having got into knots, and curdled upon some points, and left the rest of the building whey. ... The evil is when, without system, and without preference of the nobler members, the ornament alternates between sickly luxuriance and sudden blankness.(9.307–08)

A particularly glaring example of this evil is, in Ruskin's view, perpetrated by the designer of Constitution Arch at Green Park in London (ill. 45). The rectangle filled with carving in the side wall attracts his wrathful attention:

... the richness of the ornament is a mere patch and eruption upon the wall, and one hardly knows whether to be most irritated at the affectation of severity in the rest, or at the vain luxuriance of the dissolute parallelogram.(9.308)

Ruskin is often inclined, in analysing the subdivision of the chief masses of a building by ornament, to consider the architect's problems in relation to those of a painter:

... the principles on which this division is to be made, are, as regards relation of quantities, the same in architecture as in painting, or indeed in any other art whatsoever, only the painter is by his varied subject partly permitted, partly compelled, to dispense with the symmetry of architectural light and shade, and to adopt arrangements apparently free and accidental. So that in modes of grouping there is much difference (though no opposition) between the two arts; but in rules of quantity, both are alike.(8.115)

This is another statement of Ruskin's notion that architecture is neither more nor less concerned with proportion than is any other art. However, the architect, 'not being able to secure always the same depth or decision of shadow', is 'compelled to make many allowances, and avail himself of many contrivances, which the painter needs neither consider nor employ'. In subdividing his composition,

positive shade is a more necessary and more sublime thing in an architect's hands than in a painter's. For the latter being able to temper his light with an undertone throughout, and to make it delightful with sweet colour, or awful with lurid colour ... can deal with an enormous, nay, almost with an universal, extent of it ... but as light, with the architect, is nearly always liable to become full and untempered sunshine seen upon solid surface, his only rests, and his chief means of sublimity, are definite shades.(8.116)

Hence Ruskin's preoccupation with the design of shadow-casting ornament such as cornices, mouldings, and the offset columns of façades such as that of St Mark's. The architect must become used to 'thinking in shadow, not looking at a design in its miserable liny skeleton; but conceiving it as it will be when the dawn lights it, and the dusk leaves it'. The 'paper lines and proportions' of his competition drawings 'are of no value: all that he has to do must be done by spaces of light and darkness'(8.117). The overriding consideration, in disposing shadow-casting ornament, is that

the quantities of shade or light ... shall be thrown into masses, either of something like equal weight, or else large masses of the one relieved with small of the other; but masses of one or other kind there

must be. . . . This great law respecting breadth, [is] precisely the same in architecture and painting. . . .(8.117–18)

The distant effects of mouldings and other ornaments that create shadow (ill. 46) are often discussed as if they were the pencil strokes of a drawing. In some notes preserved at Yale, for example, Ruskin stresses

how much the picturesque effect of early work depended on the tracing of lines upon its surfaces. . . . Now there are of course two modes of tracing a surface line in distant effect. The one by the raising or sinking of a continuous ridge or hollow, which shall produce a line of continuous shade. The other by a succession of points of shade, obtained either by bosses or hollows.[1]

The role played by details such as crockets and finials is closely analogous to that of highlighting touches in painting, and subject to similar abuse:

Stone finials and crockets are, I think, to be considered in architecture, what points and flashes of light are in the colour of painting, or of nature. There are some landscapes whose best character is sparkling. . . . And there are colourists who can keep their quiet in the midst of a jewellery of light; but, for the most part, it is better to avoid breaking up either lines or masses by too many points, and to make the few points used exceedingly precious. So the best crockets and finials are set, like stars, along the lines, and at the points, which they adorn, with considerable intervals between them, and exquisite delicacy and fancy of sculpture in their own designs; if very small, they may become more frequent, and describe lines by a chain of points; but their whole value is lost if they are gathered into bunches or clustered into tassels and knots; and an over indulgence in them always marks lowness of school.(9.403–04)

The distant effect of the Gothic ball-flower (ill. 46) is discussed in similar terms:

The value of this ornament is chiefly in the *spotted* character which it gives to the lines of mouldings seen from a distance. It is very rich and delightful when not used in excess; but it would satiate and weary the eye if it were ever used in general architecture. The spire of Salisbury, and of St Mary's at Oxford, are agreeable as isolated masses; but if an entire street were built with this spotty decoration at every casement, we could not traverse it to the end without disgust. It is only another example of the constant aim at piquancy of effect which characterised the Northern builders; an ingenious but some-

46 Ruskin *St Mary's Tower and All Souls College, Oxford* 1835 or 1836

47 (*left*) Ruskin *St Wulfran,
Abbeville : detail of tower*

48 (*right*) Ruskin *Market Place,
Abbeville* 1868 (detail)

what vulgar effort to give interest to their grey masses of coarse
stone, without overtaxing their powers either of invention or
execution.(9.332)

The management of battlements involves even greater visual
tact, and a keen sense of composition in light and shade. At a
distance, the battlement's 'jagged outline dovetails the shadow
of the slated or leaded roof into the top of the wall', and is a
useful expedient 'where the expense of a pierced parapet cannot
be encountered'. Nonetheless, the battlement presents special
problems of design, and must be carefully subordinated to its
visual context:

remember always, that the value of the battlement consists in its
letting shadow into the light of the wall, or *vice versâ*, when it comes
against light sky, letting the light of the sky into the shade of the wall;
but that the actual outline of the parapet itself, if the eye be arrested
upon this, instead of upon the alteration of shadow, is as *ugly* a
succession of line as can by any possibility be invented. Therefore, the
battlemented parapet may only be used where this alteration of shade
is certain to be shown, under nearly all conditions of effect; and where
the lines to be dealt with are on a scale which may admit battlements
of bold and manly size. The idea that a battlement is an ornament
anywhere, and that a miserable and diminutive imitation of

94

castellated outline will always serve to fill up blanks and Gothicise unmanageable spaces, is one of the great idiocies of the present day.(9.198–99)

Countless Gothic Revival buildings are of course condemned by this latter observation. Attempts to medievalize walls, houses, college gatehouses, and so on, by the addition of minute battlements arouse Ruskin's amused contempt. Such expedients are illustrative of the concept of ornament, as something that can be arbitrarily pinned onto a composition, which he found so objectionable in many of the architects of his day:

To crown a turret six feet high with chopped battlements three inches wide, is children's Gothic . . . and in the present day the practice may be classed as one which distinguishes the architects of whom there is no hope, who have neither eye nor head for their work, and who must pass their lives in vain struggles against the refractory lines of their own buildings.(9.199)[2]

In the hands of a master designer, however, every small and seemingly insignificant detail is integrated in the larger scheme. For instance, an apparent anomaly in the composition of the towers of St Wulfran in Abbeville intrigues Ruskin as a unique method of overcoming the 'general difficulty of managing even

49 *Chambéry Cathedral: west front*

lateral division, when it is into two equal parts, unless there be some third reconciling member'. The details in question, seen close, are given in Ruskin's sketch (ill. 47):

Vexed by the want of unity between his two windows, he literally laid their heads together, and so distorted their ogee curves, as to leave only one of the trefoiled panels above, on the inner side, and three on the outer side of each arch.

While this irregularity is glaringly evident at close range, its association 'with the various undulation of flamboyant curves below' when it is seen at greater distance (ill. 48), ensures that 'it is in the real tower hardly observed, while it binds it into one mass in general effect'(8.210–11).

In contrast, the façade of the cathedral of Chambéry illustrates, in Ruskin's eyes, a disjointed and ineffectual use of ornament, characterized in a diary entry for 1846 as 'Decoration without unity'. He describes the façade (ills 49 and 50) as

remarkable for its hard, square, valueless mouldings and for the general awkwardness of all its forms. The carving, though somewhat too close and knotty, is deeply undercut, and good, but it is put in narrow cords on broad bare mouldings, and so is rather hurtful than

96

50 *Chambéry Cathedral: detail of west portal*

otherwise. A line of trefoiled foliation runs round the entrance door, but precisely in the place where it is most ineffective, that is to say nearly in the middle of its meagre mouldings, which have no columns nor capitals, but have continuous imposts, the foliation beginning abruptly and unexpectedly at the point; and so looks like a piece of pasteboard ornament stuck on. There are no traces of ornament in the blank triangular space, now painted, below, but the two little doors underneath are flat headed, or nearly so . . . the barbarous intersection of the curved by the horizontal moulding is especially painful. The rest of the detail, though not altogether so vicious, is entirely mindless, barred, ponderous, ill put together, and exactly like – even to some of the minutiae of design – that which I used to draw in the blank leaves of Arist[otle's] *Rhetoric*.[3]

Detail which appears to be 'stuck on' is, of course, totally incompatible with Ruskin's criteria for good ornamentation. His distaste for ornament which alternates between 'sickly luxuriance and sudden blankness' is, moreover, aroused by various features of this façade. A particularly unfortunate 'barbarism', he writes, is 'the imposition of the rich bracket abruptly on the meagre moulding'.[4]

More surprising, perhaps, is Ruskin's reaction to the façade of Amiens Cathedral (ill. 51), which he describes in his diary

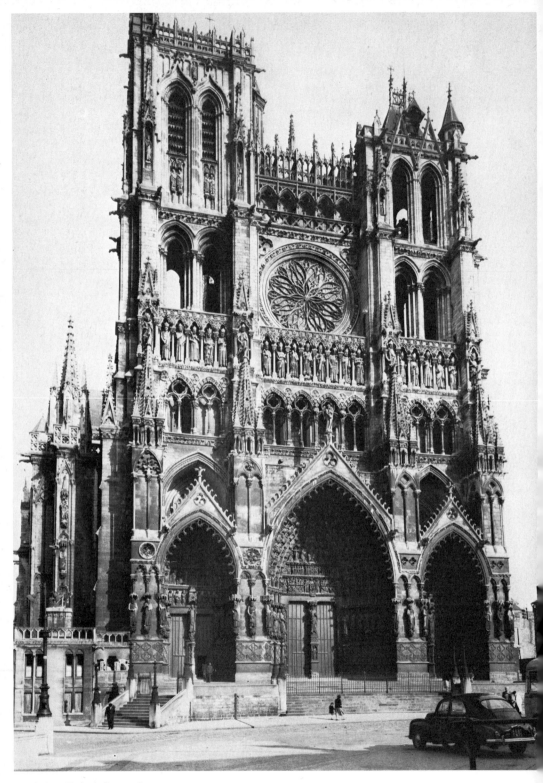

51 *Amiens Cathedral: west front*

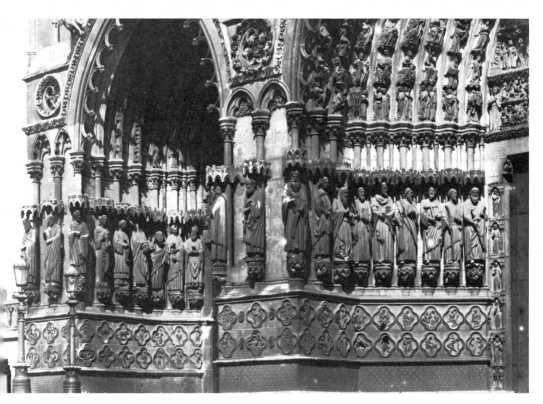

52 *Amiens Cathedral: west front: detail of northern lateral and central porches*

for 1844 as 'disjointed', 'incongruous' and 'coarse in detail'. The subdivision of the chief masses by ornamental lines and forms is, in his view, often chaotic:

The delicate, flamboyant rose in the middle, opposed to violent lines of right angles, with the trefoil altogether circular, and these again contradicted by scaly square pinnacles; while over the portals appear segments of undecorated useless and half seen arches, as if the gates had been begun too high by mistake. The columns which support the porches would be fine, were it not that they are interrupted . . . by niches and figures, of the coarsest kind, which ought to have been *between* the columns by rights, but form, instead, a portion of them.[5]

The vehemence of this youthful outburst is slightly moderated in another entry made five years later, but Ruskin still dislikes the interruption of columns by figures on the porches (ill. 52):

The figures generally conceal, or even occupy the place of the main shaft; but wherever their drapery or forms give place or opening, the shaft is seen fully and finely executed behind. The arrangement is decidedly a barbarous one, for the column, at a distance, looks cut

away; and near, the niche seems stuck against it like a clay bird's nest. Those at the outer angles, where the shaft stands clear of the wall and the long niche runs out to it like a beam of a scaffolding, [are] especially painful. . . .[6]

These objections may surprise readers familiar with Ruskin's praise of Gothic 'Savageness' in 'The Nature of Gothic' (*Stones of Venice*, vol. II). They are not, however, inconsistent with the overall tenor of his remarks in *The Seven Lamps* and the first volume of *The Stones of Venice* about what good ornament should achieve. The opposition of the delicate rose window by hard right-angles, the blurting up of the arch fragments behind the lateral porches, may well seem inharmonious to an eye attuned to the elegance of Giotto's campanile or the Doge's Palace. Some other disapproving comments about the façade of Amiens are also in keeping with his general criteria for good ornamentation. Besides the arbitrariness with which the niches and sculptured figures break the lines of the porch columns, many smaller details offend against his demand that ornament should never appear to be added as an afterthought. Among other details which have a 'confectionery-like aspect', the 'crockets of the gables . . . are what may be generally described as twitched crockets, which look as if they had been knocked or pulled up from the edge – as a cook pinches paste'.[7]

Examining the interior at Amiens, Ruskin finds further grounds for dissatisfaction. The subdivision of the roof by the vaulting ribs comprises too skimpy a pattern to satisfy his eye:

there are not lines enough in the Amiens roof: it wants infinity; the eye is not embarrassed or lost in its height, but rather stops blankly at its blank, flat, conspicuous masonry . . . and one feels as if one were built in, or fastened down in a vault. In this respect, the richer tracery roofs are far better, as confusing the eye and losing themselves in height.[8]

Ruskin's requirement that 'there must never be any sense of gap or blank' (9.307) in the distribution of ornament is in his opinion left unfulfilled by the vaulting at Amiens. The same consideration helps explain his feeling that the apse of Chartres Cathedral is seriously impaired by the lack of tracery in its windows. As it stands, the apse has, he remarks, a meagre look, with the windows reminding him of 'carving knives'.[9]

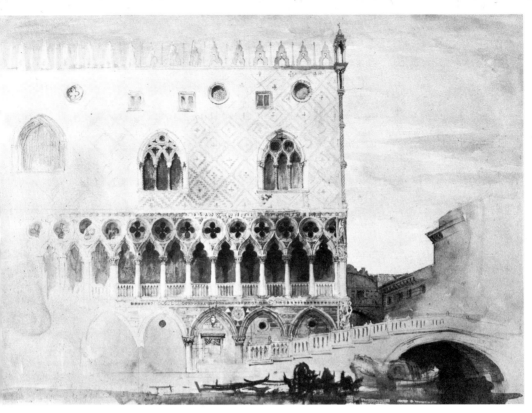

53 Ruskin *View of the Doge's Palace, Venice, taken from the water* 1852

The potency of ornamental detail in determining distant effect is further illustrated in several comments made by Ruskin about the Doge's Palace in Venice (ill. 53). Continuing his analysis of the twisted corner shafts of the building (see p. 43), he points out that they are

divided into portions, gradually diminishing in length towards the top, by circular bands or rings, set with the nail-head or dog-tooth ornament, vigorously projecting, and giving the column nearly the aspect of the stalk of a reed; its diminishing proportions being exactly arranged as they are by Nature in all jointed plants. At the top of the palace, like the wheat-stalk branching into the ear of corn, it expands into a small niche with a pointed canopy, which joins with the fantastic parapet in at once relieving, and yet making more notable by its contrast, the weight of massy wall below.(10.280)

This parapet is 'entirely decorative'(9.200), but in Ruskin's sense of the word, for its purpose is, 'by its extreme lightness, to relieve the eye when wearied by the breadth of wall beneath'(10.283). If the reader will cover the twisted corner

shafts, canopy, and parapet in Ruskin's drawing, the justice of his remarks will be immediately apparent. Without these small details, we are looking at an entirely different composition. The rectangular mass of the upper wall, despite its diaper pattern and windows, seems unbearably heavy and crude when thus surmounting the exquisite arcade below.

The reader might next cover on Ruskin's drawing the series of quatrefoils heading the second storey of the façade. No great sensitivity is needed to discern the importance of these penetrations in determining the unique character of the composition. But Ruskin, attempting to explain why the eye is drawn to them so strongly in distant viewing, finds a small detail of their design of special interest:

You may have noticed that the quatrefoil used in the Ducal Palace of Venice owes its complete loveliness in distant effect to the finishing of its cusps. The extremity of the cusp is a mere ball of Istrian marble; and consider how subtle the faculty of sight must be, since it recognizes at any distance, and is gratified by, the mystery of the termination of cusp obtained by the gradated light on the ball.

In that Venetian tracery this simplest element of sculptured form is used sparingly, as the most precious that can be employed to finish the façade.(20.212–13)

Such passages of delicate insight should be kept in mind when one attempts to grasp the truths that might lie behind Ruskin's claim that 'Ornamentation is . . . the principal part of architecture, considered as a subject of fine art.'(12.84) The façade of the Doge's Palace without its stone balls, corner shafts, angle sculpture, parapet, balcony, diaper patterning, mouldings and carved capitals would be a bungling monstrosity. The building as it stands owes its unique loveliness largely to the integrated effect of thousands of tiny details which, according to the notions of many nineteenth-century architects, could be regarded as mere 'additions' to the façade. Ruskin's sensitivity to the effect which ornamental detail has in determining the character of such a composition when seen from a distance justifies his claim that

Greatness can only be rightly estimated when minuteness is justly reverenced. Greatness is the aggregation of minuteness; nor can its sublimity be felt truthfully by any mind unaccustomed to the affectionate watching of what is least.(7.230)

Ornament viewed at intermediate distances

IN DRAWING or analysing architecture, Ruskin works a good deal from what could be regarded as an intermediate viewing position – closer than would be necessary to take in the whole building, or even a large part of it, and further away than would be necessary to focus on its finest ornamental detail. Well over half of the huge plates published in his *Examples of the Architecture of Venice* (1851) represent views taken at this intermediate range, the rest from even closer. Realizing that many of his subscribers had been conditioned by previous architectural publications to expect picturesque views – complete with clouds and circling birds – of whole buildings, he publishes a special warning in the prospectus to the first part of the work:

> In order to prevent future disappointment, MR RUSKIN wishes it especially to be observed that very few of the drawings will be of entire buildings. Nearly all the subjects are *portions* of buildings, drawn with the single purpose of giving perfect examples of their architecture, but not pictorial arrangements.(11.313–14)

There is, in his view, nothing less 'architectural', or more 'ornamental', about the view of the Duomo of Verona given in ill. 2 than in views taken at any other distance. In the nearer views, as at longer range, the observer reacts to the three-dimensional shaping of mass, the proportion of part to part, and the subdivision of larger masses by lines and masses which are – even the smallest of them – to be considered integral parts of the composition. It seemed self-evident to Ruskin that the near views of any building of architectural merit, intended to be approached and entered by human beings, must necessarily be

as important as any other view, and that no special circum-
stances need be cited in justification of close looking. He would
have been puzzled by the comment of a distinguished modern
scholar that the external effect of the apse of the Frari in Venice
is 'extraordinary, especially in the near views, which, in such a
crowded city, are often an important aspect of a building'.[1]

Underlying all Ruskin's analysis and drawing of architecture
at intermediate and close range is a profound respect for the
complexity of the act of seeing:

> there is a continual mystery caused throughout *all* spaces, caused by
> the absolute infinity of things. WE NEVER SEE ANYTHING CLEARLY . . .
> the fact is, that everything we look at, be it large or small, near or
> distant, has an equal quantity of mystery in it; and the only question
> is, not how much mystery there is, but at what part of the object
> mystification begins . . . there is literally *no* point of clear sight, and
> there never can be. What we call seeing a thing clearly, is only seeing
> enough of it to *make out what it is*(6.75–76).

He accordingly approaches even the most insignificant-
seeming detail with a degree of curiosity that often leads to
unexpected insight. His drawings, too, benefit from this respect
for the visual difficulties to be encountered by the artist:

> exactly in proportion to the nobility of any work, is the difficulty of
> conveying a just impression of it. . . . Nothing is so rare in art, as far as
> my own experience goes, as a fair illustration of architecture; *perfect*
> illustration of it does not exist. For all good architecture depends upon
> the adaptation of its chiselling to the effect at a certain distance from
> the eye; and to render the peculiar confusion in the midst of order,
> and uncertainty in the midst of decision, and mystery in the midst of
> trenchant lines, which are the result of distance, together with perfect
> expression of the peculiarities of the design, requires the skill of the
> most admirable artist(10.113–14).

Despite Ruskin's chronic dissatisfaction with his own
drawings, we might consider his depiction of the central porch
of Rouen Cathedral (ill. 54) a rather successful attempt at
overcoming such problems in architectural illustration. This
porch is one that he takes particular delight in studying at
intermediate range. Arguing in *The Seven Lamps* that 'it is one
of the affectations of architects to speak of overcharged
ornament. Ornament cannot be overcharged if it be
good' (8.52), he refers his readers to a sketch (reproduced in

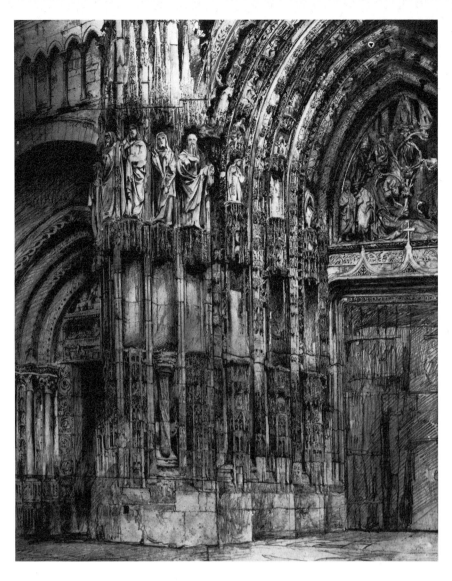

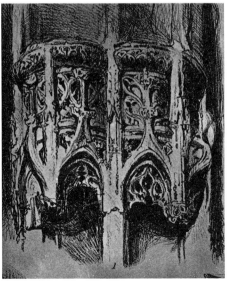

54 Ruskin *Central doorway of west front of Rouen Cathedral*

55 Ruskin *Detail from central doorway of Rouen Cathedral*

ill. 55) of one of the smallest of the niches – scarcely discernible in the finished drawing – which decorate the receding arches of the portal:

There are four strings of these niches (each with two figures beneath it) round the porch, from the ground to the top of the arch, with three intermediate rows of larger niches, far more elaborate; besides the six principal canopies of each outer pier. The total number of the subordinate niches alone, each worked like that in the plate, and each with a different pattern of traceries in each compartment, is one hundred and seventy-six.(8.52)

Ruskin explains in a footnote that though he has 'not examined the seven hundred and four traceries (four to each niche) so as to be sure that none are alike', they 'have the aspect of continual variation, and *even the roses of the pendants of the small groined niche roofs* are all of different patterns', and observes:

Yet in all this ornament there is not one cusp, one finial, that is useless – not a stroke of the chisel is in vain; the grace and luxuriance of it all are visible – sensible rather – even to the uninquiring eye; and all its minuteness does not diminish the majesty, while it increases the mystery, of the noble and unbroken vault.(8.52–53)

Retiring, in imagination, to a distance at which the degree of resolution of fine detail seen in the sketch is replaced by what is seen in the finished drawing, we can understand why this niche, and the composition of which it is a part, satisfy Ruskin's criteria for successful ornamentation. In the close view, even the finest detail of the smallest niche exhibits the continual variation of line which is attainable only in good freehand carving. At greater distance, the tiny details discernible in the sketch have become indistinct, but have grouped themselves into masses which (particularly because of the bold patches of shadow caught under the arches of each niche) constitute a distinct and ordered series of projections, analogous to the 'pleasant projecting masses' which 'delightfully roughen' the surfaces of the porch and wall of San Zeno in Verona(20.215). The fine details of the small niches are now part of that 'peculiar confusion in the midst of order, and uncertainty in the midst of decision, and mystery in the midst of trenchant lines' found in all ornament which, while finely wrought for close observation, is also designed with a view to its more distant effect as part of a larger scheme. At the distance from which Ruskin's

finished drawing is taken, the small niches add interest to, but do not destroy the flow of, the lines of the arches they occupy. Similarly, Ruskin notes, the 'feeling of breadth' is retained in the larger elements seen in his drawing:

in the more elaborate [niches] there are four projecting sides, divided by buttresses into eight rounded compartments of tracery; even the whole bulk of the outer pier is treated with the same feeling; and though composed partly of concave recesses, partly of square shafts, partly of statues and tabernacle work, arranges itself as a whole into one richly rounded tower.(8.123)

The enrichment provided by the niches, pedestals and statues is of course indispensable to the aesthetic success of this doorway. Obliterate such detail mentally from Ruskin's drawing, and little remains but an uninteresting succession of arches. Pierre Lavedan's claim that 'Flamboyant Gothic is one of those periods in which the decorators had their revenge on the architects'[2] – characteristic of an approach which assumes that the two are distinct – is seen to be inappropriate when applied to this masterpiece at Rouen.

The disposition of the columns of the façade of St Mark's in Venice is also of great interest to Ruskin as a study in ornamentation. In numerous notebook entries and diagrams, he studies the irregularity of their superimposition, which is even more remarkable than that of the decorative arcades at Pisa and Pistoia. The virtual impossibility of obtaining perfectly matching columns from a selection of spoils left the designers, according to Ruskin, with the choice of either reducing the larger to the size of the smallest in any group, or of accommodating the ornamental scheme to the columns as they were. The latter alternative was chosen, and the result is an asymmetry and continuous variation which makes for a composition of the greatest visual complexity. Having measured the height and diameter of every column on the façade, Ruskin remarks:

It has just been stated that the upper range is about two thirds of the height of the lower [ill. 56]. The fact is that the proportions are continually varying – for though the architrave & plinths are always at the same height, the shafts – being as above noticed – sorted out of a miscellaneous mass, by no means match each other, and their differences are accommodated by the help of the goodnatured capitals

56 *St Mark's, Venice: central doorway of west front*

& bases – which stretch or shorten themselves as need may be. But this very difference of size only delights the architect the more by enabling him to confuse the eye among changing proportions.[3]

In a scheme where almost every column, base or capital is of different dimensions from its neighbour, the kind of symmetry obtainable in any grouping of columns (ills 56, 57, 58) is

never altogether perfect, and dependent for its charm frequently on strange complexities and unexpected rising and falling of weight and accent in its marble syllables: bearing the same relation to a rigidly chiselled and proportioned architecture that the wild lyric rhythm of Aeschylus or Pindar bears to the finished measures of Pope.(10.104)

Exciting as all this is to Ruskin, he is even more impressed by the three-dimensional modelling of the façade which the skilful disposition of these columns has made possible. By placing the columns within three or four inches of the wall, the designer has created a remarkable chiaroscuro effect (ills 1, 11, 56, 57):

When there is much vacant space left behind a pillar, the shade against which it is relieved is comparatively indefinite, the eye passes by the shaft, and penetrates into the vacancy. But when a broad surface of wall is brought near the shaft, its own shadow is, in almost every effect

57 Ruskin *Archivolt in St Mark's c.* 1851

58 Ruskin *Drawing of north-west porch of St Mark's* 1879

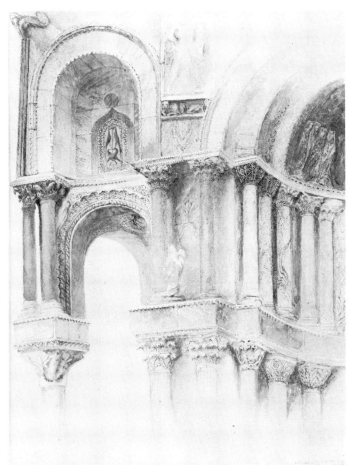

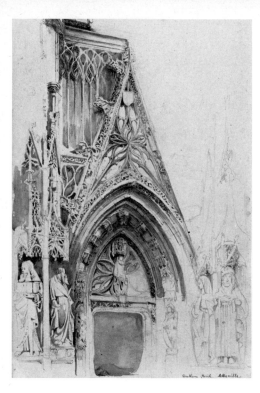

59 (*left*) Ruskin *Southern Porch of
St Wulfran, Abbeville* 1848

60 (*right*) Ruskin *Detail of St Sauveur,
Caen* 1848

61 (*far right*) Ruskin *Part of St Lô
Cathedral* 1848

of sunshine, so sharp and dark as to throw out its colours with the highest possible brilliancy; if there be no sunshine, the wall veil is subdued and varied by the most subtle gradations of delicate half shadow, hardly less advantageous to the shaft which it relieves. And, as far as regards pure effect in open air . . . I do not know anything whatsoever in the whole compass of the European architecture I have seen, which can for a moment be compared with the quaint shade and delicate colour, like that of Rembrandt and Paul Veronese united, which the sun brings out as his rays move from porch to porch along the St Mark's façade.(10.449)

These remarks are relegated to an appendix to *The Stones of Venice*. It should perhaps be noted that one leading modern authority on St Mark's agrees closely (though without giving as precise a visual explanation as Ruskin's) with this assessment of the role of the columns in creating the unique optical effect of the façade.[4]

Though it is obtained by very different methods from those employed at St Mark's, the masterly chiaroscuro of much Flamboyant architecture is equally interesting to Ruskin as a study of ornamentation at intermediate distance. A large number of drawings made in 1848 of such buildings as St Wulfran in Abbeville (ill. 59),[5] St Sauveur in Caen (ill. 60) and

the cathedral of St Lô (ill. 61) record with sensitivity his delighted perception of the designers' skilful exploitation of their building materials:

All flamboyant architecture is essentially chalk architecture, – it is built of some light, soft, greasy stone, which you can cut like cheese, which you can drive a furrow into with your chisel an inch deep, as a ploughman furrows his field. Well, of course, with this sort of stuff the workman goes instinctively in for deep cutting; he *can* cut deep, – and he does cut deep; – and he can cut fast, and he does cut fast; – and he can cut fantastically, – and he goes in for fancy. What is more, the white surface itself has no preciousness in it, but it becomes piquant when opposed with black shadow, and this flamboyant chiselling is therefore exactly, compared to a fine sculpture, what a Prout sketch is to a painting: – black and white, – against gentle and true colour.(19.251)

Ruskin admires the designers' 'facility of obtaining contrast of black space, undercut, with white tracery easily left in sweeping and interwoven rods', their 'studiously graceful disposition of the masses of light and shade'(20.313). But he is especially impressed by the manner in which the Flamboyant architects 'reduced the massive roll mouldings of the early Gothic to a

series of recesses, separated by bars of light', for calculated aesthetic reasons:

it was not in mere wanton indulgence of their love of shade that the Flamboyant builders deepened the furrows of their mouldings; they had found a means of decorating those furrows as rich as it was expressive, and the entire framework of their architecture was designed with a view to the effect of this decoration. . . .

It is, in fact, an ornament formed by the ghosts or anatomies of the old shafts, left in the furrows which had taken their place. Every here and there, a fragment of a roll or shaft is left in the recess or furrow; – a billet-moulding on a huge scale, but a billet-moulding reduced to a skeleton; for the fragments of roll are cut hollow, and worked into mere entanglement of stony fibres, with the gloom of the recess shown through them. These ghost rolls, forming sometimes pedestals, sometimes canopies, sometimes covering the whole recess with an arch of tracery, beneath which it runs like a tunnel, are the peculiar decorations of the Flamboyant Gothic.(9.329–30)

The central doorway of Rouen Cathedral furnishes many examples of the 'ghost roll' carved into the form of a pedestal or niche (ill. 54), while the southern porch of St Wulfran (ill. 59) and the windows of St Sauveur (ill. 60) exemplify the covering of the whole recess with an arch of tracery. In their disposition of such ornament, the designers have, according to Ruskin, 'a knowledge of effect which is quite consummate, and I know nothing in the whole range of art in which the touch is so exquisitely measured to its distance as in this flamboyant. Not one accent is ever lost, – it looks equally fine all over'(19.252).

Much of Ruskin's study of ornament at intermediate distances is concerned with the question of whether or not a particular detail contributes to the harmony of the composition of which it is a part. He admires, for example, the skill with which the designer of the gable of the southern porch of St Wulfran (ill. 59) modifies its upper angle by means of an apparently insignificant detail:

The chief difficulty in treating a gable lies in the excessive sharpness of its upper point. It may indeed, on its outside apex, receive a finial; but the meeting of the inside lines of its terminal mouldings is necessarily both harsh and conspicuous, unless artificially concealed. The most beautiful victory I have ever seen obtained over this difficulty was by placing a sharp shield, its point, as usual, downwards, at the apex of the gable, which exactly reversed the offensive lines, yet without

62 *Pembroke College, Oxford: Master's Lodging from the east*

actually breaking them; the gable being completed behind the shield.(9.353)

Elsewhere he expands on this analysis of the shield's visual function. It is introduced, he claims, 'to stay the eye in its ascent, and to keep it from being offended by the sharp point of the gable, the reversed angle of the shield being so energetic as completely to balance the upward tendency of the great convergent lines.'(10.263) The lines introduced by a minor detail are here of great significance in securing harmonious composition.

In contrast, Ruskin strongly dislikes a particular detail which is almost ubiquitous in the colleges of Oxford and Cambridge (ill. 62) and which is also much in evidence in institutional Gothic Revival:

One of the worst enemies of modern Gothic architecture, though seemingly an unimportant feature, is . . . the dripstone in the shape of the handle of a chest of drawers, which is used over the square-headed windows of what we call Elizabethan buildings. . . . If you break upon your terminal square, or if you cut its lines off at the top and turn them

outwards, you have lost its unity and space. It is an including form no longer, but an added, isolated line, and the ugliest possible. Look abroad into the landscape, and see if you can discover any one so bent and fragmentary as that of this strange windlass-looking dripstone. You cannot. It is a monster. It unites every element of ugliness, its line is harshly broken in itself, and unconnected with every other; it has no harmony either with structure or decoration, it has no architectural support, it looks glued to the wall, and the only pleasant property it has, is the appearance of some likelihood of its dropping off.(8.153–54)

Another feature which exhibits this fatal flaw of looking 'glued on' is the arrangement, common in Palladian buildings, consisting of 'two half-capitals glued, as it were, against the slippery round sides of the central shaft'(11.46; see 9.179, fig. 36c). The 'ungracefulness' of this arrangement is, according to Ruskin, 'never conquered in any Palladian work'(11.46).

Similar disunity in composition can easily occur in the arrangement of Gothic piers. The architect, says Ruskin,

must never multiply shafts without visible cause in the disposition of members superimposed: and in his multiplied group he should, if possible, avoid a marked separation between the large central shaft and its satellites; for if this exist, the satellites will either appear useless altogether, or else, which is worse, they will look as if they were meant to keep the central shaft together by wiring or caging it in; like iron rods set round a supple cylinder, – a fatal fault in the piers of Westminster Abbey(9.125–26).

The sub-shafts of these piers (ill. 63) are, in other words, bad ornamentation,[6] and as excrescential to the composition of which they are a part as the Elizabethan dripstone castigated above. But not only do they lack visual integration with the main shafts; these sub-shafts are themselves subdivided by stone rings which Ruskin considers ill-conceived as ornament. The rings,

occurring, as they do in the shafts of Westminster, in the middle of continuous lines ... are but sorry make-shifts, and of late, since gas has been invented, have become especially offensive from their unlucky resemblance to the joints of gas-pipes, or common water-pipes. There are two leaden ones, for instance, on the left hand as one enters the abbey at Poet's Corner, with their solderings and funnels looking exactly like rings and capitals, and most disrespectfully mimicking the shafts of the abbey, inside.(9.128)

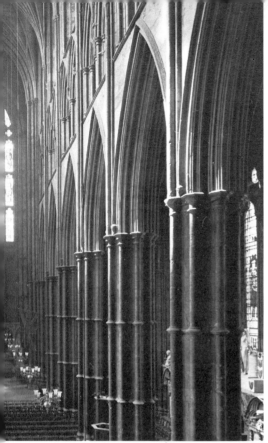
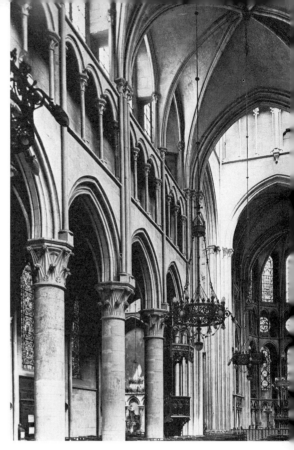

63 *Westminster Abbey: nave, looking west* 64 *Notre-Dame, Dijon: interior looking east*

In a notebook entry Ruskin criticizes the vaulting shafts of Notre-Dame in Dijon (ill. 64) for what he considers a flagrant lack of integration of their lines in the composition of which they are a part:

The Piers of Nave are circular, with octagonal capitals; carrying on their projecting edges, as a man carries a ladder on his nose, the usual square ugly bases of the vaulting shafts. Alternately three and one. Evidently, did these shafts bear any weight they would break the edge off the capital that carries them; they are visibly excrescences: and worse than this, in their excessive slenderness contrasted with the weight of the main pier, they utterly violate all idea of proportion, looking like a bundle of sticks balanced on a log. . . .[7]

Whereas the details singled out for criticism at Westminster and Dijon disrupt the compositions of which they are parts, the effective laying out of ornamental mass and line in the nave of Bayeux Cathedral (ill. 65) helps the architect achieve visual

harmony under difficult conditions of design. We have already noted Ruskin's suspicion of arrangements exhibiting equal, or nearly equal, vertical subdivision:

the nave of Bayeux is the first instance I have ever seen of a double division in height without loss. This is owing first to the peculiar opposition between the Norman base, and early English [Gothic] clerestory – the one of which is a kind of foundation for, rather than division of, the other; and secondly, to the exquisite proportions of the vaulting. . . . But the great beauty of all is in the noble clerestory windows. They are double, having an inner and entirely detached framework of correspondent tracery – or rather – pierced arches: wherein, as at Coutances, a trefoil is used for a quatfoil [*sic*] between the lancets. It would take much time to get their pure and simple cylindrical mouldings accurately, but by their slenderness and grandeur united they quite conquer the division of height – and draw the eye to their beautiful heads, and to the intermediate vaulting.[8]

Without the help of the mouldings and the lines of the clerestory windows themselves, in drawing the eye upward as described by Ruskin, this harmonious bay design would disintegrate.

 The examples cited up to this point have all dealt with parts of well-known and more or less complete buildings. But Ruskin has a peculiar fondness for mere bits and pieces of design that interest him at intermediate or close range, even though they occur in buildings of little apparent architectural interest. Few observers, for example, would find anything worthy of notice in the small trio of medieval windows preserved in a nondescript house near the Frari in Venice (ill. 66). Ruskin, however, has it engraved for readers of *The Stones of Venice*, praising the 'excessive purity of curve' employed in its composition (10.310). A notebook entry shows him trying to account to himself in more detail for the visual delight he takes in the windows:

they are remarkable first for their general rough chiselling, which I hitherto thought always a sign of recent work. Secondly, for the curious drawing of their moulding; not only is it not true to a circular segment – it really waves as it goes round: and finally bends into a slight horseshoe form. . . . In dark weather, nothing can be more lovely than these windows; their dentils stand out like a chain of silver (shown the more by the flat instead of the cavetto beside them. The usual cavetto much destroys the effect of the dentil.) Their rare and

simple moulding leaves a deep shade within; their cusps are of exquisite grace in their flow; their slender shafts detached half a foot from the recessed window; and their arches look from below nearly pure points – just crisped at the extremities into the ogee.[9]

In a perfect building, designed according to Ruskin's ideal of an 'arborescent' composition, such niceties of arrangement would be comprehended harmoniously within an all-embracing ornamental scheme. (See pp. 66–69.) But he is unwilling to sacrifice the pleasure of looking at this fragment from, say, thirty feet, to his theoretical notion that the whole building should be pleasing from a hundred. As always, visual response takes precedence over abstract dogma, and his notebooks and publications are full of drawings and studies of such fragments, considered from a distance at which they dominate the observer's visual field. This interest in fragments is no doubt partially responsible for the persistence of the myth that Ruskin 'ignores architectural contexts, focusing instead on isolated decorations'.[10] Where the architectural context is uninteresting – as in the case of the trio of windows praised above – he is sensible enough to ignore it.

118

CHAPTER SEVEN

Ornament viewed at close range

As HE approaches to within a few feet of a fine medieval or early Renaissance building, Ruskin's visual appetite seems to grow. Lingering for hours in front of features that most observers pass with a glance, he delights in drawing, measuring, and describing in words the minutest detail of the building's ornamental scheme. For in observing architecture of the kind he likes at close range, Ruskin finds, in its most intimately accessible form, his ideal of

art which proceeds from an individual mind, working through instruments which assist, but do not supersede, the muscular action of the human hand, upon the materials which most tenderly receive, and most securely retain, the impressions of such human labour.(9.456)

His own visual presuppositions, and the training of eyesight and hand that go into the creation of drawings such as that reproduced in ill. 3, are indicated in the warning he delivers in 1872 to a group of beginner drawing students at Oxford:

Our first work ... is to learn how to draw an outline; and this, perhaps, you fancy will be easy, at least when you have only to draw a little thing like that Alpine Narcissus.

It is just as difficult, nevertheless – (and you had better begin discouraged by knowing this, than fall into discouragement by discovering it) – it is as difficult to outline one of these Narcissus petals as to outline a beautiful ship; and as difficult to outline the Narcissus cup as a Greek vase; and as difficult to outline the Narcissus stalk as a pillar of the Parthenon.

You will have to practise for months before you can even approximately outline any one of them.

And this practice must be of two kinds, not only distinct, but opposite; each aiding, by correcting and counterbalancing, the other.

One kind of practice must have for its object the making you sensitive to symmetry, and precise in mathematical measurement. The other kind of practice, and chief one, is to make you sensitive to the change and grace by which Nature makes all beauty immeasurable. . . . And while every leaf and flower is governed by a symmetry and ordinance of growth which you must be taught instantly to discern, much more must you be taught that it obeys that ordinance with voluntary grace, and never without lovely and vital transgression.(21.237–38)

Such variation from mechanical precision is as evident to Ruskin in the tiniest details of good ornament as in the disposition of the arcades at Pisa. It is not snobbery that leads him to detest the kind of 'ornament' featured in manuals for design such as Pugin's *Floriated Ornament* (ill. 67).[1] The kaleidoscopic regularity of such patterns runs counter to Ruskin's deepest aesthetic instincts: 'whatever can be done by machinery, or imitated by formula, is not worth doing or imitating at all.'(6.334) Pugin's vegetal snowflakes exemplify that mechanical parody of natural forms and medieval ornament which Ruskin dislikes in much Gothic Revival design and so-called restoration. He demands of ornament, as of every other aspect of architectural design, continuous evidence of thoughtfulness and feeling on the part of its creator:

it requires a strong effort of common sense to shake ourselves quit of all that we have been taught for the last two centuries, and wake to the perception of a truth just as simple and certain as it is new: that great art, whether expressing itself in words, colours, or stones, does *not* say the same thing over and over again; that the merit of architectural, as of every other art, consists in its saying new and different things; that to repeat itself is no more a characteristic of genius in marble than it is of genius in print(10.206).

Ornamental foliage is particularly vulnerable to the regimentation by compass, ruler and formula carried out by Pugin and lesser Victorians in their manuals of design. Ruskin's constant plea to them is that 'As natural form is varied, so must beautiful ornament be varied. You are not an artist by reproving nature into deathful sameness, but by animating your copy of her into vital variation'(23.105). The fact that many

67 Plate XXI from A. W. N. Pugin's
Floriated Ornament 1849

Victorians (and moderns?) are charmed by Pugin's symmetrical patterns would not be at all surprising to Ruskin, who has his own explanation for such a reaction:

In vulgar ornamentation, entirely rigid laws of line are always observed; and the common Greek honeysuckle and other such formalisms are attractive to uneducated eyes, owing to their manifest compliance with the first conditions of unity and symmetry; being to really noble ornamentation what the sing-song of a bad reader of poetry, laying regular emphasis on every required syllable of every foot, is to the varied, irregular, unexpected, inimitable cadence of the voice of a person of sense and feeling reciting the same lines, – not incognizant of the rhythm, but delicately bending it to the expression of passion, and the natural sequence of the thought.(6.332–33)

'Doggrel ornamentation', he concludes,

can be felt or enjoyed by persons who have been educated without reference to natural forms; their instincts being blunt, and their eyes naturally incapable of perceiving the inflexion of noble curves. But the moment the perceptions have been refined by reference to natural form, the eye requires perpetual variation and transgression of the formal law.(6.333)

The idea that good ornament could be either drawn or cut by machine is of course totally unacceptable to Ruskin: 'in good design all imitation by machinery is impossible. No curve is like another for an instant. . . . A cadence is observed, as in the returning clauses of a beautiful air in music; but every clause has

121

its own change, its own surprises.'(6.333) Commenting in 1877 on the invention of machines which, it was claimed by an excited correspondent, could draw spirals and various other curves which 'had never been drawn with absolute accuracy before', he replies: 'I have no doubt the machines are very ingenious. But they will never draw a snail-shell, nor any other organic form. All beautiful lines are drawn under mathematical laws organically *transgressed*, and nothing can ever draw these but the human hand.'(29.81) In the course of a lesson in drawing a simple snail shell in *Fors Clavigera*, he tells his readers:

As your eyes get accustomed to the freely drawn, unmechanical, immeasurable line, you will be able, if you care about architecture, to know a Greek Ionic volute from a vulgar day-labourer's copy of it – done with compasses and calculations . . . and to laugh at the books of our miserable modern builders, filled with elaborate devices for drawing volutes with bits of circles: – the wretches might as well try to draw the lips of Sir Joshua [Reynolds]'s Circe . . . in that manner.(28.526)

Ruskin's brilliant study of the inflexion of curves may be pursued in the two hundred-odd pages in the fourth volume of *Modern Painters* (especially the chapter on 'Banks') devoted to analysis of the masses and curves associated with various geological formations, the analyses of leaf and stem curvature in the fifth volume of the same work, and the sections dealing with the composition of curves in *The Elements of Drawing* and *The Laws of Fésole*.

It is not surprising that, attuned as he is to looking for the minutest inflexions of curvature in natural forms, Ruskin should also be drawn to ornament which manifests similar subtlety of composition. The harshness of his comparison between the ornament of medieval and nineteenth-century Gothic is based on reasoned visual considerations. Confronting readers of *The Stones of Venice* with a mischievous sketch of what is almost certainly a section of the panelling of the Houses of Parliament (ill. 68), he remarks that

a builder without imagination at all, or any other faculty of design, can produce some effect upon the mass of his work by merely covering it with foolish foliation. Throw any number of crossing lines together at random . . . and fill all their squares and oblong openings with quatrefoils and cinquefoils, and you will immediately

68 Ruskin *Sketch of 'foolish foliation'*

69 Ruskin *Detail of a pinnacle of a tomb in Verona*

have what will stand, with most people, for very satisfactory Gothic. The slightest possible acquaintance with existing forms will enable any architect to vary his patterns of foliation with as much ease as he would those of a kaleidoscope, and to produce a building which the present European public will think magnificent, though there may not be, from foundation to coping, one ray of invention, or any other intellectual merit, in the whole mass of it.(10.260–61)

Another small woodcut (ill. 69) represents the floral ornament of one small pinnacle at Verona:

The leaves are thrown back from the stem with singular grace and freedom, and foreshortened, as if by a skilful painter, in the shallow marble relief. Their arrangement is roughly shown in the little woodcut . . . and if the reader will simply try the experiment for himself, – first, of covering a piece of paper with crossed lines, as if for accounts, and filling all the interstices with any foliation that comes into his head . . . and then, of trying to fill the point of a gable with a piece of leafage like that in [the Veronese example], putting the figure itself aside, – he will presently find that more thought and invention are required to design this single minute pinnacle, than to cover acres of ground with English perpendicular.(10.266)

The reader who conscientiously attempts Ruskin's experiment

will in the process learn something about the grounds for the cowed resentment with which many Victorian architects – tossing off building after building with relentless commercial or religious zeal[2] – regarded their keen-eyed tormentor.

Ruskin's notebooks and publications contain so many discussions of particular ornamental arrangements seen at close range that it would require a separate volume to do them justice. A few examples must suffice to indicate the careful and delighted attention he expends on work that invites close scrutiny.

Ills 70 and 71 reproduce two woodcuts used to illustrate the Edinburgh lectures on architecture. The first indicates roughly the area to be carved on the bottom of one of the pedestal brackets on the façade of Lyons Cathedral. The field to be decorated is about one and a half feet square, and is seen from about three feet as the viewer pauses beneath it. The second shows the sculpture of the top left quadrant of this field:

Now observe, this is *one* of the angles of the bottom of a pedestal, not two feet broad, on the outside of a Gothic building; it contains only one of the four little figures which form those angles; and it shows you the head only of one of the larger figures in the centre. Yet just observe how much design, how much wonderful composition, there is in this mere fragment of a building of the great times; a fragment, literally no larger than a schoolboy could strike off in wantonness with a stick: and yet I cannot tell you how much care has been spent . . . on the design . . . of this minute fragment. You see it is composed of a branch of wild rose, which switches round at the angle, embracing the minute figure of the bishop, and terminates in a spray reaching nearly to the head of the large figure. You will observe how beautifully that figure is thus *pointed to* by the spray of rose, and how all the leaves around it in the same manner are subservient to the grace of its action. Look, if I hide one line, or one rosebud, how the whole is injured, and how much there is to study in the detail of it. Look at this little diamond crown, with a lock of the hair escaping from beneath it; and at the beautiful way in which the tiny leaf at *a*, is set in the angle to prevent its harshness; and having examined this well, consider what a treasure of thought there is in a cathedral front, a hundred feet wide, every inch of which is wrought with sculpture like this!(12.60–62)

While Ruskin can spend hours in sensitive analysis of such intricacies of design (another close study of an even smaller fragment from the north door of Rouen Cathedral in *The Seven*

70 Ruskin *Base of a pedestal bracket on the façade of Lyons Cathedral* 1854

71 Ruskin *Detail of bracket shown in ill. 70*

Lamps so excited Marcel Proust that he made a special journey to see the original),[3] he remains fully aware of such detail as part of an architectural composition:

The question is first to be clearly determined whether the architecture is a frame for the sculpture, or the sculpture an ornament of the architecture. If the latter, then the first office of that sculpture is not to represent the things it imitates, but to gather out of them those arrangements of form which shall be pleasing to the eye in their intended places. So soon as agreeable lines and points of shade have been added to the mouldings which were meagre, or to the lights which were unrelieved, the architectural work of the imitation is accomplished(8.170–71).

It will be recalled that Ruskin's principle of 'arborescence' in ornamentation demands that even when the observer is looking from close range at ornament 'as delicate as the eye can follow', he should find it 'subordinated to a greater, simpler, and more powerful' visual order, and that 'if this subordination be not complete, the ornament is bad'(9.301–02). That Ruskin took this principle seriously is confirmed in countless remarks about individual details. A carving filling a spandrel at Santa Maria della Spina in Pisa, for example, is 'quite exquisite in the architectural subjection of the birds' form to the outline of the shield'(21.273). The vine pattern decorating the archivolt of St Mark's shown in ill. 72 demonstrates 'a studious subjection to architectural purpose'(10.117). The ornamental leafage of the best Venetian Gothic capitals and cornices (10. pl. xx, fig. 12) is to be admired for its 'perfect, pure, unlaboured naturalism'. Yet, despite its 'freshness, elasticity, and softness', this leafage is

72 Ruskin *Archivolt decoration at St Mark's, Venice*

always subordinated to a larger visual scheme, the leaves (ill. 73) exhibiting 'the most noble [because never precise] symmetry and severe reserve, – no running to waste, no loose or experimental lines, no extravagance, and no weakness. Their design is always sternly architectural'(10.432).

Ruskin's remarks about one specific problem of design may help clarify what he means when he talks about the architectural subordination of good ornament. One of the most important functions of the capital and cornice, he feels, is to direct the movement of the eye between different levels of a building. Capitals and cornices should therefore have an appearance of being 'distinctly rooted' in their lower parts, and should appear to 'spring to the top'. This arrangement, he argues,

is constant in all the best cornices and capitals; and it is essential to the expression of the supporting power of both. It is exactly opposed to the system of *running* cornices and *banded* capitals, in which the ornament flows along them horizontally, or is twined round them, as

73 Ruskin *Leafage of medieval cornice* 1851

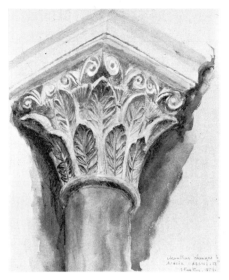

74 *York Minster: vaulting capitals in the south choir aisle*

75 Ruskin *Capital at Assisi* 1874

76 Ruskin *Archway in a street in Assisi* 1874

77 Ruskin *Leafage of a medieval cornice*

the mouldings are in the early English capital, and the foliage in many decorated ones. Such cornices have arisen from a mistaken appliance of the running ornaments, which are proper to archivolts, jambs, etc., to the features which have definite functions of support. A tendril may nobly follow the outline of an arch, but must not creep along a cornice, nor swathe or bandage a capital; it is essential to the expression of these features that their ornament should have an elastic and upward spring; and as the proper profile for the curve is that of a tree bough . . . so the proper arrangement of its farther ornament is that which best expresses rooted and ascendant strength like that of foliage.(9.366)

Failure in this regard is particularly evident to Ruskin in certain English capitals which have often been admired for their naturalistic carving:

the greater mass of the banded capitals are heavy and valueless, mere aggregations of confused sculpture, swathed round the extremity of the shaft, as if one had dipped it into a mass of melted ornament, as the glass-blower does his blow-pipe into the metal, and brought up a quantity adhering glutinously to its extremity. We have many capitals of this kind in England: some of the worst and heaviest in the choir of York.(9.367)

Comparing the two capitals from the south choir aisle of York Minster (ill. 74) with the capital at Assisi sketched by Ruskin in ill. 75 (for a more distant view see ill. 76) and the Venetian cornice in ill. 73, we can readily grasp the point he is making. The York capitals may seem more life-like, but they have a static, bandage-like effect in their linkage of the upper and lower shafts, whereas the other two examples express a rooted and ascendant movement from the lower to the upper members.

The problem of reconciling naturalism of treatment with a proper subordination to architectural context exercises much of Ruskin's attention in analysis of ornamental foliage. Some of his most delicate criticism at close range involves examples in which a subtle compromise has been reached between the two factors. The cornice illustrated in ill. 77, to give one instance, might seem at first glance somewhat lacking in the rooted and springing character which is so obvious in the cornice shown in ill. 73. Ruskin points out, however, that

we may see constant licenses taken by the great designers, and momentary violations . . . which are for our refreshment, and for

increase of delight in the general observance; and this is one of the peculiar beauties of [this] cornice . . . which, rooting itself in strong central clusters, suffers some of its leaves to fall languidly aside, as the drooping outer leaves of a natural cluster do so often; but at the very instant that it does this, in order that it may not lose any of its expression of strength, a fruit-stalk is thrown up above the languid leaves, absolutely vertical, as much stiffer and stronger than the rest of the plant as the falling leaves are weaker. Cover this with your finger, and the cornice falls to pieces, like a bouquet which has been untied.(9.366–67)

It should by now be clear why Ruskin cannot accept that a specifically architectural treatment of ornamental leafage could ever consist of the kind of 'natural leaves and flowers in geometrical forms' which Pugin tells us he has in mind in proposing his *Floriated Ornament* for the architects' consideration and emulation.[4] Since Ruskin believes that the 'especial condition of true ornament is, that it be beautiful in its place, and nowhere else, and that it aid the effect of every portion of the building over which it has influence'(9.284–85), he maintains that ornament must, from the moment of its conception, be subordinated to the particular masses and spaces it modifies. Yet even this subordination must be coaxed from leafage, rather than forced upon it with Draconian geometry:

You must not cut out a branch of hawthorn as it grows, and rule a triangle round it, and suppose that it is then submitted to law. Not a bit of it. It is only put in a cage, and will look as if it must get out, for its life, or wither in the confinement. But the spirit of triangle must be put into the hawthorn. It must suck in isoscelesism with its sap. Thorn and blossom, leaf and spray, must grow with an awful sense of triangular necessity upon them, for the guidance of which they are to be thankful, and to grow all the stronger and more gloriously. And though there may be a transgression here and there, and an adaptation to some other need, or a reaching forth to some other end, greater even than the triangle, yet this liberty is to be always accepted under a solemn sense of special permission; and when the full form is reached and the entire submission expressed, and every blossom has a thrilling sense of its responsibility down into its tiniest stamen, you may take your terminal line away if you will. No need for it any more. The commandment is written on the heart of the thing.(9.305–06)

This is one of many passages on ornament in which Ruskin insists upon the tact with which naturalism and disregard of

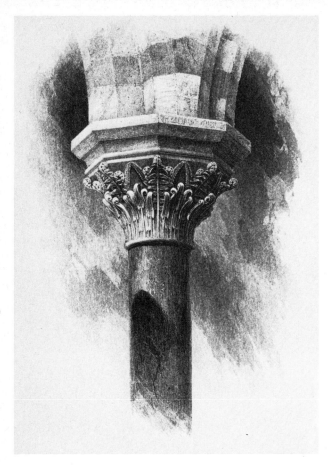

78 (*left*) *British Ferns: capital in the Oxford Museum* 1859

79 (*right*) *Capital in the Oxford Museum*

geometrical precision should be encouraged, yet directed and kept flexibly in check by the demands of architectural context.

His decidedly negative reaction to the capitals of the Oxford Museum should also be judged in the light of his familiarity with medieval design. Referring to the carvings by the Irish sculptor James O'Shea, he tells an Oxford audience in 1877:

in saying that ornament should be founded on natural form, I no more meant that a mason could carve a capital by merely looking at a leaf, than that a painter could paint a Madonna by merely looking at a young lady. And when I said that the workman should be left free to design his work as he went on, I never meant that you could secure a great national monument of art by letting loose the first lively Irishman you could get hold of to do what he liked in it.(22.525)

While the medieval capitals of Venice were 'carved by workmen left free to their work', such freedom was given them only because they had 'observed the traditions of the noblest

130

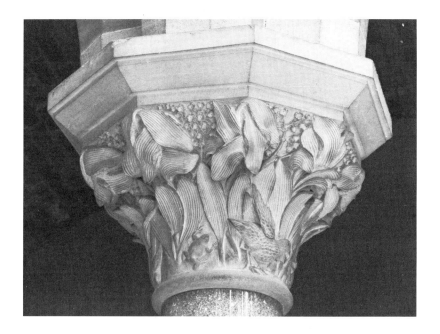

art-race of mankind through the two thousand years of uninterrupted and hereditary toil.'(22.525).

The reader who examines the Museum capitals in the light of Ruskin's analysis of his favourite Italian examples will readily discern a number of the visual considerations which led to his displeasure. Ill. 78 reproduces an engraving of O'Shea's 'British Ferns' capital, used to illustrate the joint publication by Ruskin and H. W. Acland on *The Oxford Museum*, which appeared in 1859. Already at that time, Ruskin is warning publicly that 'beautiful as that capital is . . . it is not yet perfect Gothic sculpture; and it might give rise to dangerous error, if the admiration given to these carvings were unqualified'(16.231).

At least three visual considerations seem important in evaluating this remark. In the first place, the delicate leafage of the O'Shea work does not seem distinctly and powerfully rooted *in* the base of the capital (or, to put it another way, in the head of the column below). While not swathed round the capital as in the York examples cited earlier, this leafage seems rather to be placed delicately against the backing stone than firmly incorporated in it. It looks very much as if, were the ring at the base of the capital to be removed, real British Ferns would come tumbling to the ground. In consequence of this lack of

visual rooting of the leafage in the base of the capital, and the extreme lightness of the leafage itself, the capital lacks that powerful expression of rooted, springing, and supportive strength so admired by Ruskin in examples such as those shown in ills 75, 76 and 80.

Secondly: in his favourite Venetian capitals (see plates vii and viii in the second volume of *The Stones of Venice*), he admires 'the excessive breadth of the masses, however afterwards they may be filled with detail. . . . They are all outlined by grand and simple curves, and . . . the whole of their minute fretwork and thistle-work is cast into a gigantic mould which subdues all their multitudinous points and foldings to its own inevitable dominion'(10.161). The Oxford Museum capital exhibits no such subordination of its finer detail within large and clearly articulated governing masses; the lower half of the capital shows this fault with particular clarity – the individual stems and leaves are spread in unbroken series around the capital.

This lack of subordination of the individual leaves to larger dominating masses gives rise to the third, and in Ruskin's eyes probably most damning, visual characteristic of the Museum

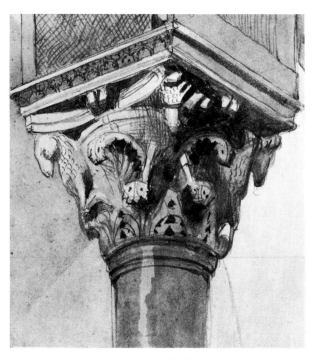

80 Ruskin *Study of a capital in St Mark's*

81 Ruskin *Lily capital of St Mark's* 82 *Capital at Paddington Station, London*

capital. Whereas the Venetian (ills 80 and 44) and Assisi (ills 75 and 76) capitals retain bold articulation and chiaroscuro when seen from a distance at which the fine details of the carving have become invisible, the carving here, even at the range from which it is seen in the engraving, lacks such articulation, and with increasing distance disintegrates into a chaos of small, undifferentiated and unconnected lines.

O'Shea's capital thus fails in carrying out some of the elementary visual duties which Ruskin feels every part of a good design should perform. The naturalism of its leafage (though one suspects Ruskin would have found the disposition of the leaflets rather too symmetrical about their stems) does not compensate for the design's lack of subordination to more important architectural considerations. Ruskin's insistence that 'it requires the powers of the very highest intellect to go on to the perfection of natural truth, and yet retain the melodies and organization of design' in ornamental carving(16.289n.), helps explain his dissatisfaction. The limitations he sees in the British Ferns capital are even more apparent in many other Museum

133

specimens, such as the one reproduced in ill. 79. Ruskin laments that, while O'Shea was 'not only the best, but the only person, who could have done anything of what we wanted to do here . . . he could only have done anything of it, after many years of earnest learning; and he too easily thought, in the pleasure of his first essays, that he had nothing to learn'(22.525).

The lily capitals of St Mark's are among Ruskin's favourites for study at close range (ill. 81; for a more distant view see ill. 11). He considers them to be 'of so great importance', in fact, that in the gigantic plate devoted to them in the *Examples of the Architecture of Venice* (ill. 84) he feels it 'necessary to give their most important features on their actual scale'(11.332). They are 'without exception the most subtle pieces of composition in broad contour which I have ever met with in architecture'(10.164). The 'exquisite refinements of the curves'(9.387) utilized in their design are studied lovingly from every angle, and three profile lines are distinguished as being of special significance: the innermost line of the bell of the capital behind the lily (ill. 83, left, inner line); the line of the profile of the basket work, taken through the side of the capital (left, outer line); and the outer profile of the capital at its angle (right). Ruskin comments:

the reader will easily understand that the passing of the one of these lines into the other is productive of the most exquisite and wonderful series of curvatures possible within such compass, no two views of the capital giving the same contour. Upon these profoundly studied outlines, as remarkable for their grace and complexity as the general mass of the capital is for solid strength and proportion to its necessary service, the braided work is wrought with more than usual care. . . .(10.164)

The pleasure Ruskin derives from careful study of these capitals is manifest in the drawing, as engraved by J. H. Le Keux, which he prepared for *The Stones of Venice* (ill. 81). But he claims that

no amount of illustration or eulogium would be enough to make the reader understand the perfect beauty of the thing itself, as the sun steals from interstice to interstice of its marble veil, and touches with the white lustre of its rays at midday the pointed leaves of its thirsty lilies.(10.165)

Turning with reluctance from this lily capital to the specimen of Victorian ingenuity represented alongside it, we can perhaps

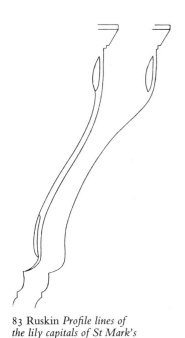

83 Ruskin *Profile lines of the lily capitals of St Mark's*

84 Ruskin *Details of the lily capitals of St Mark's*

share Ruskin's feeling that the 'capitals of the iron shafts in any railway station . . . are things to make a man wish – for shame of his species – that he had been born a dog or a bee'(30.306), or, as he even more despairingly puts it in another outburst, 'a blind fish in Kentucky cave'(34.723). At the close range from which he derives so much delight in study of medieval architecture, an observer with Ruskin's appetite for subtlety of design can indeed have seen little that did not either amuse or irritate him in the vast majority of Victorian buildings. The ornamental detail of a few Gothic Revivalists, especially G. E. Street, seems on occasion to have pleased him(16.462). But the fact that Ruskin, who always draws the things that give him visual pleasure, does not appear to have left a single drawing (other than a parody) of a nineteenth-century building or its detail speaks for itself.

Bored by what he sees at close range in Victorian architecture – there is 'more mind poured out in turning a single angle' of St Mark's 'than would serve to build a modern cathedral'(4.307) – he is appalled by the so-called 'restoration' of medieval detail. In 1877 he writes:

It is impossible for any one to know the horror and contempt with which I regard modern restoration – but it is so great that it simply paralyses me in despair, – and in the sense of such difference in all thought and feeling between me and the people I live in the midst of, almost makes it useless for me to talk to them. Of course all restoration is accursed architect's jobbery, and will go on as long as they can get their filthy bread by such business.(34.531)

In *Mornings in Florence* he advises his readers that when 'Mr Murray's Guide tells you that a *building* has been "magnificently restored," you may pass the building by in resigned despair; for *that* means that every bit of the old sculpture has been destroyed, and modern vulgar copies put up in its place'(23.355). By vulgar copies Ruskin means, of course, mechanically re-gularized parodies of the original freehand work. In 1877 he writes to the *Kidderminster Times* of the 'extreme interest of the old perpendicular traceries in the freehand working of the apertures' at Ribbesford Church and pleads:

Permit me to say, with reference to the proposed restoration of the church, that no modern architect, no mason either, can, or would if they could, 'copy' those traceries. They will assuredly put up with geometrical models in their place, which will be no more like the old traceries than a Kensington paper pattern is like a living flower.(34.532)

Ruskin's diaries record the continual horror with which he contemplates the blighting touch of the prolific restorers of nineteenth-century England and France. Visiting Selby Abbey in 1876, he finds it restored by Gilbert Scott: 'all be-Scottified'.[5] At Vézelay, in 1882, he laments that the 'mimicked "last judgment" over central door – M. V[iollet] le D[uc]'s – is very carefully vile'.[6]
Ruskin's painstaking study at close range of many medieval and early Renaissance buildings had shown him that their detail requires 'as much care in delineation as the petals of a living flower', and that 'these qualities of a building can only be

85 Ruskin *Carved boss from outer central arch of the façade of St Mark's*

known by drawing it'(13.502). Of the little fragment from the outer central arch of St Mark's (ill. 85; located at about the ten o'clock position on the arch as shown in ill. 56), he states that one cannot 'at all know how good it is, unless you will learn to draw'(24.287). Similarly, the interpenetration of mouldings in much flamboyant Gothic exhibits a finesse of touch that is inimitable,

the strangest possible shapes of sections being calculated to a hair's breadth, and the occurrence of the under and emergent forms being rendered, even in places where they are so slight that they can hardly be detected but by the touch. It is impossible to render a very elaborate example of this kind intelligible, without some fifty measured sections(8.95).

All attempts to replace such original work with modern copies are 'more fatal to the monuments they are intended to preserve, than fire, war, or revolution'(12.422).

Ruskin asserts that no one can be a successful designer on a large scale who is incapable of effective design on a small scale: 'All great works of architecture in existence are either the work of single sculptors or painters, or of societies of sculptors and painters, acting collectively for a series of years.'(12.85). This is

137

entirely in keeping with his refusal to associate large-scale layout with 'architectural', and small-scale detail with a separately 'ornamental', art:

for most assuredly, those who cannot design small things cannot design large ones; and yet, on the other hand, whoever can design small things *perfectly*, can design whatever he chooses. The man who, without copying, and by his own true and original power, can arrange a cluster of rose-leaves nobly, can design anything. He may fail from want of taste or feeling, but not from want of power.

And the real reason why architects are so eager in protesting against my close examination of details, is simply that they know they dare not meet me on that ground. Being, as I have said, in reality *not* architects, but builders, they can indeed raise a large building, with copied ornaments, which, being huge and white, they hope the public may pronounce 'handsome.' But they cannot design a cluster of oak-leaves – no, nor a single human figure – no, nor so much as a beast, or a bird, or a bird's nest! Let them first learn to invent as much as will fill a quatrefoil, or point a pinnacle, and then it will be time enough to reason with them on the principles of the sublime.(12.88–89)

Ruskin's belief that the ability to excel in close, detailed composition almost guarantees a relatively easy mastery of large-scale design may well be open to doubt. That he is right in his belief that ornament which can be examined with as much interest from five feet as from a hundred, and which is integrated with its visual context at both distances, cannot be created by a bureaucrat who delegates the carving of pattern-book ornaments to subordinate 'operatives', is demonstrated by the overwhelming majority of nineteenth-century buildings and restorations.

It is easy to understand why the entrepreneur-architects of Ruskin's day regarded him as a 'malevolent of the worst description'. His visual criteria, if taken to heart, would have reduced them to spending a lifetime on two, perhaps three buildings; and while such a proceeding might have resulted in architecture comparable in aesthetic qualities with the medieval and early Renaissance buildings which had trained Ruskin's eye and established his tastes, the results, in terms of the architects' incomes, would have been disastrous. Replying in a lecture of 1874 to an article in which one of them, William Burges, a specialist in ornate Gothic, had described the Duomo of Florence

and its campanile as disappointing works in the 'workbox style', Ruskin advises his listeners not to 'be too hard upon him. These are quite the natural impressions of a man who had never been trained to look at sculpture, and had never done anything with his own hand, and had been taught to sell on commission the labour of others.'(23.269)[7]

In the same year, Ruskin turned down the offer of the Royal Gold Medal of the Royal Institute of British Architects. His blistering response to Sir Gilbert Scott's offer of the medal expresses the fury he felt at the architects' apparent blindness to the visual importance of ornament to the integrity of every building, whether medieval or modern. As regards medieval architecture, the chief activity of modern builders had involved

the destruction, under the name of restoration, of the most celebrated works, for the sake of emolument; and . . . the sacrifice of any and all to temporary convenience.

For the existence of this state of things we, the members, actual and honorary, of the Institute of British Architects, are assuredly answerable, at least in England; and under these circumstances I cannot but feel that it is no time for us to play at adjudging medals to each other(34.514).

Sir Gilbert remonstrated (he had, after all, received his own Royal Gold Medal in 1859), but in a second letter Ruskin carried his attack further:

I very solemnly deny, and wish in the face of the public to deny . . . that either the Architects' Institute or any other Dominant Association of Artists . . . is, or can be in the present day, an Association for the Improvement of Architecture. . . . The primary object of all such Associations is to exalt the power of their own profession over the mind of the public, power being in the present century synonymous with wealth. And the root of all the evil and ruin which this century has seen (and it has destroyed already more than the French Revolution did of what *that* had left) is summed up in four words, 'Commission on the Cost.' And, from any body of architects, however small, who will bind themselves henceforward to accept a given salary (whatever amount, according to their standing, they may choose to name) for their daily work, and to work with their men (or at least with their own hands, on the sculpture of the building) while they take such salary – from such a body I will take a medal to-morrow.(34.515)

CHAPTER EIGHT

Colour

COLOUR has proved a continual embarrassment to architectural writers concerned that their study of buildings should be strictly accurate and systematic, for it is difficult – perhaps ultimately impossible – to reduce the visual complexities introduced by colour to categories that lend themselves to analysis. A common procedure for getting round the embarrassment in Ruskin's day was to deny that colour is, in fact, an important aesthetic consideration in architecture, and to proceed contentedly to think about buildings in black and white. Joseph Gwilt, for example, in his gigantic *Encyclopaedia of Architecture* (1842), reassures his readers:

Colour abstractedly considered has little to do with architectural beauty, which is founded, as is sculpture, on fine form. We are here speaking generally, and are not inclined to assert that the colour of a building in a landscape is unimportant to the general effect of that landscape, or that the colours used on the walls of the interior of a building are unessential considerations; but we do not hesitate to say that they are of minor consequence in relation to our art.[1]

Most modern architectural writers seem to assume the same position, but without feeling that an explanation is necessary. Even Nikolaus Pevsner's otherwise masterly summary of the ways in which a building can appeal aesthetically to the observer makes no mention of colour.[2]

It is clear, however, that colour introduces visual complications which can more or less radically transform the eye's perception of large and small-scale composition. Optical connections, transitions, contrasts, tensions and rhythms can be

created by colour patterning which may not exist at all in the building's formal articulation. Further, the observer's very perception of such basic elements of form as spatial or massive volume, degrees of curvature, and so on, can be significantly manipulated by the architect through use of colour. Considered 'abstractedly', to use Gwilt's term, the sculptured columns of San Martino in Lucca may indeed appear as seen in ill. 38. But considered realistically, under specific conditions of lighting, their appearance is much closer to what we see in ill. 4. The coloured view reveals an infinitely subtler relationship between lights and shadows – (the lights and shadows all being differentially coloured) – both on the column itself, and in respect of the column's relationship to the backing stone, than does the monochromatic view. Important, if almost indefinable qualities, such as warmth and lightness, are also evoked by the coloured view. The tendency of the warm colours to advance, and of cooler colours to recede, perceptually, is a further cause of enrichment of the optical relationship between the sculptured column and its context. If the reader will attempt to transfer his impressions of this single fragment to the view of San Martino given in ill. 39, some idea of the importance of colour in such architecture may be felt.

Ruskin is unsympathetic to visual analysis which ignores colour, and laments the 'endeavours, much fostered by the metaphysical Germans, to see things without colour, as if colour were a vulgar thing, the result being, in most students, that they end by not being able to see anything at all' (6.67). Responding to a jeering denigration of the exterior of St Mark's by an architect who had avoided all considerations of colour, he remarks:

The perception of colour is a gift just as definitely granted to one person, and denied to another, as an ear for music; and the very first requisite for true judgment of St Mark's, is the perfection of that colour-faculty which few people ever set themselves seriously to find out whether they possess or not. For it is on its value as a piece of perfect and unchangeable colouring, that the claims of this edifice to our respect are finally rested; and a deaf man might as well pretend to pronounce judgment on the merits of a full orchestra, as an architect trained in the composition of form only, to discern the beauty of St Mark's. (10.97–98)

We have already noticed Ruskin's remarks about the unique colour and shadow effect created by the columns of St Mark's. A number of his watercolours attempt to capture some impression of what he describes as 'the most subtle, variable, inexpressible colour in the world'(10.115). He regards such drawings (cover/frontispiece and ill. 1) as modest attempts at noting some of the more obvious harmonies in an infinitely subtle scheme.

Of St Mark's, or any other building belonging to 'the great schools of colour', Ruskin cautions that 'its criticism becomes as complicated, and needs as much care, as that of a piece of music, and no general rules for it can be given'(10.267–68). Indeed, the more he studies architecture, painting, or even such simple things as feathers and flowers, the greater his sense of the complexity of all beautiful colouring:

In all the best arrangements of colour, the delight occasioned by their mode of succession is entirely inexplicable, nor can it be reasoned about; we like it just as we like an air in music, but cannot reason any refractory person into liking it, if they do not(15.205n.).

Colour harmonies, like proportions, or the arrangements of line and mass in fine ornament, are thus unique, and while a 'man of no talent, a bad colourist, would be ready to give you mathematical reasons for every colour' he employs, the 'real man of talent' works entirely by instinct(12.500). The critic who wishes to write about colour thus faces a bewilderingly complex phenomenon with nothing but his own perceptions to aid him:

In the original plan of *Modern Painters* . . . I had planned an exact inquiry into the effects of colour-masses in juxtaposition; but found when I entered on it that there were no existing data in the note-books of painters from which any first principles could be deduced, and that the analysis of their unexplained work was far beyond my own power, the rather that the persons among my friends who had most definitely the gift of colour-arrangement were always least able to give any account of their own skill.(14.362)

Despite all the research carried out during the last hundred years by visual psychologists, the modern critic faces precisely the same problems as Ruskin. It is not known why certain colour arrangements are more pleasing to the eye than others.[3]

While precise explanation of what makes a particular colour scheme harmonious is therefore impossible, Ruskin nonetheless asserts – as in discussing proportion – that several general considerations are worthy of notice. In the first place, all effective colour must be gradated:

It is a marvellous thing to me that book after book should appear on [the subject of colour], without apparently the slightest consciousness on the part of the writers that the first necessity of beauty in colour is gradation, as the first necessity of beauty in line is curvature, – or that the second necessity in colour is mystery or subtlety, as the second necessity in line is softness. Colour ungradated is wholly valueless; colour unmysterious is wholly barbarous. Unless it loses itself, and melts away towards other colours, as a true line loses itself and melts away towards other lines, colour has no proper existence, in the noble sense of the word. What a cube, or tetrahedron, is to organic form, ungradated and unconfused colour is to organic colour(16.423).

By gradation of colour, Ruskin does not mean that it is

merely paler or darker at one place than another. Generally colour changes as it diminishes, and is not merely darker at one spot, but also purer at one spot than anywhere else. It does not in the least follow that the darkest spot should be the purest; still less so that the lightest should be the purest. Very often the two gradations more or less cross each other, one passing in one direction from paleness to darkness, another in another direction from purity to dulness, but there will almost always be both of them, however reconciled(15.148).

A second principle is that, just as a good ornamental scheme contains no details that could be done without, so 'all harmonies of colour depend for their vitality on the action and helpful operation of every particle of colour they contain'(16.424). A particle of colour that does not contribute to the whole is not merely an excrescence, but a destructive influence: 'The grain of colour which does not work is dead. It infects all about it with its death. . . . We acknowledge this instinctively in our use of the phrases "dead colour," "killed colour," "foul colour." '(16.419) Closely related to this second principle is a third:

The final particles of colour necessary to the completeness of a colour harmony are always infinitely small; either laid by immeasurably subtle touches of the pencil, or produced by portions of the colouring substance,

however distributed, which are so absolutely small as to become at the intended distance infinitely so to the eye.(16.424)

Perfect exemplification of these three principles is provided by the colour scheme of the fragment of one of the archivolts of St Mark's shown in ill. 72:

The balls in the archivolt project considerably, and the interstices between their interwoven bands of marble are filled with colours like the illuminations of a manuscript; violet, crimson, blue, gold, and green, alternately: but no green is ever used without an intermixture of blue pieces in the mosaic, nor any blue without a little centre of pale green; sometimes only a single piece of glass a quarter of an inch square, so subtle was the feeling for colour which was thus to be satisfied (The fact is, that no two tesserae of the glass are exactly of the same tint, the greens being all varied with blues, the blues of different depths, the reds of different clearness, so that the effect of each mass of colour is full of variety, like the stippled colour of a fruit piece). The intermediate circles have golden stars set on an azure ground, varied in the same manner: and the small crosses seen in the intervals are alternately blue and subdued scarlet, with two small circles of white set in the golden ground above and beneath them, each only about half an inch across (this work, remember, being on the outside of the building, and twenty feet above the eye), while the blue crosses have each a pale green centre. Of all this exquisitely mingled hue, no plate, however large or expensive, could give any adequate conception. . . .(10.116)

This description leads directly to Ruskin's fourth general principle of good colouring, which states that

No colour harmony is of high order unless it involves indescribable tints. It is the best possible sign of a colour when nobody who sees it knows what to call it, or how to give an idea of it to any one else. Even among simple hues the most valuable are those which cannot be defined; the most precious purples will look brown beside pure purple, and purple beside pure brown; and the most precious greens will be called blue if seen beside pure green, and green if seen beside pure blue.(16.424)

And finally: '*The finer the eye for colour, the less it will require to gratify it intensely.* But that little must be supremely good and pure, as the finest notes of a great singer, which are so near to silence.'(16.424)

These general principles are, of course, a far cry from detailed understanding of what makes particular combinations of

colours aesthetically pleasing: we must look to the psychologists of perception and aesthetics to develop such understanding in the future. Ruskin's criteria are, nonetheless, clear statements of certain requirements that must be satisfied before a colour arrangement is pleasing to *his* eye. As such, they represent a degree of intelligent study of his own responses to colour which has never, to my knowledge, been paralleled in subsequent architectural criticism.

They also help explain why, in considering permanent polychromy in large-scale design, Ruskin is most readily satisfied by work done in natural stone:

The true colours of architecture are those of natural stone, and I would fain see these taken advantage of to the full. Every variety of hue, from pale yellow to purple, passing through orange, red, and brown, is entirely at our command; nearly every kind of green and grey is also attainable; and with these, and pure white, what harmonies might we not achieve? Of stained and variegated stone, the quantity is unlimited, the kinds innumerable; where brighter colours are required, let glass, and gold protected by glass, be used in mosaic – a kind of work as durable as the solid stone, and incapable of losing its lustre by time(8.80).

Marble, in particular, makes possible the gradated subtleties so dear to Ruskin's eye:

The colours of marble are mingled for us just as if on a prepared palette. They are of all shades and hues (except bad ones), some being united and even, some broken, mixed, and interrupted, in order to supply, as far as possible, the want of the painter's power of breaking and mingling the colour with the brush.(11.38)

He goes so far as to assert that he 'never yet saw an offensive introduction of the natural colours of marble and precious stones, unless in small mosaics, and in one or two glaring instances of the resolute determination to produce something ugly at any cost.'(9.266)

The use of paint, on the other hand, entails certain visual risks (easily deducible from Ruskin's general criteria), unless the architect can count on the services of a first-rate artist:

to conquer the harshness and deadness of tones laid upon stone or on gesso, needs the management and discretion of a true painter; and on this co-operation we must not calculate in laying down rules for

145

general practice. If Tintoret or Giorgione are at hand, and ask us for a wall to paint, we will alter our whole design for their sake . . . but we must, as architects, expect the aid of the common workman only; and the laying of colour by a mechanical hand, and its toning under a vulgar eye, are far more offensive than rudeness in cutting the stone. The latter is imperfection only; the former deadness or discordance. At the best, such colour is so inferior to the lovely and mellow hues of the natural stone, that it is wise to sacrifice some of the intricacy of design, if by so doing we may employ the nobler material.(8.176)

Three works, in particular, stand out for Ruskin as examples of supreme colouring: St Mark's and the Doge's Palace in Venice, and the campanile of the cathedral of Florence. St Mark's is 'a vast illuminated missal, bound with alabaster instead of parchment, studded with porphyry pillars instead of jewels, and written within and without in letters of enamel and gold'(10.112). The façade of the Doge's Palace is 'the purest and most chaste model that I can name (but one) of the fit application of colour to public buildings.'(8.183). The exception is in favour of the campanile at Florence, which is described as 'that bright, smooth, sunny surface of glowing jasper . . . that serene height of mountain alabaster, coloured like a morning cloud, and chased like a sea shell'(8.189).

Only a handful of Victorian buildings win praise for their colouring. The Engineering School (now the Museum) of Trinity College in Dublin, by Thomas Deane and Benjamin Woodward (1853–57) is described in 1868 as 'the beautiful building . . . which was the first realization I had the joy to see, of the principles I had, until then, been endeavouring to teach!'(18.149–50). One reason for Ruskin's enthusiasm must surely be the tasteful inlaying of panels of delicately coloured stone in the building. The designs of G. E. Street are praised by Ruskin in 1859 as 'pure beyond anything he had ever seen in modern architecture, in exquisite propriety of colour and in fineness of line'. Street's restoration of St Paul's, Herne Hill, London (built 1844, burned down 1858, restored 1858–59) is 'remarkable for a piece of colouring admirably introduced' which Ruskin does not think 'could be excelled by any of the colours in ancient art'(16.462–63).[4] The piece of colouring which wins such praise seems to be the band of Devonshire marble built into the white stone of the piers of the church's nave arcade.

Ruskin's dislike of almost all Victorian coloured patterns in brick – still sometimes referred to, by some brutal irony, as 'Ruskinian' – is fully consistent with his general criteria for good colouring. Gradation of colour, infinitely minute touches, tints of indescribable delicacy and subtlety, and the kind of restraint stressed in the last of his criteria, – one might as hopefully look for such qualities in the packaging of modern breakfast cereals as in pattern-work carried out in brick in most Victorian buildings. A footnote to the well-known passage in *The Stones of Venice* in which Ruskin praises the partially completed All Saints, Margaret Street, London, suggests the chief reason for his subsequent silence concerning the work of its architect, William Butterfield:

I do not altogether like the arrangements of colour in the brickwork; but these will hardly attract the eye, where so much has been already done with precious and beautiful marble, and is yet to be done in fresco.(11.229n.)

In his later work, Butterfield seems almost deliberately to attract the eye to those arrangements of colour in the brickwork which Ruskin dislikes, but feels are more or less satisfactorily neutralized in general effect, at All Saints. As for the 'ornamental arrangements of zigzag bricks, black and blue tiles ... and the like' of Victorian railroad architecture, Ruskin assures readers of *Time and Tide* in 1867 that '*all that architecture is bad*' (17.390).

Predictably, the prospect of his contemporaries attempting 'restoration' of the faded colours of ancient and medieval buildings fills Ruskin with a horror equal to that aroused by their assaults on the carved stonework of such buildings. In his unpublished 'Addresses on Decorative Colour', delivered at the Architectural Museum in 1854, he is quoted as stating:

When a person had coloured rightly, a grain more or a grain less would injure the whole. . . . It was this extreme delicacy of all good colour, and the care which was taken in its application even to architectural decoration, that rendered fruitless and unsuccessful all attempts to restore or to represent the old decorations upon any architectural works of the past centuries. We know nothing of what colours were employed by the Egyptians, or by any of the ancient decorators. We had found a bit of red in one place and a powder of blue or yellow upon some other, and we know nothing more. There

were nearly twenty different reds now known to us; which one did the Egyptians use? . . . Till we knew this we could not restore the rudest monument of past ages! Until we knew absolutely and certainly what colours they used, – till, in fact, we could call the men up from the dead, – we had no right to touch what they had left behind.(12.503)

The temerity and self-assurance of restorers always shocks Ruskin. One mistake 'continually made by modern restorers', for example, is the result of their willingness to act upon the supposition that traces of purple are faded remnants of an original crimson. Their substitution of full crimson in restoration is 'instantly fatal to the whole work, as, indeed, the slightest modification of any hue in a perfect colour-harmony must always be'. Hence, Ruskin concludes, 'the intense absurdity of endeavouring to "restore" the colour of ancient buildings by the hands of ignorant colourists, as at the Crystal Palace'(6.69, 69n.).

The relationship between ornamental detail and colour is discussed at some length in *The Seven Lamps*. The 'first great principle of architectural colour' enunciated is that it should be

visibly independent of form. Never paint a column with vertical lines, but always cross it. Never give separate mouldings separate colours . . . and in sculptured ornaments do not paint the leaves or figures . . . of one colour and their ground of another, but vary both the ground and the figures with the same harmony. Notice how Nature does it in a variegated flower; not one leaf red and another white, but a point of red and a zone of white, or whatever it may be, to each. In certain places you may run your two systems closer, and here and there let them be parallel for a note or two, but see that the colours and the forms coincide only as two orders of mouldings do; the same for an instant, but each holding its own course.(8.177–78)

A perfect example of such practice is afforded by the Doge's Palace, where the 'wall surface is chequered with marble blocks of pale rose, the chequers being in no wise harmonized, or fitted to the forms of the windows; but looking as if the surface had been completed first, and the windows cut out of it.'(8.183)

Ruskin himself soon discovered grounds for casting doubt upon this principle. In the second volume of *The Stones of Venice*, discussing inlaid ornamentation such as the sculptured peacocks visible in the two drawings of St Mark's reproduced here in ills

I and II, and in detail in his eleventh plate for that volume, he comments at length on the optical effects created by backing such ornament with 'a golden ground, formed of glass mosaic inserted in the hollow of the marble'. He explains that 'when the whole ornament is cast into shadow, the golden surface, being perfectly reflective, refuses the darkness, and shows itself in bright and burnished light behind the dark traceries of the ornament.'(10.169) Clearly, the ground colour is subordinated here to the carved forms it throws into contrast.

The use of paint on the carved ornament of northern Gothic also often controverts the notion that form and colour should operate independently in architectural design. He admits in the second volume of *The Stones of Venice* that carved ornament which is highly naturalistic justifies the abandonment of abstract colour harmonies which are independent of the forms they modify:

the architect of Bourges Cathedral liked hawthorn, and . . . the porch of his cathedral was therefore decorated with a rich wreath of it; but . . . he did not at all like *grey* hawthorn, but preferred it green, and he painted it green accordingly, as bright as he could. The colour is still left in every sheltered interstice of the foliage. He had, in fact, hardly the choice of any other colour; he might have gilded the thorns, by way of allegorizing human life, but if they were to be painted at all, they could hardly be painted anything but green, and green all over. People would have been apt to object to any pursuit of abstract harmonies of colour, which might have induced him to paint his hawthorn blue.

In the same way, whenever the subject of the sculpture was definite, its colour was of necessity definite also; and, in the hands of the Northern builders, it often became, in consequence, rather the means of explaining and animating the stories of their stone-work, than a matter of abstract decorative science.(10.110–11)

While the naturalism of much northern Gothic carving thus justifies the abandonment of Ruskin's principle, he is clearly dissatisfied with the aesthetic consequences: 'Flames were painted red, trees green, and faces flesh-colour; the result of the whole being often far more entertaining than beautiful.'(10.111) His preference lies with decorative schemes which, while perhaps associated with less naturalistic carving, encourage abstract harmonies of colour. In Byzantine ornamentation, in particular,

the flatness and comparatively vague forms of the sculpture, while they appeared to call for colour in order to enhance their interest, presented exactly the conditions which would set it off to the greatest advantage; breadth of surface displaying even the most delicate tints in the lights, and faintness of shadow joining with the most delicate and pearly greys of colour harmony; while the subject of the design being in nearly all cases reduced to mere intricacy of ornamental line, might be coloured in any way the architect chose without any loss of rationality. Where oak-leaves and roses were carved into fresh relief and perfect bloom, it was necessary to paint the one green and the other red; but in portions of ornamentation where there was nothing which could be definitely construed into either an oak-leaf or a rose, but a mere labyrinth of beautiful lines, becoming here something like a leaf, and there something like a flower, the whole tracery of the sculpture might be left white, and grounded with gold or blue, or treated in any other manner best harmonizing with the colours around it. And as the necessarily feeble character of the sculpture called for, and was ready to display, the best arrangements of colour, so the precious marbles in the architect's hands give him at once the best examples and the best means of colour.(10.111–12)

Ruskin's personal preferences have won out here over several famous Ruskinian dogmas which might have led us to expect a very different reaction. The red flames, flesh-coloured faces, and bright green leaves of northern work would appear to exemplify both the 'Savageness' and the 'Naturalism' which are so highly praised in 'The Nature of Gothic'. Furthermore, by 'explaining and animating the stories of their stone-work', they also make themselves particularly adaptable to Ruskin's advice, at the end of that resounding manifesto, that the spectator should 'read' the sculpture of buildings 'precisely on the same principles as that of a book'(10.269). And yet the distinctively un-savage, unnaturalistic combination of decorative line and abstract colour harmony in the Byzantine ornament is clearly more to his taste.[5]

Colour seems to have been the element which attracted him more strongly than any other to his favourite Italian buildings. Hence his impatience with critics – including even his revered instructor Robert Willis – who do not take sufficient note of it in their assessment of those buildings. Willis had criticized the use of alternate horizontal bars of colour in the churches of Pisa and surrounding districts, remarking that 'a practice more destructive of architectural grandeur can hardly be conceived'.[6]

Ruskin counters with several comments. In the first place, these bars of colour are important modifiers of the optical effect of large surfaces: 'they are valuable as an expression of horizontal space to the imagination, space of which the conception is opposed, and gives more effect by its opposition, to the enclosing power of the wall itself'(9.347). Secondly, they are valuable aids in the structural articulation of the building. Since, for example, the 'main things to be expressed in a base are its levelness and evenness', the architect finds ideal decorative reinforcement of such expression in the 'marked level bars of colour all along the foundation' in many Italian wall bases(9.333). Thirdly, these bars of inlaid colour are used by the architect (ill. 21) as visual foils to his ornamental sculpture:

I think that the grace of the carved forms is best seen when it is thus boldly opposed to severe traceries of colour, while the colour itself is ... always most piquant when it is put into sharp and angular arrangements. Thus the sculpture is approved and set off by the colour, and the colour seen to the best advantage in its opposition both to the whiteness and the grace of the carved marble.(8.186–87)

Ruskin therefore asserts, in one of his few disagreements with Willis, that there are 'no ornaments more deeply suggestive in their simplicity than these alternate bars of horizontal colours; nor do I know any buildings more noble than those of the Pisan Romanesque, in which they are habitually employed'(9.348).

Near the end of *The Stones of Venice* he reiterates, as if it could not be stressed enough, his belief that the criticism of buildings which make extensive use of decorative colour requires perceptive and analytical powers different from those required for the study of form:

I hope that . . . enough has been said to show the nobility of colour, though it is a subject on which I would fain enlarge whenever I approach it; for there is none that needs more to be insisted upon, chiefly on account of the opposition of the persons who have no eye for colour, and who, being therefore unable to understand that it is just as divine and distinct in its power as music (only infinitely more varied in its harmonies), talk of it as if it were inferior and servile with respect to the other powers of art: whereas it is so far from being this, that wherever it enters it must take the mastery, and whatever else is sacrificed for its sake, *it*, at least, must be right.(11.218)

The tone of this statement belies the modesty with which

Ruskin regards his own efforts to record architectural colour. All attempts to represent on paper the colours of a building such as St Mark's are, he states, 'hopeless from the beginning', and he warns that it is 'dangerous for me to endeavour to illustrate my meaning, except by reference to the work itself' (10.113–15).

To this healthy encouragement of his readers to see the actual buildings, Ruskin adds a warning which is particularly relevant in an age which tends to accept the photograph rather uncritically as visual evidence in architectural discussion. Black-and-white photography, though often praised by him as an aid in the recording of details of form which could be taken down only with painstaking labour by the draughtsman, is nonetheless a misleading tool if used without a strong sense of its limitations. He devotes many passages to these limitations, the most important of which, he feels, is that 'a photograph necessarily loses the most subtle beauty of all things, because it cannot represent blue or grey colours, and darkens red ones; so that all glowing and warm shadows become too dark'(28.446–47). This drawback is, of course, felt with particular force in study of polychromatic buildings which are normally seen under strong sunlight.

It is at the point of subtlety in composition – whatever the scale involved – at which words, and his own draughtsmanship, begin to fail him that Ruskin detects the beginnings of those qualities of design which differentiate the masterpiece from the copy which any hack could put up in its place. Colour is the subtlest of the visual elements which, in all great buildings, defy complete explanation. The complicated and variable nature of the individual viewer's perceptive faculties must also be allowed for in assessing the validity of his attempts at analysis. 'You will find', he writes, 'your power of colouring depend much on your state of health and right balance of mind; when you are fatigued or ill you will not see colours well, and when you are ill-tempered you will not choose them well'(15.156). Such complications, among a host of others which are laid bare in Ruskin's diaries and letters, lead him to question 'whether anybody can understand exactly what it is that the person beside them is enjoying – is even perceiving'.[7]

CHAPTER NINE

Conclusion

IT IS EASY in reading Ruskin to be swept past those relatively quiet passages in which many of his most interesting visual insights are expressed. One must fight with determination against the intoxication, and occasional nausea, which the ethical, religious, and prophetic harangues of *The Seven Lamps* and *The Stones of Venice* so easily induce. Ruskin himself warns admirers of his rhetoric in 1880 that the argument of *The Seven Lamps* is 'overlaid with gilding, and overshot, too splashily and cascade-fashion, with gushing of words', in consequence of which the book 'might be taken for a mere mist of fine words, and read – practically – in vain'(8.15, 17n.). On the other hand, while one may sympathize with the reviewer who claimed in 1888 of *The Stones of Venice* that 'the serpent of rhetorical exaggeration has drawn as noxious a trail over this as over most of the author's other works', it is impossible to join him in concluding that the 'whole of the author's so-called reasoning on architecture – as on everything else – is a jumble of sensational and contradictory rhetoric'.[1]

We are surely far enough removed in time from Ruskin to begin reading his works as we do those of that other great pontificator of our literature, Dr Johnson. No sensible reader of Johnson's Shakespearean criticism will allow himself, because of the undoubted prejudice and silliness of some pronounce-ments, to be blinded to the justice of much that Johnson has to say. A similar tolerance is required in reading Ruskin. One of his admirers has stated: 'The real way to read and to follow Ruskin is to share his generous enthusiasms, and frankly to disregard his personal dictation. He is a great guide, but an unsafe ruler.'[2]

This is sound advice. Ruskin himself acted in accordance with its spirit throughout his life.

It is amusing to note, for example, how his famous theory that the abandonment of Gothic architecture coincided with the spiritual 'Fall' of Venice is jettisoned during moments of infatuation with both earlier and later phases of the city's architectural development. In 1871, referring to the early Renaissance in Venice and Verona, he laments that 'the delicate school of classical architecture' of the fifteenth century 'was overpowered by the sensational and dramatic – essentially *un*classical – schools of Michael Angelo and Raphael', and that 'with it perished the hope of the arts in Europe'(21.124). Nine years later, he informs us that the 'real strength of Venice was in the twelfth, not the fourteenth century: and the abandonment of her Byzantine architecture *meant* her ruin'(8.130n.).

His violent denunciations of Renaissance architecture are balanced by ardent affection for many of its individual exemplars. He likes far more buildings of the early Renaissance than he does buildings raised during the Gothic Revival, and devotes many passages to the study of their leading characteristics.[3] Similarly, even though the 'Central Renaissance' is vilified throughout *The Stones of Venice*, he still finds time, in the midst of his campaign to strike 'effectual blows . . . at this pestilent art of the Renaissance'(9.47), to write a description of the Casa Grimani which is so sympathetic (see p. 52) that it was quoted in parliament by a supporter of the 'Italian' faction during the 'Battle of the Styles' in 1859 over the design for the new Foreign Office(16.466n.).

In some respects 'The Nature of Gothic' is also misleading if taken as an index of Ruskin's aesthetic reactions.[4] His actual encounters with Gothic 'Savageness', for instance, are frequently out of sympathy with the doctrine laid down in that chapter. A diary reference to some sculptured figures at Southwell Minster is quite typical:

the utter stupidity of the heads meant to be human; the miserable attempts to be subtle without knowledge, and dextrous without feeling; the essentially hard, coarse and vile touch . . . and the palpable inability to carve the body of *any*thing; that of men never attempted (all English Gothic is mere boss and decapitation) and the beasts – mere logs with legs for lions, or ropes with scales for serpents – utterly gross and humiliating to one's English soul.[5]

154

Yet this same English soul, in its best-known architectural effusion, had celebrated the 'wildness of thought, and roughness of work' of northern Gothic, and had regarded the 'ugly goblins, and formless monsters' as honourable testimonies to the liberty of the medieval workman. 'Savageness' may be palatable or even praiseworthy in the abstract, but it is reassuring to witness Ruskin brushing his own condescension aside when actually looking at something which disgusts him. As Kenneth Clark puts it: 'However severely he tried to bind it with dogma, Ruskin's sensibility usually escaped in the end'.[6]

Besides ignoring Ruskinian dogma when it conflicts with his aesthetic responses, Ruskin is often explicit in condemning it. Commenting in 1879 on his assertion in *The Stones of Venice* that Venice had been 'the centre of the pure currents of Christian architecture', he admits: 'I am ashamed of having been so entrapped by my own metaphor. . . . She was the *centre* of Christian art only as the place of slack water between two currents.' (9.47n.) In a lecture delivered in 1882 he says:

I do not think the readers of the essays on architecture, which of all my writings have had the most direct practical influence, will think their hour mis-spent in enabling me personally to ask their pardon for the narrowness of statements into which either their controversial character, or the special direction of my earlier studies, hurried me.(33.244)

Ruskin himself, then, has suggested strong grounds for attempting to study his architectural writings from a point of view which disregards his sweeping ethical and historical pronouncements. The realities of modern architectural development, and prevailing attitudes toward that development, are also, unfortunately, strong inducements to such an approach. During an age in which a leading architectural journal can publish a stinging editorial attack on high-rise building on a page facing a full-page advertisement for materials specifically and stridently recommended for use in high-rise building,[7] the ethical premises of the author of *The Seven Lamps of Architecture* seem unlikely to arouse much interest in the profession which might benefit most from their influence.

It is in the area of visual analysis that Ruskin's originality, and most useful potential contribution to modern architectural

study, is to be sought. A small portion of his work in this area has been surveyed in the foregoing pages, but a difficult and extensive task of editing unpublished materials will have to be undertaken before the bulk of his research can be generally available. Even on the basis of the limited discussion attempted in this book, however, it is possible to suggest several ways in which Ruskin's approach might be of value in enriching our study of architecture.

His constant watchfulness for the modifying effect that small details can have on the eye's grasp of the overall composition presented in any particular view of a building could, if emulated, do much to increase the sophistication of contemporary analysis. It is still customary, for example, to discuss the composition of a building with reference to diagrams which represent its major subdivisions of mass and surface, but obliterate all ornamental detail. Such simplification, it is thought, facilitates study of the proportions observed in large-scale layout. Yet this procedure cannot – if applied to a building of any complexity – be justified on visual grounds. A recent study has shown (to give just one discomfiting example) that the apparent size of a simple square can be increased by up to thirty per cent if its surface is enriched by means of pattern. The more complex the pattern, the greater the observer's estimate of area.[8] Enrichment of architectural mass and surface by ornamental pattern can thus in no wise be regarded as a dispensable addition to basic geometrical shapes which can be abstracted from the ornament and studied in isolation. The process of abstraction is simply a falsification of the composition's actual effect on the eye. All reasoning about the proportions of a medieval façade which ignores the fact that the various parts of that façade have been differentially modified in apparent size by ornamental pattern of varying complexity is thus open to serious criticism. Ruskin's appreciation of the further complications in perception of form which are introduced by shadow – and the fact that shadow is differentially coloured – adds another degree of difficulty to the problems faced by the analyst. It must be conceded that Ruskin seldom dissects any composition with the thoroughness which his notions of the integrated optical role of ornament and colour would seem to invite. Nonetheless, the many fascinating glimpses and brief analyses he does provide are more closely

156

attuned to the realities of actual perception than much modern criticism.

This grasp of the complexity of visual experience is perhaps most apparent in Ruskin's sensitivity to the variable roles played by lighting and shadow in architecture. It is because of his habit of viewing buildings over a period of time, of revisiting his favourites repeatedly and recording fresh impressions each time in sketches and notes, that he is aware of a vital element in architectural effect which modern scholars – working to a considerable extent from photographs rather than prolonged viewing of the buildings themselves – often seem to overlook. For no building, unless lit artificially, can possibly look exactly the same from one minute to the next. It changes continually according to the kind of light that illuminates it, the angles from which it is illuminated, the amount and colour of light it reflects, the shadow which one part of it casts on another, and the shadow which is cast upon it from without. What scholars define as 'spatial' and 'massive' elements – and assume to be unchanging entities – should be considered mere conceptual aids (somewhat analogous to solid models of the atom) to the study of the optical effects actually created by the shifting of coloured light and shadow within and upon a building. Unlike the vast majority of observers who think of buildings as limited and unchanging 'facts', Ruskin understands that a building is, as an optical phenomenon, infinitely and continually variable. His lovely phrase about 'watching' buildings (p. 61) seems the best possible description of his own habitual response to this changefulness.

This brings us back to an aspect of Ruskin's achievement as an observer which makes him unique among English writers on architecture. We have seen how effective he can be in the patient recording of facts and measurements and, often, how brilliant in his interpretation of the composition presented to the eye. We have seen, further, that his sensitivity to optical complexities provides many useful lessons for all who enjoy looking at buildings. But Ruskin is more than an analytic observer. He is also the most gifted draughtsman ever to devote a large part of his talent to architectural subjects. Though he himself rejected the notion that he was more than a draughtsman, the following words from *The Stones of Venice* can surely be applied to a good deal of his own drawing and painting of architecture:

86 Ruskin *Arch and buttresses of St Wulfran, Abbeville* 1868

The whole function of the artist in the world is to be a seeing and feeling creature; to be an instrument of such tenderness and sensitiveness, that no shadow, no hue, no line, no instantaneous and evanescent expression of the visible things around him, nor any of the emotions which they are capable of conveying to the spirit which has been given him, shall either be left unrecorded, or fade from the book of record.(11.49)

And what a record he has left us. No other draughtsman provides such a variety of impressions of architecture seen from so many vantage points, under such varying conditions of light, and expressive of such a range of emotional response in the viewer.

Look, for example, at the wonderful study of flying buttresses at St Wulfran given in ill. 86. It irresistibly calls to mind Ruskin's verbal evocation of the 'grey, shadowy, many-pinnacled image of the Gothic spirit within us', of

that strange *disquietude* of the Gothic spirit that is its greatness; that restlessness of the dreaming mind, that wanders hither and thither among the niches, and flickers feverishly around the pinnacles, and frets and fades in labyrinthine knots and shadows along wall and roof, and yet is not satisfied, nor shall be satisfied.(10.182, 214)

Turn next to the equally fine rendering, from about the same distance, of a compartment of the Baptistery of Florence (ill. 87). All here is calm and measured: 'It is an Etruscan–Greek building – the most exquisite piece of proportion I know in the world'(23.241). Then consider the drawing, again from about the same distance, of a building in which a compromise is made between the spirit of St Wulfran and that of the Baptistery, the chapel of Santa Maria della Spina at Pisa (ill. 88) – the kind of building Ruskin has in mind when he suggests that 'the best Gothic building is not that which is *most* Gothic'(10.242). Sympathetic treatment of stylistic compromise is again apparent in the drawing of the inner court of the Doge's Palace (ill. 89), an unusual blending of Gothic and Renaissance forms and modes of composition.

Moving out with him into the streets of medieval northern Europe, compare the rather stiff, matter-of-fact and uniform delineation of architectural masses in his youthful drawing at Rouen (ill. 90) with the dramatic contrasts in his later treatment of a similar scene at Strasbourg (the spire of which is for

87 (*left*) Ruskin *A compartment of the Baptistery, Florence* 1872

88 (*right*) Ruskin *Part of the church of Santa Maria della Spina, Pisa* 1845

89 Ruskin *Interior court of the Doge's Palace, Venice* 1841

him 'the grandest achievement of Gothic architectural science'[21.121–22]), given in ill. 91. The Venetian drawings probably register the greatest extremes of mood. Compare the tranquillity of drawings such as those reproduced in ills 53 and 92 with the fitful impatience (ill. 93) and the menacing, almost claustrophobic oppressiveness (ills 94 and 95) of the drawings produced during a winter of severe mental and emotional strain at Venice in 1877. Ruskin's numerous studies of bridges offer further evidence of such wide variability of expression. Compare the vague, floating quality of the chief masses in his drawing of the Ponte Vecchio in ill. 96 ('quiet shadows and vaguely-sketched contours surrounding details of windows and roofs that are drawn like private tokens of Ruskin's broken thoughts and feelings')[9] with the brute-like muscularity of the bridge at Verona shown in ill. 97. St Wulfran in Abbeville appears as its solid, everyday self in the drawing reproduced in ill. 32. But in another sketch made at about the same time from

90 Ruskin *Street scene, Rouen* 1835

91 Ruskin *Tower of Strasbourg Cathedral*

92 Ruskin *Upper reach of the Grand Canal, Venice* 1870

93 Ruskin *Grand Canal looking toward Santa Maria della Salute, Venice* 1877

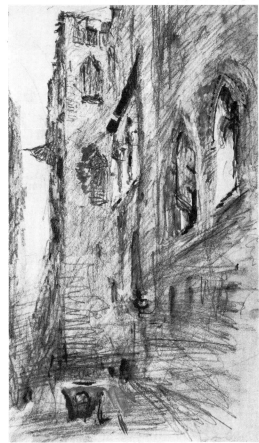

94 Ruskin *At Venice* 1877

95 Ruskin *Street in Venice* 1877

a few feet closer, it dissolves into the evanescence of a dream (ill. 98). Moving back to a position from which buildings become components of landscape, compare the dramatic fantasy of the view of Amalfi given in ill. 99 with the much more terrestrial, yet perhaps also more moving, view of Bologna shown in ill. 100.

Ruskin's mastery of words is at least as potent, in communicating his visual responses, as his draughtsmanship. Tiresome as a preacher, he is the most exciting of architectural writers when focusing all his powers of vision, thought and imagination on the work before him. Charlotte Brontë's reaction to the first volume of *Modern Painters* – 'I feel now as if I had been walking blindfold – this book seems to give me eyes'(3.xxxix) – is as applicable to many passages in the architectural books, diaries and letters. Nikolaus Pevsner has singled out intensity of feeling as the unique characteristic of

96 Ruskin *Ponte Vecchio,
Florence* 1882

Ruskin's appreciation of architecture.[10] Ruskin's ability to
transmit, not merely visual information, but the emotional
responses which accompany perception, compels us, in reading
him, 'to acquire new perceptions of what our life actually
means, in terms of human sensation'.[11]

The infectiousness of his love for the subject is one of Ruskin's
most valuable legacies to architectural study. Modern texts are
for the most part learned, accurate and systematic, but
sometimes also boring. Occasionally they seem calculated to
test, rather than to fire, the reader's interest in architecture.
Ruskin's writings provide a healthy supplement to these dried
fruits of scholarly expertise. Though the strength of his
emotional responses occasionally leads him into serious

97 Ruskin *Ponte della Pietra, Verona* 1872

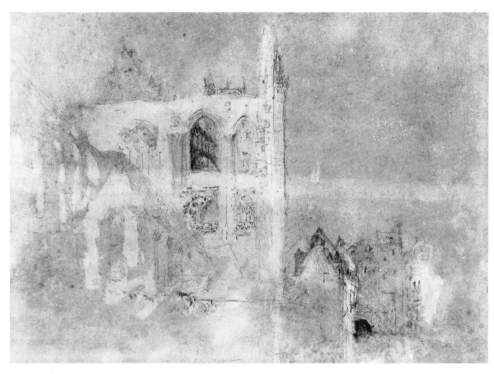

98 Ruskin *Part of St Wulfran, Abbeville* 1868

mistakes and inconsistencies, there is much truth in his claim that 'the errors of affection are better than the accuracies of apathy'.(10.452)

The experience of looking at architecture has been permanently enriched by his work. In a memorable passage of autobiography, Proust suggests that Ruskin's thought

gives a greater beauty to the world, or, at least, to certain special, certain defined objects in the world, because it has laid its hand upon them, has initiated us into their secrets by compelling us, in our search for understanding, to love them.

And that is precisely what happened in my case. I suddenly saw the universe as something of infinite value. My admiration for Ruskin gave such high importance to the objects he had made me love, that they seemed charged with a greater value even than life itself. It was at a time when I believed, quite literally, that my days were numbered. I went to Venice that I might, before I died, approach, touch, see incarnate, in Palaces crumbling yet still standing and flushed with pink, Ruskin's ideas on the domestic architecture of the Middle Ages. What possible importance, what possible reality could there be for someone about to leave this world, in a city so individual, so localised in time, so particularised in space as Venice: and how could theories

99 Ruskin *Amalfi* 1844

about domestic architecture, which I might study there and verify by reference to actual examples – how could such things conceivably belong to the great body of those truths which 'have power over death, and prevent us from fearing, almost make us love, it'? It is the peculiar power of genius to make us love a beauty, which we feel to be more real than ourselves, in things that, to other eyes, are no less limited, no less perishable than are we.[12]

100 Ruskin *View of Bologna* 1845 or 1846

Notes

References are to the editions cited in the Bibliography

INTRODUCTION *pp. 13–28*

1 *The Gothic*, 561.
2 Willis's analysis of Gothic vaulting is singled out for praise several times in the first volume of *The Stones of Venice* (9.133n., 183), and is cited frequently elsewhere. Ruskin was acquainted with the author (8.xl) and stated his belief in 1880 that Willis had been 'the first modern who observed and ascertained the lost structural principles of Gothic architecture' (8.95n.).
3 In *Mornings in Florence* he states that one of the two most delightful features of 'a fine Gothic building' is 'the springing of its vaultings' (23.302). Most of the studies of vaulting in the diaries have been omitted from the selection published by Evans and Whitehouse in *Diaries*. It is somewhat unfair of K. O. Garrigan, in her book *Ruskin on Architecture* (78–86), to treat the discussion of vaulting in 'The Nature of Gothic' as if it represented the limits of Ruskin's understanding of the subject.
4 Arnheim, 256.
5 *The Drawings of John Ruskin*, Oxford, 1972, 70. Garrigan claims that 'Ruskin's drawings provide interesting evidence . . . of his tendency to perceive the world about him as two-dimensional. . . . But specifically in his architectural drawings, there is comparatively little feeling of roundness or solidity' (177–78). This must be one of the most astonishing claims ever made about Ruskin.
6 Evans, 141.
7 *Ibid.*, 415.
8 *Ibid.*, 411.
9 Whiffen, 2–3. Ruskin says of the true dome that 'the ordinary spectator's choice among its various outlines must always be dependent on aesthetic considerations only, and can in no wise be grounded on any conception of its infinitely complicated structural principles' (9.184n.).
10 E. L. Garbett's *Elementary Treatise on the Principles of Design in Architecture* had appeared in 1850.
11 Le Corbusier, 153.
12 *Ibid.*
13 For example, in introducing the architectural photographs displayed in his Reference Series at Oxford, Ruskin states that there are two main types of architecture, one 'which depends chiefly for its effect on the sculpture or colouring of surfaces', and one 'which depends on construction or proportion of forms. Both these schools have their own peculiar powers, and neither of them are to be praised, or blamed, for the principle they maintain, but only for their wise or unwise manner of maintaining it' (21.29).
14 MS. 'St. M. Book', Bembridge School, 55, 80.
15 'I gave three years' close and incessant labour to the examination of the chronology of the architecture of Venice; two long winters being wholly spent in the drawing of details on the spot; and yet I see constantly that architects who pass three or four days in a gondola going up and down the Grand Canal, think that their first impressions are just as likely to be true as my patiently wrought conclusions. Mr. Street, for instance, glances hastily at the façade of the Ducal Palace – so hastily that he does not even see what its pattern is, and misses the alternation of red and black in the centres of its squares – and yet he instantly ventures on an opinion on the chronology of its capitals, which is one of the most complicated and difficult subjects in the whole range of Gothic archaeology' (16.126n.–27n.). The reference is to Street's *Brick and Marble in the Middle Ages: Notes of a Tour in the North of Italy*, 1855, ch. 8.

16 The trefoil mentioned can be seen in the group of three small arches at the bottom left in Ruskin's drawing (ill. 88), made in 1845, before the restorations in question had taken place.
17 Walton, 70.
18 Garrigan, 51.

CHAPTER ONE *pp. 29–50*

1 Pevsner, *An Outline of European Architecture*, 15.
2 Danby, 37.
3 Giedion, 26.
4 White, 323–24.
5 The apparent shrinkage in size of the vault is due to a common optical illusion. Arnheim explains that objects appear smaller than they really are whenever 'the continuity of the spatial framework is interrupted.' Thus, for example, 'when we look down from an airplane, the interval between ourselves and the ground is almost unstructured. Therefore the distance looks shorter, and consequently things on earth appear smaller' (Arnheim, 267). The same thing happens when an observer looks directly up into a vault instead of also running his eyes along structural members leading up to it: the space between the observer and the vault comes to seem unstructured; therefore, the distance (as Ruskin indicates) seems shorter than it really is, and the vault appears smaller. The width of the nave of the Duomo, and the extremely wide spacing of its piers, make this illusion almost unavoidable, since perspective cues of height derived from the apparent convergence of upright structural members are very difficult to obtain when standing under this vaulting. The comparatively narrow bays of most northern Gothic buildings make it much easier for an observer to include enough upright shafts in his view to obtain perspective cues of the height, and hence of the approximate size, of the vault. The abrupt termination of the vertical lines of the vaulting shafts by the heavy horizontal line of the gallery in the Duomo further reduces cues as to the height of the vault. Other factors are no doubt operative in Ruskin's experiment. The importance of fixation of vision in the production of visual illusions, for example, is discussed by Luckiesh (106, 112). For some interesting remarks by Ruskin on the tendency of observers to underestimate the size of any large object, see the manuscript passage intended for *Modern Painters*(5.434–35).
6 Luckiesh, 104.
7 Garrigan, 62.
8 Pevsner, *An Outline of European Architecture*, 15.
9 Diary MS. Vol. 6, 46.
10 At Avignon in 1840, for example, he notes the 'Italian roofs of beautiful form and grouping; one light Gothic tower, contrasting beautifully with the heavy battlemented towers of the walls' (*Diaries*, I, 91). In *The Stones of Venice* he states that the finial is 'properly the ornament of gabled architecture; it is the compliance, in the minor features of the building, with the spirit of its towers, ridged roof, and spires. Venetian building is not gabled, but horizontal in its roofs and general masses; therefore the finial is a feature contradictory to its spirit'(11.12).
11 *Diaries*, I, 184.
12 *Diaries*, III, 927.

CHAPTER TWO *pp. 51–64*

1 Arnheim, 47–49.
2 MS. 'Stones of Venice II. Ch. 4. Additional', 50–55; 8.208–9. Ruskin also touches upon the variations in the width of the archivolts of the façade in 10.152–53.
3 F. C. Penrose's *Investigation of the Principles of Athenian Architecture* had been published two years earlier in 1851.
4 Ehrenzweig, 310.
5 Arnheim, 403.

CHAPTER THREE *pp. 65–76*

1 *An Outline of European Architecture*, 383.
2 Garrigan, 77. Italics mine.
3 Garrigan's claim that 'Ruskin ignores architectural contexts, focusing instead

168

on isolated decorations' (56) is a most misleading generalization, and overlooks a mass of evidence available in his architectural books, as well as in his notebooks and diaries.

4 For a fine drawing by Ruskin of the fig-tree angle, showing the effectiveness of its carving in providing terminal lines for the building, see pl. H, facing 10.358. Commenting on this drawing elsewhere Ruskin notes 'the way in which the light is let through the edges of the angle by penetration of the upper capital, and of the foliage in the sculpture below; so that the mass may not come unbroken against the sky' (19.456). The carving of the vine angle is shown in ill. 23 of this book.

5 Grumbling in his diary for 1849 about what he considers the degenerate Gothic of Milan Cathedral, he notes, similarly, that 'the statues all over are of the worst possible common stonemason's yard species, and look pinned on for show' (*Diaries*, II, 445). In a letter of 1854 Ruskin says of nineteenth-century imitation of ancient Greek and medieval figure sculpture: 'It makes me as sick as if people were to feed me with meat that somebody else had chewed' (36.172).

6 It is interesting to note that the mosaic discussed by Ruskin would probably be considered separately (if at all) by many architectural critics as added surface decoration, rather than as an integral element of the architectural design. Yet, as ornamentation of a dome, the surface in question is three-dimensional. Both the tree-trunks and the figure of the Madonna are, therefore, three-dimensional modifiers of the spatial sensations evoked in the viewer by the dome. The 'brilliancy' secured for the dome by the placement and colouring of the figure of the Madonna, furthermore, must affect the viewer's perception of its apparent volume, and height above the floor. To discuss the spatial articulation of the interior of the building without taking such visual factors into account is to indulge in over-simplification.

CHAPTER FOUR *pp. 77–88*

1 Notes for ch. 3, vol. 2 of *The Stones of Venice*, V-9 and V-10 in Ruskin's numbering.

2 See further, on the same subject, 10.28–29 and 23.168.

3 MS. 'Stones of Venice II. Ch. 4. Additional', 44.

4 It seems clear that no photograph taken at a steep angle could, if viewed from the comfortable angle at which one normally reads a book, evoke with much success the very different experience of looking up at a building with the head thrown back. The image produced by the photograph may be similar to that produced by the building, but the emotional differences resulting from the viewer being in a superior, instead of inferior, position with respect to what he is looking at destroy some of the photograph's value in architectural discussion. Ill. 35 in this study is a case in point. While it is helpful in elucidating certain of Ruskin's remarks, it is a hopelessly inadequate substitute for actually looking at the dome itself.

CHAPTER FIVE *pp. 89–102*

1 'Architectural note-book', 1.

2 Ruskin is similarly outraged by the widespread misuse of the buttress by Gothic Revival architects: 'in most modern Gothic, the architects evidently consider buttresses as convenient breaks of blank surface, and general apologies for deadness of wall. They stand in the place of ideas, and I think are supposed also to have something of the odour of sanctity about them; otherwise one hardly sees why a warehouse seventy feet high should have nothing of the kind, and a chapel, which one can just get into with one's hat off, should have a bunch of them at every corner; and worse than this, they are even thought ornamental when they can be of no possible use, and these stupid penthouse outlines are forced upon the eye in every species of decoration; in some of our modern

chapels I have actually seen a couple of buttresses at the end of every pew'(9.210).

3 *Diaries*, I, 326–27.
4 *Ibid.*, 327.
5 *Ibid.*, 314.
6 *Diaries*, II, 440.
7 *Ibid.*
8 *Ibid.*, 441.
9 *Ibid.*, 495.

CHAPTER SIX *pp. 103–18*

1 White, 193.
2 Lavedan, 120.
3 MS. 'Stones of Venice II. Ch. 4. Additional', x9 in Ruskin's numbering.
4 Demus, 100, 103. One searches in vain among the hundreds of titles listed in Demus's gigantic bibliography for *The Stones of Venice*.
5 Further drawings of St Wulfran are reproduced in 19.pl. 8, 9, 11.
6 Ruskin frequently asserts that the arrangement of clustered piers in Gothic buildings is primarily a question of aesthetics, not of construction. In the first lecture of *Aratra Pentelici* he states: 'You have, perhaps, thought that pure early English architecture depended for its charm on visibility of construction. It depends for its charm altogether on the abstract harmony of groups of cylinders, arbitrarily bent into mouldings, and arbitrarily associated as shafts, having no *real* relation to construction whatsoever, and a theoretical relation so subtle that none of us had seen it till Professor Willis worked it out for us'(20.213). In some manuscript notes for the fifth lecture in the same series, Ruskin claims that 'though the fluting of a Doric column, the moulding of an Early English pointed arch, and the divisions of stones in the basement of a building like Whitehall, are all of them more grateful to the eye because they explain the directions of force to be resisted and direct attention to the points where the masonry needs to be adjusted with the greatest care, all the final value of these decorative methods of treatment depends on a proportion of masses which is wholly independent of construction'(20.309n.). He had been deeply influenced, as acknowledged, by the brilliant discussion of the distinction between the 'mechanical' and the 'decorative' construction of Gothic buildings in Willis's *Remarks on the Architecture of the Middle Ages*, 17–19.

7 Diary MS. Vol. 6, 166. The entry was made in September 1849.
8 Diary MS. Vol. 6, headed 'Bayeux 1848', 36–38.
9 MS. 'Architectural note-book', 77–78.
10 Garrigan, 56.

CHAPTER SEVEN *pp. 119–39*

1 Published in 1849. Pugin's 21st plate is reproduced here.
2 *Punch* has great fun at Pugin's expense in a mock-advertisement stressing the speed with which the architect can provide anything that is requested of him: 'PUGSBY begs to acquaint Bishops, Priests, Commissioners of Fine Arts, patrons of "Pure Art", and dealers in Ancient Windows, that he has opened a manufactory for every article in the Mediaeval line at very reduced prices. . . . New door-handles, pump-handles, water-vats, candlesticks, and weather vanes, warranted to look five hundred years old. . . . N. B. Designs for Cathedrals made in five-and-forty minutes; superior ditto in one hour; ditto ditto for Churches in twenty-six minutes. Episcopal chapels in fifteen minutes – and, to save trouble, no Dissenters need apply' (22 Nov 1845, 238).
3 The passage in question, discussing one of the bas-reliefs of the north door, occurs in 'The Lamp of Life' (8.216–17) and contains two sentences dealing with a carving representing a dwarf. Proust writes: 'I was seized by a desire to see the little man about whom he speaks. So I went to Rouen as though in obedience to a testamentary behest, as though Ruskin, at the moment of death, had, in some sort, bequeathed to his readers that poor creature into whom he had, with his words, breathed the breath of life' (Proust, 77–78).

4 'Mr. Pugin on Christian Art', *The Builder*, Vol. III, 1845, 367.

5 *Diaries*, III, 896.

6 *Diaries*, III, 1018.

7 Burges's remarks were made in an article published in *The Ecclesiologist*, Vol. 22, 1861, 158.

CHAPTER EIGHT *pp. 140–52*

1 Gwilt, 678.

2 *An Outline of European Architecture*, 15–17. That this silence about colour is not an accidental oversight is confirmed by the fact that Pevsner discusses both St Sophia and the church of San Vitale in Ravenna without a word about their colouring. The *Outline* is deservedly the most famous and influential modern book of its kind. Its reticence concerning colour agrees with the prevailing tendency of present-day architectural analysis.

3 See V. K. Ball, 441: 'There is as yet no extensive scientific knowledge about how colours affect people, but some start has been made in the experimental determination of the basic facts of colour aesthetics.' Just how elementary that start was in 1965 can be gauged from her advice that experiments on 'simple and basic synaesthetic reactions to colour' which 'can be more easily tested than can more complex preference statements' are urgently needed (449). Clearly, the visual psychologists are still a long way from being able to supply information that might be useful to the architectural critic in analysis of a colour scheme of any complexity. See also G. W. Granger, 'The Prediction of Preferences for Color Combinations', *Journal of General Psychology*, vol. 52, 1955, especially 213, 220–21.

4 Remarks made at a meeting of the Architectural Photographic Association, 15 Feb 1859, as reported in *The Builder* for 19 Feb 1859.

5 It should be pointed out that Ruskin is not unaware of the fact that the northern colourists, in work not specifically associated with naturalistic carving, are as capable of abstract colour harmony as the Byzantines. Nonetheless, 'though in the lines of the mouldings and the decorations of shafts or vaults, a richer and more abstract method of colouring was adopted (aided by the rapid development of the best principles of colour in early glass-painting), the vigorous depths of shadow in the Northern sculpture confused the architect's eye, compelling him to use violent colours in the recesses, if these were to be seen as colour at all, and thus injured his perception of more delicate colour harmonies' (10.111).

6 Willis, 12n.

7 Letter of about 1855 (Pierpont Morgan Library, MS. no. R-V Autogr. Misc. English: MA 2274 [28]).

CHAPTER NINE *pp. 153–66*

1 The writer is identified in *The Wellesley Index to Victorian Periodicals* as Henry Heathcote Statham. Statham, 219–20, 234.

2 Benson, 56.

3 See the chapters dealing with Ruskin's evaluation of the Renaissance and of English nineteenth-century architecture in my doctoral dissertation, 'A Study of Ruskin's Architectural Writings', submitted at Oxford in 1969.

4 Garrigan discusses the question with admirable clarity in *Ruskin on Architecture* (especially 34–42).

5 Entry for 26 April 1876 (*Diaries*, III, 895).

6 Clark, 181.

7 *The Architect*, May 1972, 35 and facing advertisement.

8 Verrillo and Graeff, 289–90.

9 Walton, *The Drawings of John Ruskin*, 118.

10 *Ruskin and Viollet-le-Duc*, 24, 42.

11 Robertson, 195.

12 Proust, 93–94.

Selective bibliography

Place of publication is London unless otherwise specified

Published Texts

The Works of John Ruskin, edited by E. T. Cook and A. Wedderburn, 39 volumes, 1903–12.

The Diaries of John Ruskin, selected and edited by J. Evans and J. H. Whitehouse, 3 vols, Oxford, 1956–59.

Ruskin's Letters from Venice: 1851–1852, edited by J. L. Bradley, New Haven, 1955.

'Three Ruskin Letters', published by R. E. T. Williams, *Notes and Queries*, Jan. 1963, 23–25.

Unpublished Materials

'Architectural note-book, Italy, 1850–1851, with sketches and diagrams in pencil and ink', Beinecke Rare Book and Manuscript Library, Yale University Library (MS. Vault Sect. 14, Drawer 2).

'Ruskin: Original Notes and Sketches for the Stones of Venice' (4 large folios full of drawings; also loose sheets of architectural notes), Bembridge School, Isle of Wight.

'Ruskin: Stones of Venice: Notes' (3 large cases containing various loose architectural notes and sketches pasted onto thick paper), Bembridge School, Isle of Wight.

'Ruskin: Stones of Venice: Note-Books'. These are kept in two cases at Bembridge, and comprise the following:

In Case No. 1: 'House-Book I'. 'House-Book II'. 'Palace Book'. 'Bit Book'. 'Door Book'.

In Case No. 2: 'Gothic Book'. 'St. M. Book'. 'N. Book. 1849'.

'Ruskin: Diary MS. Vol. 5B. 1845', largely in the handwriting of Ruskin's valet 'George' Hobbs, Bembridge School, Isle of Wight.

'Ruskin: Diary MS. Vol. 5C. 1848', Bembridge School, Isle of Wight.

'Ruskin: Diary MS. Vol. 6. 1848–1849', Bembridge School, Isle of Wight.

'Ruskin: Diary MS. Vol. 10; for Autumnal Journey, 1849', Bembridge School, Isle of Wight.

Manuscript for *The Stones of Venice*, containing a good deal of material not published in the book. Pierpont Morgan Library, New York. In three large cases. The first contains, besides the text for volume I, a good deal of additional material, especially for chapters 2 and 3. The second contains, besides the text for volume II, much unpublished material ('Stones of Venice II. Ch. 2, 3, 4, Additional'). The third contains the text for volume III, with much extra material not assignable to any particular chapter.

'Ruskin: Sketch and Note-books for *Seven Lamps of Architecture*', MS. Nos. SA3915: 1: 386, vols. 1–6, Princeton University Library. 6 small notebooks, containing numerous drawings in pencil, ink, and watercolour, and many architectural notes. The first four are of particular interest.

Typed transcripts of Ruskin's diaries and notebooks prepared for Cook and Wedderburn, portions of which are quoted in Cook's introductions to each volume of *Works*. There are 41 volumes of these, deposited in the Bodleian Library under the shelf-marks MS. Eng. misc. c.209–49. A further series of 21 volumes of typed transcripts of letters and other writings not included in the *Works* is deposited under the shelf-marks MS. Eng. lett. c.32–52.

Works dealing with Architecture, Ruskin, and Visual Perception

Arnheim, R., *Art and Visual Perception*, 1967 (first published in Berkeley in 1954).

Arslan, E., *Gothic Architecture in Venice*, trans. A. Engel, 1972 (originally published as *Venezia Gotica*, Venice, 1971).

Ball, V. K., 'The Aesthetics of Color: A Review of Fifty Years of Experimentation', *The Journal of Aesthetics and Art Criticism*, vol. 23, 1965, 441–50.

Bell, Q., *Ruskin*, 1963.

Benson, A. C., *Ruskin: A Study in Personality*, 1911.

Clark, K., *The Gothic Revival: an Essay in the History of Taste*, 1928, ch. 10.

Collingwood, W. G., *The Art Teaching of John Ruskin*, 1891.

Collins, P., *Changing Ideals in Modern Architecture*, 1965.

Danby, M., *Grammar of Architectural Design*, 1963.

Day, R. H., *Human Perception*, Sydney, New York, Toronto and London, 1969.

Dearden, J. S., *Catalogue of the Drawings by John Ruskin on Permanent Exhibition in the Ruskin Gallery, Bembridge School*, Bembridge, 1967.

, *Catalogue of the Pictures by John Ruskin and Other Artists at Brantwood, Coniston*, Brantwood, 1960.

Demus, O., *The Church of San Marco in Venice*, Washington, D.C., 1960.

Ehrenzweig, A., 'A New Psychoanalytical Approach to Aesthetics', *British Journal of Aesthetics*, vol. 2, 1962, 301–17.

Evans, J., *John Ruskin*, 1954.

Frankl, P., *The Gothic: Literary Sources and Interpretations through Eight Centuries*, Princeton, 1960.

Garrigan, K. O., *Ruskin on Architecture: His Thought and Influence*, Madison, 1973.

Gauldie, S., *Architecture*, 1969.

Giedion, S., *Space, Time and Architecture: the growth of a new tradition*, 5th ed., Cambridge, Mass., 1967.

Gwilt, J., *An Encyclopaedia of Architecture*, 1842 (many later editions).

Harrison, F., *John Ruskin*, 1902.

Hersey, G. L., *High Victorian Gothic: A Study in Associationism*, Baltimore and London, 1972.

Hitchcock, H.-R., *Architecture: Nineteenth and Twentieth Centuries*, 2nd ed., Harmondsworth, 1963.

Hough, G., *The Last Romantics*, 1949, ch. 1.

Jordan, R. F., *Victorian Architecture*, Harmondsworth, 1966.

Knight, H. G., *The Ecclesiastical Architecture of Italy from the Time of Constantine to the Fifteenth Century*, 2 vols, 1842 and 1844.

Krautheimer, R., *Early Christian and Byzantine Architecture*, Harmondsworth, 1965.

Lavedan, P., *French Architecture*, Harmondsworth, 1956 (first published in French in 1944).

Le Corbusier (C. E. Jeanneret), *Towards a New Architecture*, trans. F. Etchells, from the 13th French ed., 1927.

Leon, D., *Ruskin: the Great Victorian*, 1949.

Lethaby, W. R., *Architecture: An Introduction to the History and Theory of the Art of Building*, 1911.

Luckiesh, M., *Visual Illusions: Their Causes, Characteristics and Applications*, 1922. Reprinted in New York, 1967.

Masson, G., *Italian Villas and Palaces*, 1959.

Pevsner, N., *An Outline of European Architecture*, 7th ed., Harmondsworth, 1963.

, *Ruskin and Viollet-le-Duc: Englishness and Frenchness in the Appreciation of Gothic Architecture*, 1969.

, *Some Architectural Writers of the Nineteenth Century*, Oxford, 1972.

Proust, M., 'John Ruskin', in *Marcel Proust: a Selection from his Miscellaneous Writings*, ed. G. Hopkins, 1948. The essay on Ruskin is the third chapter of this book.

Pugin, A. W. N., *Floriated Ornament*, 1849.

Rasmussen, S. E., *Experiencing Architecture*, 1959.

Ricci, C., *Romanesque Architecture in Italy*, 1925.

Robertson, J., *Modern Humanists*, 1891.

Rosenberg, J. D., *The Darkening Glass: a Portrait of Ruskin's Genius*, New York, 1961.

Salmi, M., *Chiese Romaniche della Toscana*, Milan, 1961.

Sanfaçon, R., *L'Architecture flamboyante en France*, Quebec, 1971.

Scott, G., *The Architecture of Humanism: a Study in the History of Taste*, 1914.

Selvatico, P., *Sulla Architettura e Sulla Scultura in Venezia*, Venice, 1847.

Sharp, T., *Town and Townscape*, 1968.

Statham, H. H., 'The Works of Mr. Ruskin', *Edinburgh Review*, vol. 167, Jan 1888, 198–234.

Thompson, P., *William Butterfield*, 1971.

Vernon, M. D., *Perception Through Experience*, 1970.

Verrillo, R. T., and Graeff, C. K., 'The Influence of Surface Complexity on Judgments of Area', *Perception and Psychophysics*, vol. VII, no. 5 (May 1970), 289–90.

Wade, N. J., 'The Interaction of Postural Systems in Visual Orientation', *Perception and Psychophysics*, vol. 6, no. 5, 1969, 309–10.

Wagner-Rieger, R., *Die Italienische Baukunst zu Beginn der Gotik*, 2 vols, Vienna, 1956–57.

Walton, P. H., 'Seven Ruskin Drawings in the Fogg Art Museum', *Harvard Library Bulletin*, 1960, 265–82.

—, *The Drawings of John Ruskin*, Oxford, 1972.

Whiffen, M., *Stuart and Georgian Churches: The Architecture of the Church of England outside London, 1603–1837*, 1948.

White, J., *Art and Architecture in Italy: 1250–1400*, Harmondsworth, 1966.

Wilenski, R. H., *John Ruskin: an Introduction to further Study of his Life and Work*, 1933.

Willis, R., *Remarks on the Architecture of the Middle Ages, Especially of Italy*, Cambridge, 1835.

Wölfflin, H., *Prolegomena zu einer Psychologie der Architektur*, doctoral dissertation, Munich, 1886.

Woods, J., *Letters of an Architect, from France, Italy, and Greece*, 2 vols, 1828.

List of illustrations

ink and wash. 13″ × 16¾″. City Museum and Art Gallery, Birmingham.

11 Ruskin. *Angle of the façade, St Mark's, Venice.* Undated. Watercolour. 37″ × 24″. Tate Gallery, London.

12 Ruskin. *Casa Contarini Fasan, Venice.* 1841. Pencil, ink and wash. 12½″ × 17″. Ashmolean Museum, Oxford.

13 Ruskin. *Venetian Renaissance capital.* 1879. Watercolour. 11″ × 8¾″. Fogg Art Museum, Harvard University.

14 Ruskin. *Part of the façade of San Michele, Lucca.* Reproduced from the first volume of *The Stones of Venice.*

15 *San Michele, Lucca.* Reproduced from H. G. Knight's *Ecclesiastical Architecture of Italy* (vol. II, 1844), by courtesy of the Bodleian Library.

16 *Florence Cathedral: interior looking east.* Photo: Alinari.

17 *The Spanish Chapel, Santa Maria Novella, Florence.* Photo: Alinari.

18 Ruskin. *Town Hall, Aix-La-Chapelle.* Undated. Pen and watercolour. 14¾″ × 12¾″. Fogg Art Museum, Harvard University.

19 Ruskin. *Entrance to Feldkirch*, Tyrol. Undated. Pencil, ink and wash. 8⅞″ × 11″. Fogg Art Museum, Harvard University.

20 *Bayeux Cathedral: east end.* Photo: Courtauld Institute of Art.

21 *Pisa Cathedral: interior looking east.* Photo: Courtauld Institute of Art.

22 Ruskin. *Architectural study, Venice.* Undated. Pencil, ink and wash. 14½″ × 7½″. Fogg Art Museum, Harvard University.

23 Ruskin. *Doge's Palace, Venice: the vine angle.* 1869. Watercolour. 19½″ × 13″. City of Manchester Art Galleries.

24 *Santa Maria della Salute, Venice.* Photo: Courtauld Institute of Art.

25 *Palazzo Grimani, Venice.* Photo: Alinari.

26 *The Banqueting House, Whitehall.* Photo: National Monuments Record.

27 *Pisa Cathedral: west front.* Photo: Courtauld Institute of Art.

28 *San Giovanni Fuorcivitas, Pistoia.* Photo: Alinari. Reproduced by kind permission of the Mansell Collection.

29 Ruskin. *Diagram of the façade of the Fondaco dei Turchi, Venice.* Reproduced from the second volume of *The Stones of Venice.*

30 *Casa Loredan and Casa Farsetti, Venice.* Photo: Courtauld Institute of Art.

31 *Bayeux Cathedral: west front.* Photo: Courtauld Institute of Art.

32 Ruskin. *St Wulfran, Abbeville.* 1868. Pencil, heightened with white. 14″ × 20″. The McCallum Collection, University of Glasgow.

33 Ruskin. *Rouen Cathedral gables.* 1854. Watercolour. 19½″ × 12½″. Fitzwilliam Museum, Cambridge.

34 *St Paul's Cathedral, London: panel under a window of the south wall of the choir.* Photo: Helmut Gernsheim. Reproduced by kind permission of the Warburg Institute.

35 *St Mark's, Venice: looking up into the principal dome.* Photo: Alinari.

36 *San Zeno Maggiore, Verona: west front.* Photo: Courtauld Institute of Art.

37 *San Zeno Maggiore, Verona: west portal.* Photo: Courtauld Institute of Art.

38 Ruskin. *Detail of atrium pier of San Martino, Lucca.* 1882. Watercolour. 14″ × 8½″. The Ruskin Collection (Guild of St George), University of Reading.

39 Ruskin. *Part of the front of San Martino, Lucca.* 1874. Pencil and watercolour. 13″ × 20″. Ashmolean Museum, Oxford.

40 Ruskin. *Archivolt of San Donato, Murano.* Reproduced from the second volume of *The Stones of Venice.*

41 *San Donato, Murano: part of the apse.* Photo: Alinari.

42 Ruskin. *Sculptured decoration of the apse of San Donato, Murano.* Reproduced from the second volume of *The Stones of Venice.*

43 *Bourges Cathedral: piers and pier bases.* Photo: Courtauld Institute of Art.

44 *St Mark's, Venice: arcade supporting the gallery.* Photo: Courtauld Institute of Art.

45 *Constitution Arch, Green Park, London.* Photographed by the author.

46 Ruskin. *St Mary's Tower and All Souls*

College, Oxford. 1835 or 1836. Pencil. $14\frac{1}{2}'' \times 10\frac{1}{2}''$. The Witt Collection, Courtauld Institute of Art, London.

47 Ruskin. *St Wulfran, Abbeville: detail of tower*. Reproduced from plate XII of *The Seven Lamps of Architecture*.

48 Ruskin. Detail from *Market Place, Abbeville*. 1868. Pencil. Reproducing a $6'' \times 8''$ portion of the original, which measures $14'' \times 20''$. Ashmolean Museum, Oxford.

49 *Chambéry Cathedral: west front*. Photo: Caisse Nationale des Monuments Historiques, Paris.

50 *Chambéry Cathedral: detail of west portal*. Photo: Colette Sanfaçon, Quebec City.

51 *Amiens Cathedral: west front*. Photo: Courtauld Institute of Art.

52 *Amiens Cathedral: west front: detail of northern lateral and central porches*. Photo: Caisse Nationale des Monuments Historiques, Paris.

53 Ruskin. *View of the Doge's Palace, Venice, taken from the water*. 1852. Pencil and wash. $14\frac{1}{2}'' \times 20''$. Ashmolean Museum, Oxford.

54 Ruskin. *Central doorway of west front of Rouen Cathedral*. Undated. Pencil and watercolour. $30'' \times 24''$. The William Morris Gallery, Walthamstow.

55 Ruskin. *Detail from central doorway of Rouen Cathedral*. Reproduced from Plate I of *The Seven Lamps of Architecture*.

56 *St Mark's, Venice: central doorway of west front*. Photo: Courtauld Institute of Art.

57 Ruskin. *Archivolt in St Mark's*. c. 1851. Reproduced, by courtesy of the Bodleian Library, from *Studies in Both Arts: Being Ten Subjects Drawn and Described by John Ruskin*, ed. W. G. Collingwood, Orpington, 1895.

58 Ruskin. *Drawing of north-west porch of St Mark's*. 1879. Copied at Brantwood from the watercolour reproduced as frontispiece to this book (1877). $20\frac{1}{8}'' \times 15''$. Fogg Art Museum, Harvard University.

59 Ruskin. *Southern porch of St Wulfran, Abbeville*. 1848. Pencil and

watercolour. $18'' \times 12''$. Ashmolean Museum, Oxford.

60 Ruskin. *Detail of St Sauveur, Caen*. 1848. Pencil, ink and wash. $18\frac{3}{4}'' \times 13\frac{5}{8}''$. Fogg Art Museum, Harvard University.

61 Ruskin. *Part of St Lô Cathedral*. 1848. Pencil, ink and wash. $17\frac{3}{4}'' \times 12\frac{3}{4}''$. Fogg Art Museum, Harvard University.

62 *Pembroke College, Oxford: Master's Lodging from the east*. Photo: P. S. Spokes, by courtesy of the National Monuments Record.

63 *Westminster Abbey: nave, looking west*. Photo: National Monuments Record.

64 *Notre Dame, Dijon: interior looking east*. Photo: Courtauld Institute of Art.

65 *Bayeux Cathedral: north side of nave*. Photo: Caisse Nationale des Monuments Historiques, Paris.

66 *Medieval windows from a house near the church of the Frari in Venice*. Reproduced from the second volume of *The Stones of Venice*.

67 Plate XXI from A. W. N. Pugin's *Floriated Ornament* (1849). Reproduced by kind permission of the Bodleian Library.

68 Ruskin. *Sketch of 'foolish foliation'*. Reproduced from the second volume of *The Stones of Venice*.

69 Ruskin. *Detail of a pinnacle of a tomb in Verona*. Reproduced from the second volume of *The Stones of Venice*.

70 Ruskin. *Base of a pedestal bracket on the façade of Lyons Cathedral*. Illustration for the *Lectures on Architecture and Painting* (1854). Reproduced from 12.61.

71 Ruskin. *Detail of bracket shown in ill. 70*. Reproduced from 12.pl. 7.

72 Ruskin. *Archivolt decoration at St Mark's, Venice*. Reproduced from the second volume of *The Stones of Venice*.

73 Ruskin. *Leafage of medieval cornice*. Reproduced from *Examples of the Architecture of Venice* (1851).

74 *York Minster: vaulting capitals in the south choir aisle*. Photo: National Monuments Record.

75 Ruskin. *Capital at Assisi.* 1874. Pencil, wash on grey paper. $7\frac{1}{2}'' \times 6\frac{3}{8}''$. South London Art Gallery. Reproduced by kind permission of the London Borough of Southwark.

76 Ruskin. *Archway in a street in Assisi.* 1874. Pencil and watercolour on grey paper. $7'' \times 6\frac{1}{2}''$. Whitworth Art Gallery, University of Manchester.

77 Ruskin. *Leafage of a medieval cornice.* Reproduced from the first volume of *The Stones of Venice* (plate XVI).

78 *British Ferns: A Capital in the Oxford Museum.* Reproduced from the steel engraving by J. H. Le Keux in the first edition of *The Oxford Museum*, by Ruskin and H. W. Acland (1859).

79 *Capital in the Oxford Museum.* Photo: William Taylor and The Oxford Polytechnic School of Architecture.

80 Ruskin. *Study of a capital in St Mark's.* Undated. Pencil and watercolour. $4\frac{1}{2}'' \times 4''$. South London Art Gallery. Reproduced by kind permission of the London Borough of Southwark.

81 Ruskin. *Lily capital of St Mark's, Venice.* Reproduced from the second volume of *The Stones of Venice.*

82 *A capital at Paddington Station, London.* Photographed by the author.

83 Ruskin. *Profile lines of the lily capitals of St Mark's.* From plate X of the second volume of *The Stones of Venice.*

84 Ruskin. *Details of the lily capitals of St Mark's.* Reproduced from *Examples of the Architecture of Venice.*

85 Ruskin. *Carved boss from outer central arch of the façade of St Mark's.* Undated. Pencil and wash. $6'' \times 5''$. The Ruskin Collection (Guild of St George), University of Reading.

86 Ruskin. *Arch and buttresses of St Wulfran, Abbeville.* 1868. Pencil and watercolour. $13'' \times 20''$. The Ruskin Collection (Guild of St George), University of Reading.

87 Ruskin. *A compartment of the Baptistery, Florence.* 1872. Ink and watercolour. $20\frac{1}{2}'' \times 14''$. Ashmolean Museum, Oxford.

88 Ruskin. *Part of the church of Santa Maria della Spina, Pisa.* 1845.

Watercolour. $14\frac{3}{4}'' \times 19\frac{3}{4}''$. The Ruskin Collection (Guild of St George), University of Reading.

89 Ruskin. *Interior court of the Doge's Palace, Venice.* 1841. Pencil, ink and wash. $13\frac{3}{4}'' \times 18\frac{1}{2}''$. Ashmolean Museum, Oxford.

90 Ruskin. *Street scene, Rouen.* 1835. Pen and indian ink, with some white. $13\frac{1}{4}'' \times 9\frac{1}{4}''$. Fitzwilliam Museum, Cambridge.

91 Ruskin. *Tower of Strasbourg Cathedral.* Undated. Pencil and watercolour. $18\frac{3}{8}'' \times 11\frac{7}{8}''$. Whitworth Art Gallery, University of Manchester.

92 Ruskin. *Upper reach of the Grand Canal, Venice.* 1870. $14'' \times 20''$. Ashmolean Museum, Oxford.

93 Ruskin. *Grand Canal looking toward Santa Maria della Salute, Venice.* 1877. Pencil. $5\frac{1}{4}'' \times 7\frac{1}{4}''$. Library of the Royal Institute of British Architects.

94 Ruskin. *At Venice.* 1877. Pencil. $7\frac{5}{8}'' \times 4\frac{7}{8}''$. South London Art Gallery. Reproduced by kind permission of the London Borough of Southwark.

95 Ruskin. *Street in Venice.* 1877. Pencil and wash. $7\frac{5}{8}'' \times 4\frac{5}{8}''$. South London Art Gallery. Reproduced by kind permission of the London Borough of Southwark.

96 Ruskin. *Ponte Vecchio, Florence.* 1882. Pencil. $11\frac{3}{4}'' \times 18\frac{3}{4}''$. Fogg Art Museum, Harvard University.

97 Ruskin. *Ponte della Pietra, Verona.* 1872. Pencil. $7'' \times 10\frac{1}{2}''$. Norfolk Museums Service (Norwich Castle Museum).

98 Ruskin. *Part of St Wulfran, Abbeville.* 1868. Pencil and wash. $8\frac{3}{4}'' \times 10\frac{3}{8}''$. Fogg Art Museum, Harvard University.

99 Ruskin. *Amalfi.* 1844. Pencil and watercolour. $13\frac{1}{2}'' \times 19\frac{1}{2}''$. Fogg Art Museum, Harvard University.

100 Ruskin. *View of Bologna.* 1845 or 1846. Sepia drawing. $13\frac{1}{2}'' \times 19\frac{1}{4}''$. Tate Gallery, London.

Index

Page numbers in italics indicate illustrations. The number is not repeated when there are text references as well as illustrations on the same page.

180